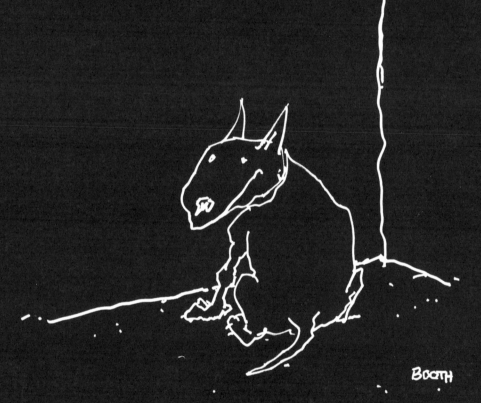

DOG, CORNERED

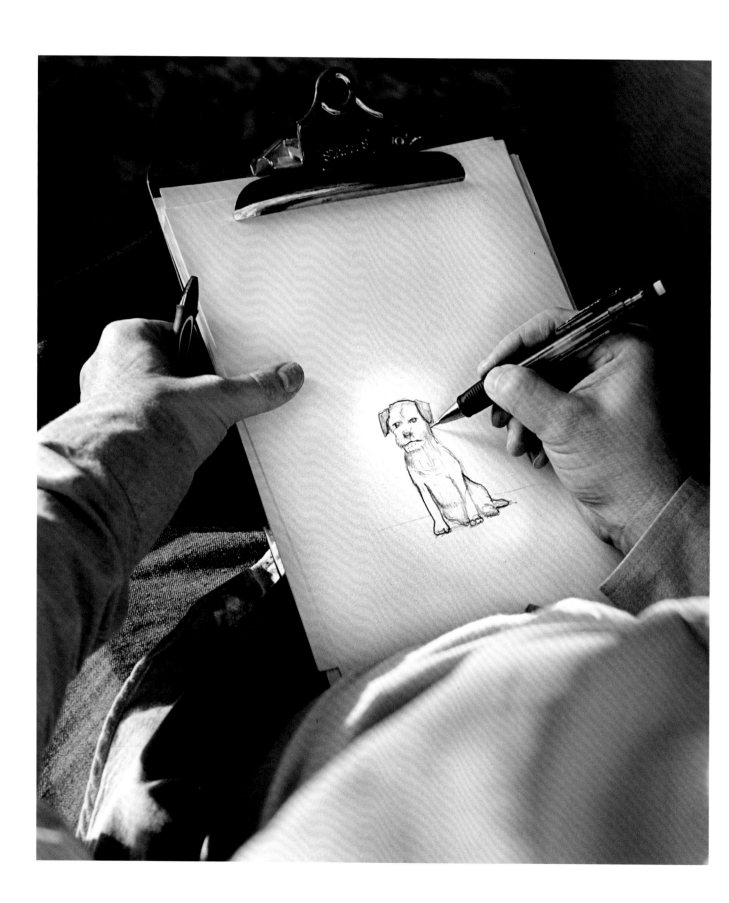

AT WIT'S END

CARTOONISTS OF *THE NEW YORKER*

Photographs by Alen MacWeeney

Words by Michael Maslin

Clarkson Potter/Publishers

New York

Published in the United States
by Clarkson Potter/Publishers, an
imprint of the Crown Publishing Group, a division
of Penguin Random House LLC, New York.
ClarksonPotter.com

CLARKSON POTTER is a trademark
and POTTER with colophon
is a registered trademark of
Penguin Random House LLC.

All photographs by Alen MacWeeny © UCC 2019.
Alen MacWeeney's photographs are housed at
University College Cork.

Cartoon credits located on page 223.

Library of Congress Cataloging-in-Publication
Data is on file with the publisher.

ISBN 978-0-5935-8105-6
Ebook ISBN 978-0-5935-8106-3

Printed in China

Editor: Sahara Clement
Editorial assistant: Darian Keels
Art direction/design: Bob Ciano
Production design: Beth Brann
Design: Guang Yuan Lim
Production editor: Ashley Pierce
Production manager: Kelli Tokos
Compositors: Beth Brann and Nick Patton
Copy editor: Aja Pollock
Proofreader: Mike Richards
Marketer: Monica Stanton

10 9 8 7 6 5 4 3 2 1

First Edition

To my long-time
friendship with Bob Ciano.

—Alen MacWeeney, 2024

THE CARTooNISTS

9 Introduction

10 Foreword

12 Ellie Black

16 Harry Bliss

20 Barry Blitt

24 George Booth

28 David Borchart

32 Hilary Fitzgerald Campbell

36 Roz Chast

40 Michael Crawford

44 Joe Dator

48 Drew Dernavich

52 Liza Donnelly

56 Liana Finck

60 Ed Fisher

64 Emily Flake

68 Seth Fleishman

72 Dana Fradon

76 Mort Gerberg

80 William Haefeli

84 Charlie Hankin

88 Amy Hwang

92 Zachary Kanin

96 Bruce Eric Kaplan

100 Farley Katz

104 Jason Adam Katzenstein

108 Lars Kenseth

112 Edward Koren

116 Peter Kuper

Amy Kurzweil **120**
Maggie Larson **124**
Robert Leighton **128**
Robert Mankoff **132**
Michael Maslin **136**
Jeremy Nguyen **140**
Paul Noth **144**
John O'Brien **148**
George Price **152**
Akeem Roberts **156**
Ellis Rosen **160**
Benjamin Schwartz **164**
Justin Sheen **168**
David Sipress **172**
Barbara Smaller **176**
Edward Sorel **180**
Edward Steed **184**
Peter Steiner **188**
Mick Stevens **192**
Tom Toro **196**
Victor Varnado **200**
P.C. Vey **204**
Christopher Weyant **208**
Gahan Wilson **212**
Jack Ziegler **216**
About the Authors **220**
Acknowledgments **222**
Cartoon Credits **223**

To my family and to
my colleagues.

—Michael Maslin, 2024

INTRODUCTION

For a magazine that's been around for a century, one might suppose that it has had its act together for much of that time. But the truth is: *The New Yorker* has been restless since its debut in the mid–Roaring Twenties. That restlessness, defined by a desire and openness to change, has been, and continues to be, its core strength.

The magazine that made a name for itself in the last millennium is in some ways not the magazine it is today. And we hope that *The New Yorker* of a hundred years from now will not be a duplicate of the current magazine. It has always been the magazine of surprise, beginning with issue #1's cover by Rea Irvin of an oddly compelling top-hatted Victorian-era gent (soon to be dubbed Eustace Tilley). The magazine's cartoonists have kept the element of surprise afloat to this very day. Who among us does not flip through the latest issue to see the cartoons, looking and hoping to be surprised.

My guess is that not a year has gone by—not even a month in a year—without someone somewhere saying that the cartoons "aren't as funny as they used to be." If we're lucky, that will continue as long as there's a *New Yorker*. Change at the magazine means that the idea of *what's funny* changes. In 2025, cartoonists should not be trying to mimic cartoons that tickled funny bones in 1925—they should be capturing the humor of the present. Looking at a 1920s cartoon will inform you of that era's fashion and concerns and behaviors, and even politics. The same can be said for the cartoons of the 2020s. Around and around it goes, with plenty enough oddities to make things more than interesting. This is the meat and taters of *The New Yorker*.

In a now grand tradition, the magazine's cartoonists identify themselves as "*New Yorker* cartoonists"—but in truth they work for themselves. They remain, for the most part, solo acts, seeing what most of us see, then running that through their brains' highly attuned and complex cartoonist gadgetry. They're hard workers, these cartoonists—they always have been. As you will see in Alen MacWeeney's photographs of the artists in this volume, they are a determined lot.

—Michael Maslin

FOREWORD

When I found out that I was going to be *The New Yorker*'s next cartoon editor (its fourth, in its nearly century-long history—but no pressure), I did what anyone would do. I panicked, and started making flashcards. I had been a cartoon zealot from childhood, but despite being able to identify the unique styles and often obscure signatures—BEK?!—of the magazine's cartoonists, I was worried that I wouldn't be able to ID the people behind the pens when they marched into my office. So, I glued printed-out photos onto index cards and started quizzing myself. (For what it's worth, I did the same thing that year for the 2017 Yankees, whose roster had experienced a real shake-up—I'm not so much crazy as completist.)

There was, however, a more worrying question that no amount of study prep could help me answer. WHAT WERE THESE PEOPLE GOING TO BE LIKE? WOULD THEY ALL RESEMBLE THE CHARACTERS IN THEIR CARTOONS? That would certainly be useful—and is, hilariously, sometimes the case, though I won't name names. Regardless, I was terrified and intimidated. Before my official start date in my new role, I caught one of the cartoonists (whose face

I could of course now recognize) surreptitiously taking a photo of me through my glass office door. Time was running out—they were at the gates.

On my first day of inviting cartoonists into my office, to chat and give feedback on their submissions for that week (aka their "batches" of ten-ish roughly drawn cartoons), George Booth, a hero of mine, burst in and yelled, "You're a ray of sunshine!" I ditched the flashcards shortly thereafter. It turned out that the cartoonists are, by and large, teddy bears—very neurotic, very talented teddy bears. Wonderful, sensitive people committed to doing a very odd job that no longer ensures the kind of income that can pay off your mortgage.

The older guard was quick to inform me about how they'd once been able to take their batches from magazine to magazine, around town, till they'd sold the lot, then go out together for lunch and a cognac. The younger generations taught me about the many other gigs that now support a gag cartooning "career"—kindergarten teacher, art installer, animator, projectionist, truck driver, etc.

There have been cartoons in *The New Yorker* since it was founded as a "comic weekly" in 1925. And if I have anything to do with it, there will be as many cartoons as possible in our pages and on our website, drawn by a diverse and ever-expanding roster of cartoonists, till the next asteroid hits.

This wonderful book profiles only a tiny fraction of our current contributor pool. Every week I receive batches from around 150 cartoonists, from across the globe—and yes, 150 times 10 equals a lot of cartoons.

ur–*New Yorker* cartoon—but rather to draw anything that makes them laugh.)

There are certainly some attributes that the *New Yorker* cartoonist crew share. Whether it's their proclivity to come up with insane conspiracy theories when they haven't sold in a few weeks, or their persistent humor in the face of the indignity that is sending jokes off to be judged and most often rejected, or the fact that they can all talk to you about types of paper for twenty minutes.

But I don't know that I, or this book, have the definitive answer. Except to say that *New Yorker* cartoonists are lovely people, with a weird, insistent will to keep this delightful medium alive, and an incredible generosity toward one another. If you've been considering joining their ranks, I highly recommend it. Because, hopefully, this is just volume one of many, raising the curtain, inch by inch, on the secret lives behind those inscrutable signatures.

Additionally, new people are constantly being brought into the fold, whether it's via Instagram (where, for instance, in COVID lockdown, I first encountered Sarah Akinterinwa's fabulous cartoons about romantic relationships), or comics festivals and conventions, or the zine racks at local comic bookstores. Even the chin-deep "slush" pile of unsolicited submissions has brought the likes of Edward Steed and the then-lawyer, now-Pulitzer-finalist Zoe Si into our pages.

So what, at the end of the day, makes someone a *New Yorker* cartoonist, when, as this book demonstrates, they work so differently, think so differently, see the world so differently, and draw so differently? (In fact, my top advice for aspiring cartoonists is *not* to mimic what they think of as some sort of

—Emma Allen
Cartoon Editor
The New Yorker

ELLIE BLACK

Massachusetts-born, Maine-raised Ellie Black is an excellent example of the present-day *New Yorker* artist. Ellie (whose pronouns are they/them) was part of the freshman class of 2019, which included twenty-six newbies—the biggest influx of cartoonists ever in modern times.

Growing up as a *Far Side* and *Calvin and Hobbes* kid who eventually studied film in college, they took a class in cartooning taught by another *New Yorker* cartoonist Jason Adam Katzenstein (himself relatively new, having begun publishing in *The New Yorker* in 2014). The class inspired Ellie to submit to the magazine postgraduation, resulting in their first "OK"—the two letters that are shorthand for "*The New Yorker* has decided to buy this draw-ing from you." That drawing, titled *Grave Robber Meet-Cute,* appeared in the magazine's ninety-fourth-anniversary issue.

It's an interesting debut, as it seems, ever so slightly, to point to Charles Addams's oeuvre: within the grave-yard scene, there is the idea of making a possible roman-tic connection while digging up a grave. Within the norm is the oddly unusual. Off the drawing board, there is, as you see in Ellie's photo, one fur-ther Addams-y vibe: the large ceramic teeth-baring wolf named "Socks" they keep in their apartment.

I asked them, "Why 'Socks'?"

They told me, "I use him to dry socks or other things that come out of the dryer a little damp."

It is the handling of Ellie's drawings—their graphic nature—that points to the pres-ent day. Although they took art classes, they feel essentially self-taught as they "spent so much of [their] free time draw-ing throughout [their] entire life." Nowadays Ellie says: "My favorite thing to do really is drawing in bed while watch-ing TV."

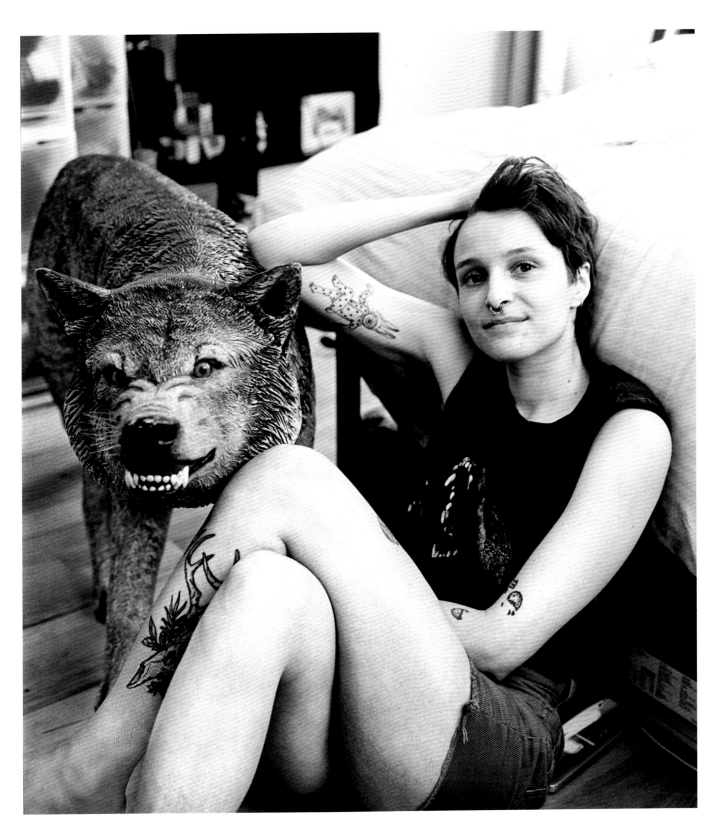

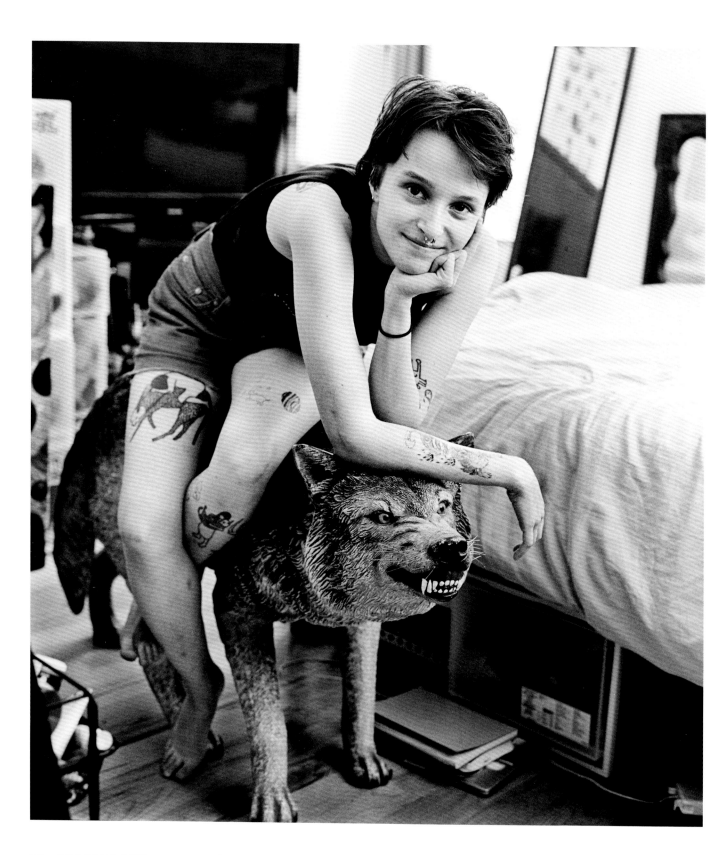

Drawing throughout one's entire life translates into an assured style: exteriors, interiors—no problem. MICE: NO PROBLEM. COCKROACHES: NO PROBLEM. DRAGONS: NO PROBLEM. There's no overdrawing, no awkward perspective. Each drawing—i.e., the "look" of each drawing—is comfortable in its own skin.

The subject matter is at times universal, with nods to global warming and a postapocalyptic world; at other times the work is intensely self-centric. Ellie told me: "I find myself to be pretty bad at cartoons that address specific current events. Instead, I usually try to reflect on what's been on my mind lately. Often this is current events, but I can rarely think of a joke based on a specific headline. My more 'topical' jokes tend to be about prevailing attitudes toward a certain issue [rather] than breaking news in the issue itself."

When looking at any new cartoonist's work, I immediately jump to the future—their future. Sometimes I fret. One can feel the struggle in the drawing, and/or the struggle for a well-written caption—a struggle to integrate both. When those concerns aren't present, I'm left with the exciting prospect of what comes next, and looking forward to more, more, more.

"Mark my words—someday all the chewing up paper bags and pooping on stovetops will be done by those things, and we'll all be out of jobs."

"She doesn't want to see you, man."

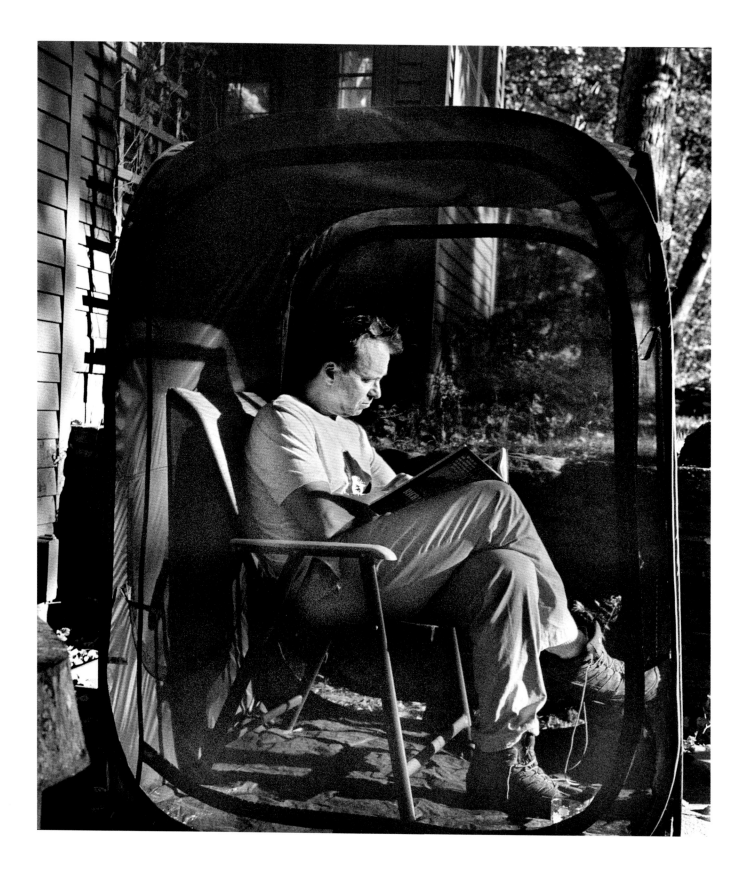

HARRY BLISS

In the history of collaborative *New Yorker* cartoonists—those who work with writers—Harry Bliss is the only cartoonist to work with a writer who is a household name. That part-time partner is actor, writer, and comedian Steve Martin. When Mr. Martin approached Harry about working together, it began a relationship that produced the cartoon collection *A Wealth of Pigeons,* along with Martin's memoir *Number One Is Walking: My Life in the Movies and Other Diversions.* The media coverage was outside of what we normally (actually, always) experience when a cartoonist publishes a book, aside from, of course, the hoopla surrounding Roz Chast's memoir,

Can't We Talk About Something More Pleasant?

If we take Mr. Martin out of the picture for the moment and focus on Harry's cartoonist CV, it would be, for any contributing *New Yorker* cartoonist, notable. Not only has he provided hundreds of cartoons since he came to the magazine in 1998, he's also contributed a number of covers. Beyond *The New Yorker,* he's produced a syndicated cartoon and done well in the children's book arena. His association with Steve Martin is but the cherry—albeit a very large cherry—on top of a quarter-century career.

There is no typical Bliss *New Yorker* cartoon, but many of his

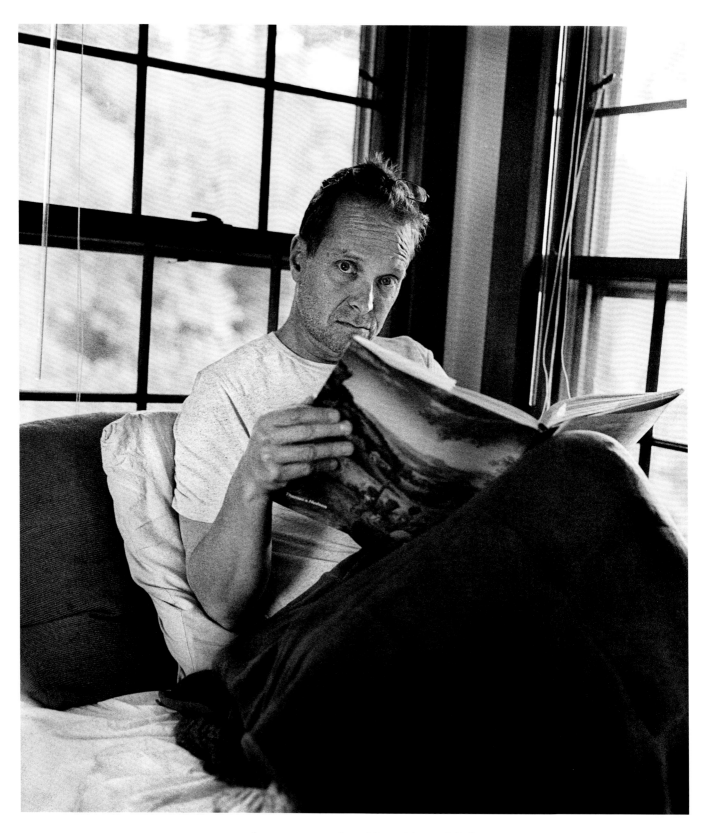

cartoons are rendered in a frieze: think ancient Egyptian art. You get a sideways look at faces, both human and animal. If I imagined one off the top of my head it would be boxed (as many of his are) with a tree and a dog and a guy. Another

imagined cartoon might include a superhero (the Incredible Hulk makes a number of appearances) or Hollywood monster.

Do Bliss cartoons deliver any insight into his person? I don't know—and maybe it really doesn't matter. Harry is his work. Our scant in-person intersections a few times over the years did not illuminate the cartoonist's inner life. The first time we met, at a book event in New York's Soho district, Harry seemed engagingly ill at ease—but then most every cartoonist seems that way. The second meeting was years later near *The New Yorker*'s elevator bank. I RECALL THAT DURING OUR BRIEF EXCHANGE HARRY STRUGGLED TO EITHER OPEN OR CLOSE AN UMBRELLA.

It's always a bad idea to generalize, but here I go anyway: Cartoonists, for the most part, seem to be creatures of solitude. They mostly work at home, by themselves. If there's any glare, it's from light bouncing off their drawing paper.

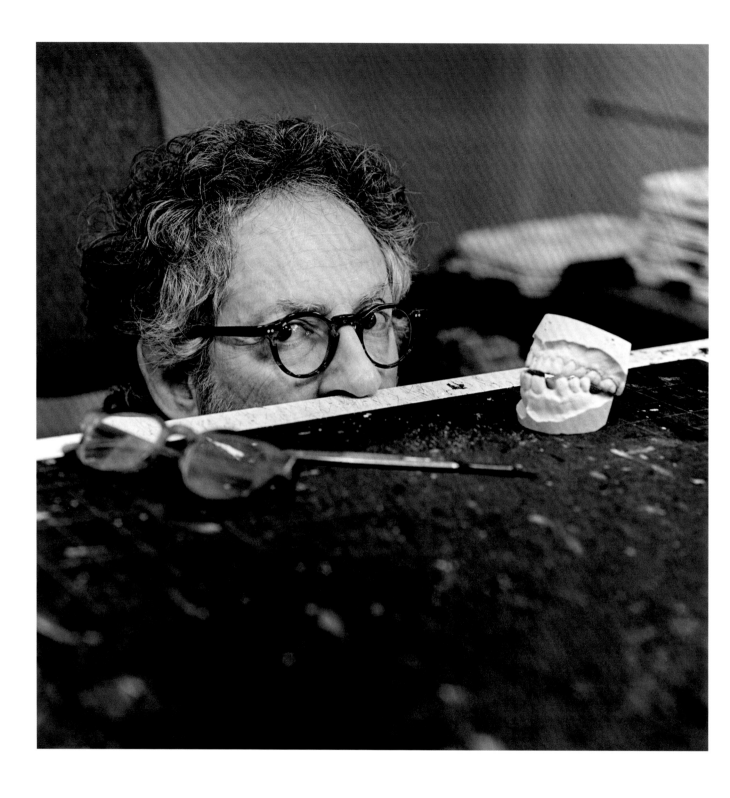

BARRY BLITT

In hindsight, it's easy as pie to see that Barry Blitt was destined for a Pulitzer Prize for his *New Yorker* cover work. As much as Edward Sorel is identified as *the* cover artist during former editor in chief Tina Brown's *New Yorker* era, Barry Blitt has come to be identified with the David Remnick era. In one of those too-good-to-be-true-but-true moments, Blitt sought Sorel's counsel when his (Blitt's) first cover was in the works. Since then, things have gone very well for Barry—he's now contributed over one hundred covers to the magazine, many of them forever unforgettable, including the so-called Obamas fist-bump cover of November 15, 2010.

Though Barry's entrée to the magazine was through the cartoon department, his specialty is covers. Each one looks effortless—an idea playing off an up-to-the-minute news story, presented in casual lines that come together to form an instantly recognizable public figure. There is never a nanosecond of doubt about who we are seeing flitting across the cover. By the end of the Trump presidency, Barry must've been able to lay down a Trump caricature as easily as he would find middle C on the piano (an instrument he plays as part of a jazz group, the Half-Tones).

Barry himself is the calm in the graphic storm he creates. I remember

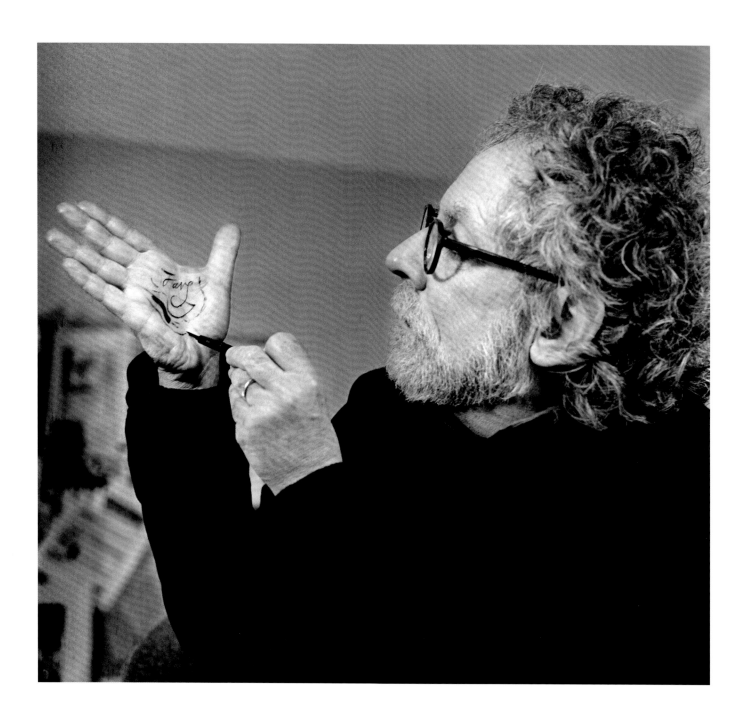

him at the home of *The New Yorker*'s editor, during a packed book signing for *Blitt,* a compendium of his work. After the speeches, I came upon Barry seated alongside a wall in one of the rooms. I sat in the chair next to him. We spoke:

MM: Hey, Barry.
BB: Hey, Michael.
MM: Nice event. Congratulations on the book.
BB: Yeah, thanks.

Then we both sat in silence, our backs to the wall, watching the partyers as they slowly encroached upon our limited space. THERE SEEMS TO BE NO SUBJECT TOO SACRED FOR BARRY. IT IS, AS IT OUGHT TO BE FOR SOMEONE PUNCTURING THE HIGH and mighty—the essential modus operandi. His satiric style fits him as perfectly as the hat you will almost always see him wear.

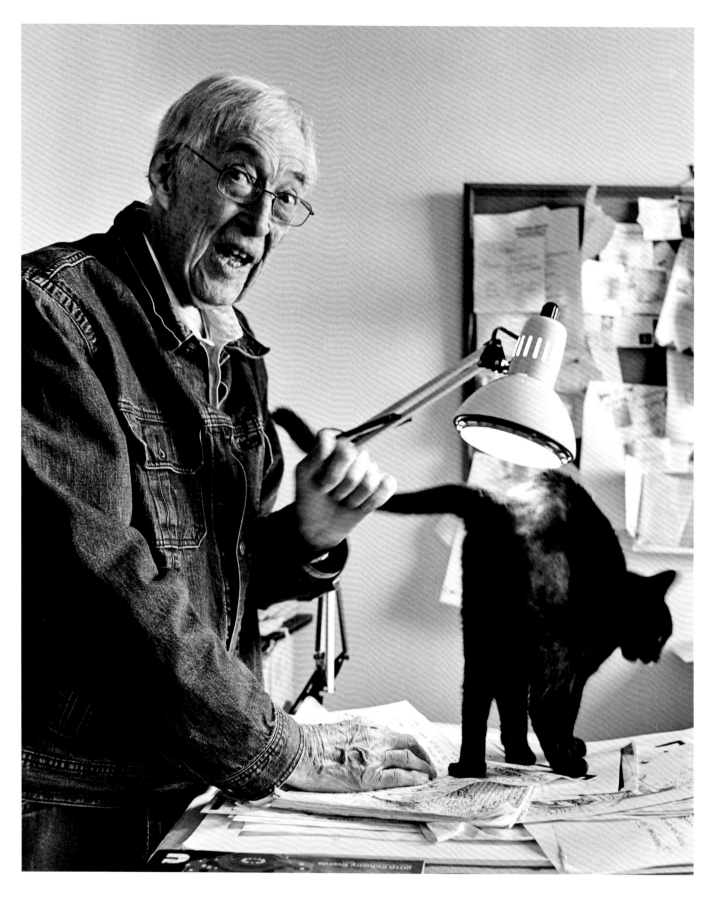

GEORGE

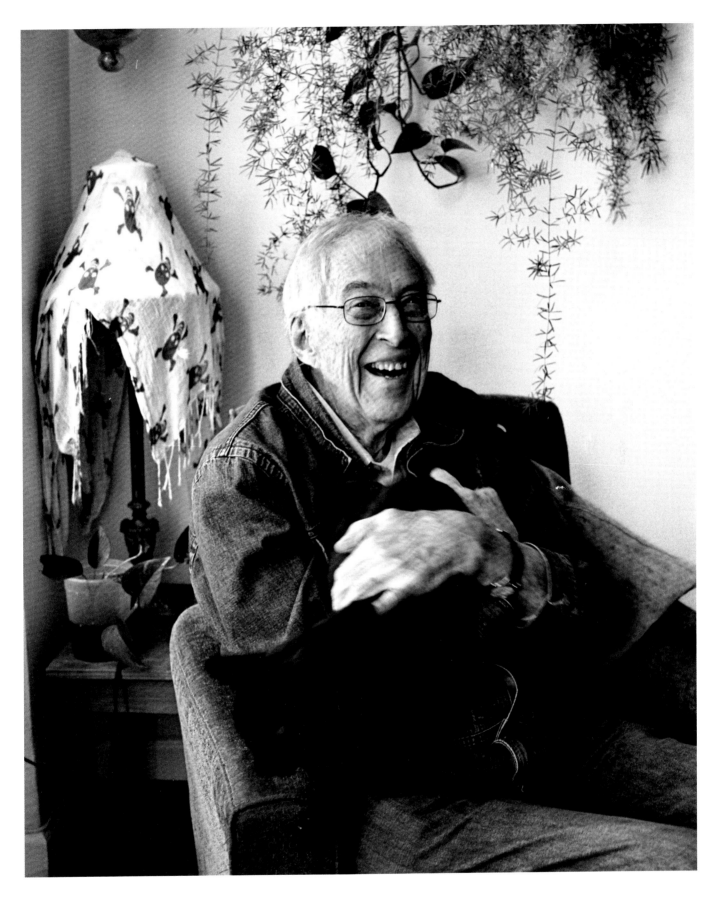

BOOTH 1926-2022

There wildly different sensibilities were brought into *The New Yorker*'s stable of cartoonists in 1969: Sam Gross, Charles Barsotti, and George Booth. Gross cartoons were mostly composed of simple lines with subject matter related to the Charles Addams school of unsettledness. Anchoring it all was a large dose of *MAD* magazine irreverence. Barsotti's world—also simple lines—was inhabited by his "pups" and people making do in a complicated, often confusing world. Of the three, Booth brought the wider cast of characters, who perhaps tracked closer to real life. The energetic senior citizen Mrs. Rittenhouse, the man in the claw-foot tub, the Booth dog, and cats. And then the settings: the wainscoted room, with rumpled rug, and the swung hanging ceiling lamp. Booth visited and revisited all until we knew, in an instant, where we were and who we were with. Of the *New Yorker* superstar artists to emerge in the late 1960s and early '70s, he had a style that was the look of that period as much as Edward Koren's was. Both styles were interchangeable with the *New Yorker* logo; their work was *The New Yorker*, *The New Yorker* was their work.

His drawing style was at once new to our eyes and seemingly familiar—an honest original. Seeing a Booth drawing, one might marvel at the intricacies of people, places, and things. Look at the original art and you'd see cut-out

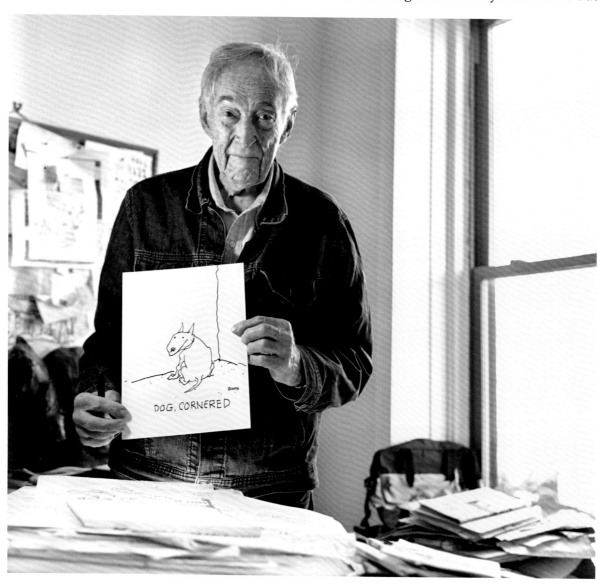

chairs, plants, or dogs, placed and arranged as if on a theater set. He was a master of design and a master of humor. Everything was funny. The way he drew a piano was funny. His humor transferred directly to the page, where the drawings' good vibrations continued.

Booth is among the handful of *New Yorker* cartoonists, including Charles Addams and Saul Steinberg, of whom it could be said the artist closely resembles the artist's work. Meeting Booth was like meeting a character in his cartoon world. As he spoke, it was tempting to think of what he was saying as captions—captions that work only in a Booth cartoon. I can easily picture Booth in a garage bay, as an auto mechanic speaking to a customer—"We'll have to keep your car another day. There's a devilled egg in the carburetor"—or as the customer hearing the news. Either way, it's a terrifically Boothian experience.

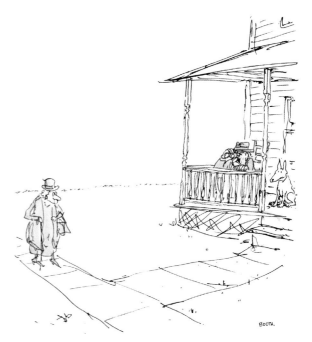

"By Jupiter, an angel! Or, if not, an earthly paragon!"

HE WAS A TALL MAN WITH A WILL ROGERS-LIKE TUFT OF HAIR FALLING ONTO HIS FOREHEAD. He had a touch of a Missouri
accent (that makes sense: it's where he was born). Booth was a real character. Bursts of laughter—perhaps a snort! Laughing fully out loud as if he was surprised by humor in others. Not the least bit shy about laughing at his own work—an honest reaction to the absurdities he'd laid down on paper. When Booth appeared along with Lee Lorenz, Frank Modell, and Charles Addams on *The Dick Cavett Show* in 1976, it was Booth who laughed the loudest at the cartoons shown to the audience. His laughter, like his cartoons, provided a moment or two of contagious pure joy.

The first time I met Booth, it was in the late 1970s at a gathering of cartoonists on Manhattan's Upper East Side. I was a fledgling cartoonist, with, perhaps, one or two *New Yorker* drawings published. I recognized him from his book jacket photographs. It took a lot for me to do it, but I walked up to him; the closer I got, the taller he looked. I introduced myself, saying something original like, "So pleased to meet you, Mr. Booth." He leaned down and asked if I was a cartoonist—

I answered, "Yes." He said something nice to me—I can't remember the exact words (they might've been "Good! Good!")—before being called away to waiting friends. As he walked away, I imagined him heading off to a happy gathering of *New Yorker* cartoonist giants.

DAVID

It is unlikely that someone coming across a drawing by David Borchart in *The New Yorker* will give it a quick glance—a once-over—and then move on to the next cartoon. For one thing, there's a whole lot to see in one of David's beautifully rendered drawings. As is said about a great meal, you want it to last. In 2016, when I interviewed the late great Jack Ziegler, he had this to say: "It's always nice when cartoonists know how to draw so that they can give us something pleasant and fun to look at." David, perhaps as much as any other contemporary *New Yorker* cartoonist, most certainly gives us something pleasant and fun to look at. His drawings are not done in haste; he does not whip them off à la James Thurber (or even this cartoonist). David's finished work takes

BORCHART

time—a lot of time. As he told me: "A finish rarely takes less than three to four hours, and I'm not unwilling to scrap a finish after three hours and start over if I don't like how it's coming along."

I have to believe that his desire for the high bar comes from his earliest acquaintance with *New Yorker* drawings: a book of Mary Petty's cartoons titled *This Petty Pace*. Subsequent purchases of collections by André Françoise, Charles Addams, and George Booth led to his saying: "Thanks to those books, I thought *New Yorker* cartoons lived in hardcover volumes. You pored over them for hours, studying the pen lines, the shading, and—especially in Mary Petty's work—the completely unexpected but totally perfect compositions."

David is not afraid to take on the big picture—he is, in fact, one of the modern masters: seemingly able to render the Palace of Versailles as easily as a contemporary living room. Looking at one of David's *New Yorker* gems *"Bigger than Godzilla? Sir, it's lighting its cigar with Godzilla"* (June 7, 2021), one sees that David chose to make things more difficult for himself by giving us a drone's-eye view of the scene. Laying out the piece as he has, it would take just one graphic miscalculation to make the whole thing fall apart visually. But nothing fails—the caption couldn't be better paced or funnier—and we are rewarded with a drawing that Harold Ross, *The New Yorker*'s legendary founder and first editor, would've found difficult to fault. But drawing alone does not make a great cartoonist.

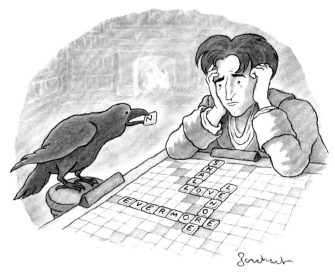

"You're going to hate yourself."

DAVID IS IN POSSESSION OF THE SECRET SAUCE OF CARTOONING: as with so

many of the very best cartoonists, we feel we're seeing some of him within his work, and not a constructed gag cartoon tagged with his name (not that that's a crime). If you by chance happen to run into David, as I have over the years, you get the impression he possesses, but does not bombard us with, a cathedral of comic wisdom. His wife, the poet Sharon Mesmer, once posted something David had texted her as he sat on the subway in New York City: "The B train is slow but the tracks are patient."

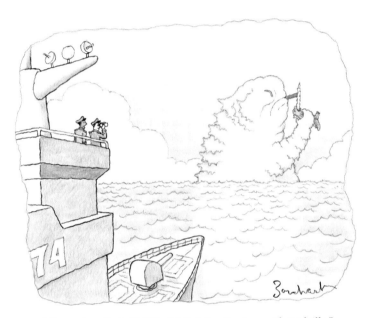

"Bigger than Godzilla? Sir, it's lighting its cigar with Godzilla."

HILARY FITZGERALD CAMPBELL

Hilary Fitzgerald Campbell is a *New Yorker* cartoonist who can claim membership in a special club: those who submitted to one *New Yorker* cartoon editor without any luck, only to find acceptance with the editor's successor. A few examples: I'm in that club, having submitted to and been rejected by James Geraghty for years, only to be accepted by Geraghty's successor, Lee Lorenz; David Borchart's work was rejected by Lorenz, then accepted by Bob Mankoff. Hilary's work was rejected during Bob Mankoff's final year as cartoon editor. The minute he was out the door, she sold to Mankoff's successor, Emma Allen.

Raised in a *Peanuts*-centric environment (her mother's father was golfing buddies with Charles Schulz), Hilary was inspired to put pencil to paper very early on. Hilary told me: "I mainly learned to draw from *Peanuts*." As strong as that influence was, there is, as far as I can tell, hardly a trace of the *Peanuts* gang in her work, with the exception of the black Snoopy nose she draws on her cartoon dogs. Like for so many of her colleagues, copying her favorite artist's work eventually gave way to her own style. She has said in at least one interview that she began writing down her thoughts more post-college "and started attaching them to [her] cartoons."*

In Hilary's case, the style, to my eyes, looks like very slo-mo animation. There's movement in those static people—the figures seem to be on the verge of activity. I would argue that this is unusual in *New Yorker* cartoon land. Compared to Victoria Roberts's

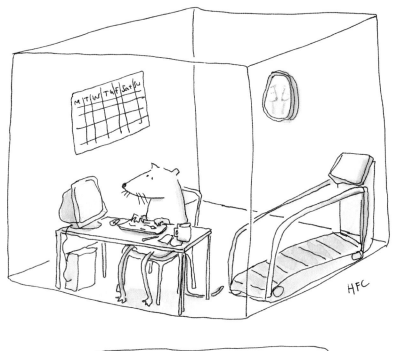

FREELANCE TEST RAT

wonderful couples all settled in on easy chairs in a living room, Hilary's people are antsy.

Even though I spend much of my day drawing and watching things develop on paper, I've always loved seeing others do the same. The drawing decisions made, SUBCONSCIOUSLY OR CONSCIOUSLY; THE HESITANCY OF THE PEN; THE "MISTAKES" AND HOW THEY HANDLE THEM (crumple the paper or forge ahead). It's all fun and all instructive. In a number of videos of Hilary drawing, she exhibits a real ease with her pen and paper. It's obvious she and the art form have been together for a long, long time.

When I asked Hilary what her favorite go-to topics were, she replied, "My general go-to when I don't know what to doodle are dancing, dogs, and anxiety." Even if we're not actually seeing drawings ripped from her diary, they often feel that way: funny and fun things that happen to a real person who happens to be, luckily for us, a cartoonist.

*CreativeLive, "Finding the Funny with New Yorker Cartoonist Hilary Fitzgerald Campbell," YouTube, August 20, 2020.

"And it has pockets!"

ROZ CHAST

There are cartoonists who seem to belong to a "school"—that is, they stylistically fit together (Robert Weber, Charles Saxon, and Frank Modell, for example)—and then there are those who are schools unto themselves. A few examples: Saul Steinberg, Jack Ziegler . . . and Roz Chast. These artists convey a highly personal take on the world—a view only they are able to bring successfully to the page.

We feel we're "seeing" these artists in their work, much as we felt we saw Steinberg's brain at work in his drawings and Ziegler's wacky DNA laid down in pen and ink.

Roz's *New Yorker* debut was in the issue of July 3, 1978. Interestingly, Roz was one of two Rozes stepping into *The New Yorker*'s stable of artists that year. Roz Zanengo, whose cartoon world was also highly personal, was the other. Her first drawing appeared in an October issue (sadly, Zanengo's run at *The New Yorker* lasted less than a decade).

Roz Chast's first drawing, *Little Things,* was the coming attraction for all that followed from her

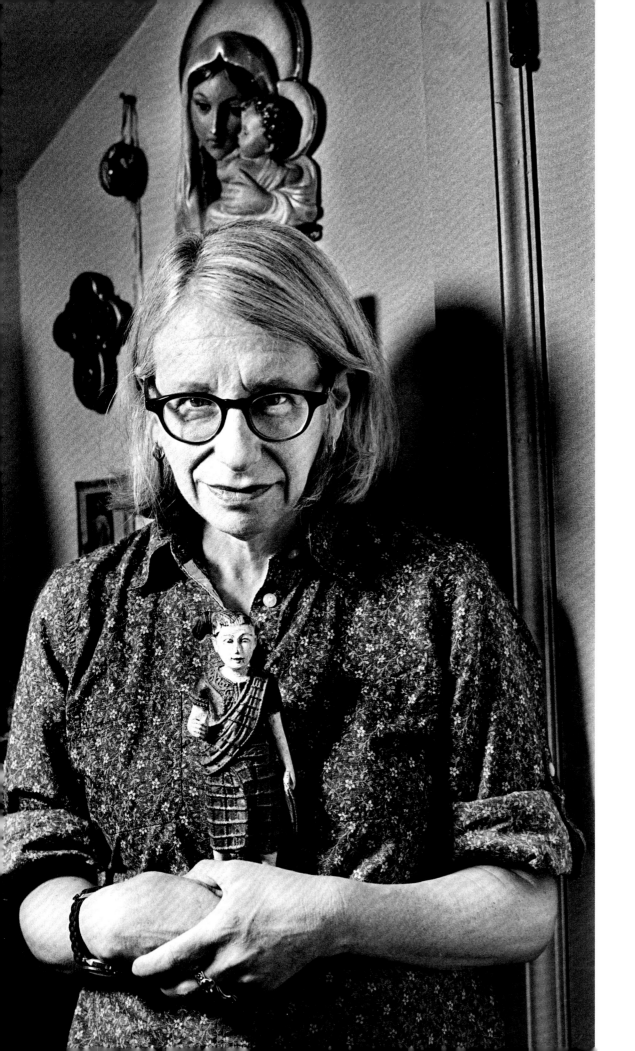

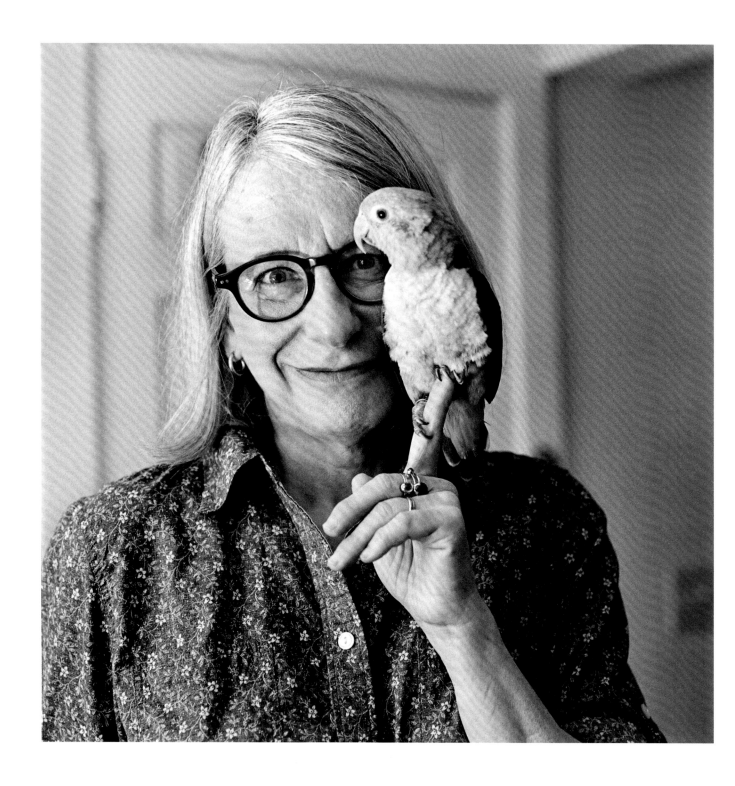

very deep creative well. It foretold graphically how Roz would zero in on her interests for the decades to come: the piece was boxed. Not that she wouldn't give us work at times in the classic *New Yorker* single panels, but a Google search of her work will wow you with a plethora of boxed drawings—an Amazon warehouse full, to be honest. These boxed pieces eventually, and often, worked their way into a more conventional comic book format, horizontal strips of panels stacked upon each other. Her masterpiece of the long form *Can't We Talk About Something More Pleasant* in 2014 was just that

(with some detours)—a graphic comic book, or what is commonly called a graphic novel.

It was about forty years ago that the *New Yorker* cartoonist Richard Cline, a tall, bearish-sized person, introduced me to Roz, who is not a tall, bearish-sized person, in the Grand Ballroom of Manhattan's Pierre Hotel. We shook hands amidst the considerable music and noise attendant with William Shawn–era *New Yorker* anniversary parties. A combo played beyond the dance floor; circles of writers and cartoonists and *New Yorker* business types had already formed and were loudly chitchatting the evening away, everyone holding a glass of wine or scotch or some other libation—the scene resembled an animated *New Yorker* cartoon. Roz and I, perhaps recognizing the absurdity of our fledgling status amidst so many accomplished adults, became "buddies"; we were both in our early twenties, fresh out of college, now suddenly affixed to a most refined universe, a culture that included what Tina Brown called "*New Yorker* snobbery." We laughed a lot in that first meeting.

Here's a not-so-well-kept secret about Roz: she is, as are many of her Hall of Fame *New Yorker* colleagues, a through-and-through artist. SHE IS NOT SOMEONE GRINDING OUT JOKES TO PLEASE AN EDITOR. She is at home, at her desk, transmitting her world—and all that that means—to ours. The little things that Roz focused on in her first *New Yorker* drawing, and in the work to come, are in many cases the big things in life.

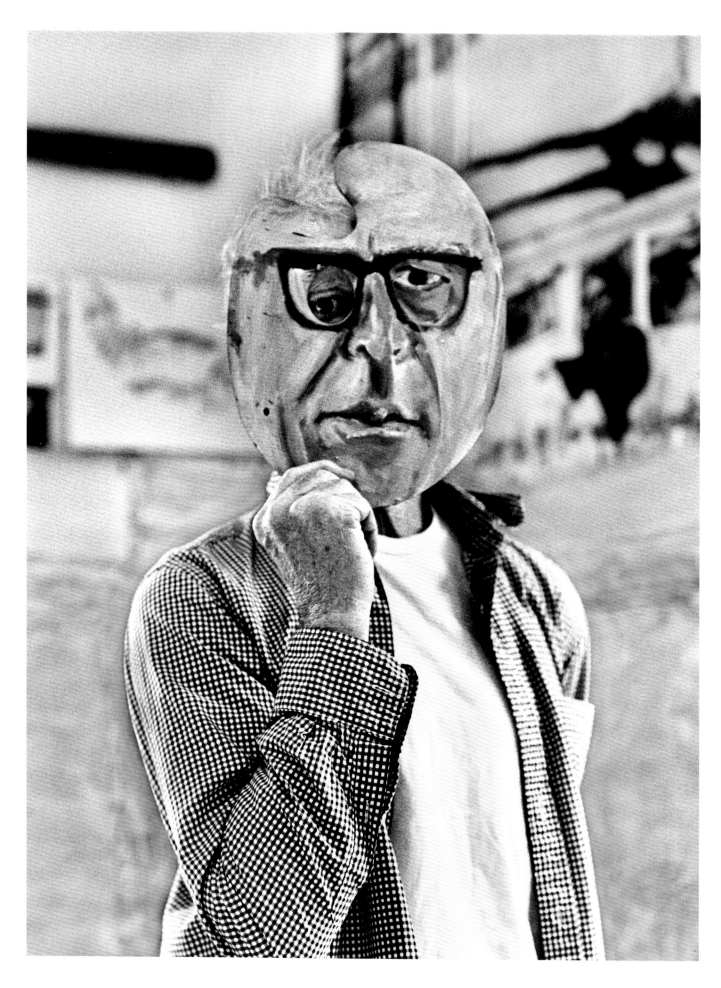

MICHAEL CRAWFORD
1945-2016

Crawford, as he was referred to by almost everyone in the *New Yorker* cartoon community, was seventy when he left for the big drawing board in the sky. His *New Yorker* career had had a slow start under William Shawn but picked up mightily two editors later, when Tina Brown ruled the roost.

Although I got to know Crawford a little, he always seemed somewhat like a closed shop. When I got around to interviewing him in 2013, he opened up just a bit about various dear-to-his-heart topics, baseball among them, and even a little about his life as a cartoonist.

To a question about his cartoon heroes, he replied:

"I got a kick out of most cartoons I saw when I was young, indiscriminately. There was no accounting for variations in 'funny.' At some point, certain artists became 'idol'—as in: 'I want to be him or her—they have a way with language and/or a line I want, but it's been done—forget it,' which is where the seed of your own resourcefulness is planted. Or not. Immediately appealing to me visually—cartoonists and painters—were Steinberg, Steig, George Price, Mary Petty, Peter Arno, Perry Barlow, Arthur Getz, and Edward Hopper. Who has always been to me—while an astonishing painter—a sort of latent cartoonist who got on the A train, not the D, and never got off. Thank God."

And when I asked him what he did daily before the "magic" began at his drawing board, he responded:

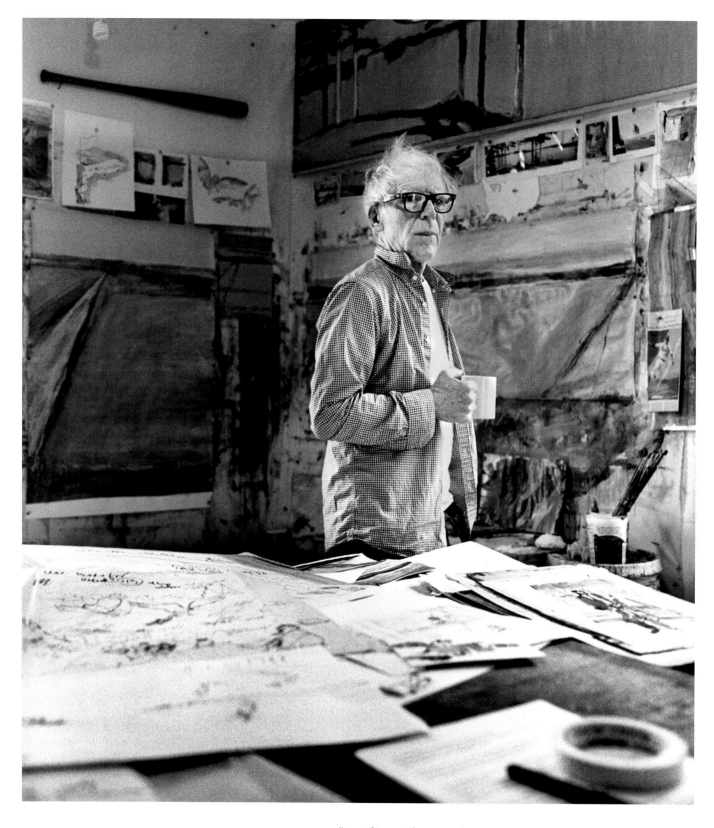

"Just live. I draw 24/7 wherever I am, just trying to look busy. When I'm not painting, also, I keep notebooks, which fill up with stray material from many sources, which I play with near

my deadline and try to write a dozen lines, which might work with a dozen recent sketches for the batch. Pretty arbitrary but amusing process fueled by caffeine and tobacco."

"Trying to look busy" was an interesting choice of words, for that is exactly how he always appeared: busy. Never one to rest up against a wall at an event, he would be either arriving or departing. His work, to echo what *New Yorker* editor David Remnick once said about it, "was an expanding world all the time. He didn't sit still." HE WAS ALWAYS ON THE MOVE, CAPTURING A CULTURAL MOMENT, WHETHER A PHRASE OR A FAD, SECONDS BEFORE THE REST OF US, and turning it into cartoon gold. His use of marker rather than ink wash was unique to our cartoonist stable. The flat strokes of the marker's nib added to the visual immediacy. *No time to wait for a wash to dry—gotta get going.*

I recently met my first whippet. The dog jumped around for a ten-second greeting and then ran off looking here and there, seemingly barking at nothing. The dog's owner said that whippets are visual hunters—a term I'd never heard. I think Crawford was, in his cartoonist way, a visual hunter. He never settled down for long before heading off, seeing things most of us couldn't, and then reacting to them, using paper, pen, and markers.

FRENCH ARMY KNIFE

"You're amazing! Where do you even find the time to shave your legs?"

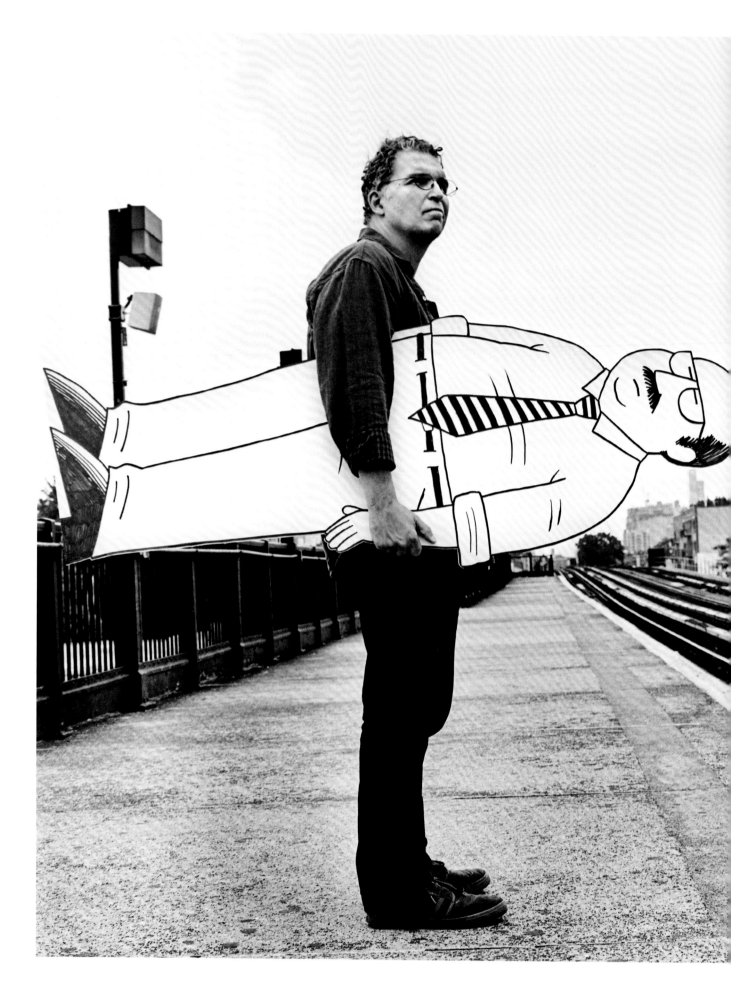

JOE DATOR

Joe Dator was one of just six cartoonists who joined *The New Yorker* in 2006 (the others: Pete Holmes, Evan Forsch, Jason Polan, Martha Gradisher, and Julia Suits). In the years since, Joe has made good on the grand *New Yorker* tradition of creating one's own world, establishing himself as a mainstay in the magazine's ever-expanding stable. Dator's world is not like Chast's or Liana Finck's—it's his very own Joe Dator world, a place occupied by puzzled people encountering less-than-bearable situations.

If I could only take two of his drawings to a cartoon desert island with me, the first would be the classic piece *How We Do It: A Week in the Life of a* New Yorker *Cartoonist,* which he contributed to the 2012 *New Yorker* cartoon issue. The other would be the drawing titled *Very Rare Color Drawing of Abraham Lincoln.* There are, of course, many, many other fine Dators—but in *How We Do It,* Joe leaves the single panel and shows a command of content and style in a different form: a page of panels (eight to be exact). It

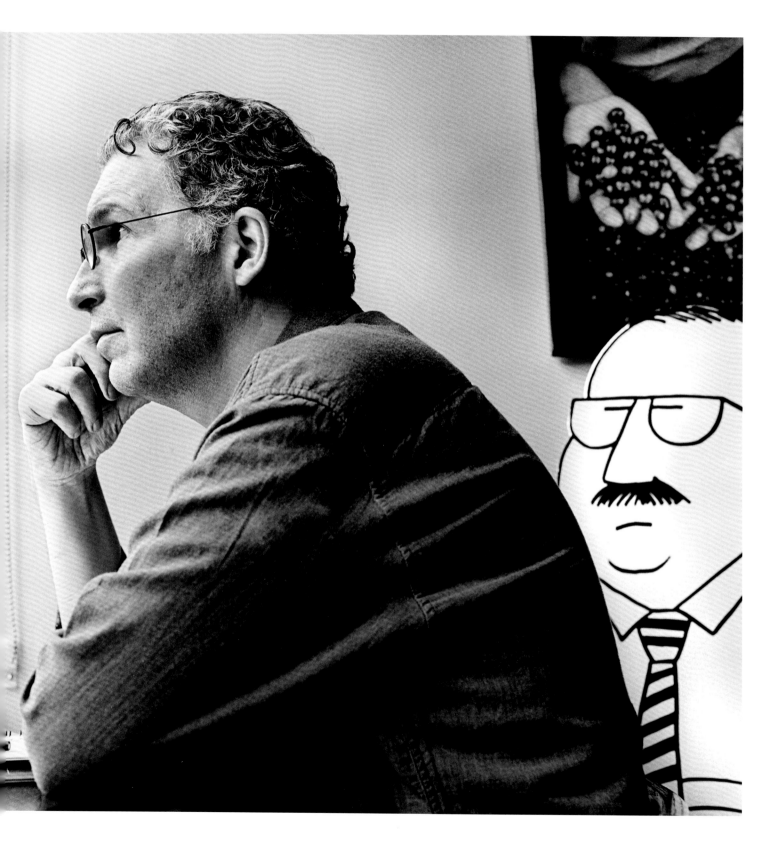

is a thoroughly hilarious piece with no filling, no stuffing. In the single-panel Abe Lincoln drawing, it is the unexpected wild shock of color applied to an iconic setting (Lincoln meeting his generals) that carries the drawing above and beyond. Abe Lincoln lived in color, of course, but we never, ever, ever in a zillion years imagined him living in *those* colors.

Joe Dator in person is an interesting study. Knowing his body of work perhaps offsets the person I see before me. HE APPEARS CALM, SOMEWHAT RESIGNED. BUT I IMAGINE A RUBE GOLDBERG GIZMO INSIDE JOE'S BRAIN, FOREVER SPINNING, REELING, TWISTING TROPES, TURNING PHRASES, TURNING WORDS INSIDE OUT— all in the name of humor; all for the sake of emitting something new, something we've never seen or heard of before. However, when you speak to Joe, the notion of resignation disappears. He remains calm, but there's a sharpness so precise one feels X-rayed. Joe knows his stuff. The proof—not that we need any—is in his work.

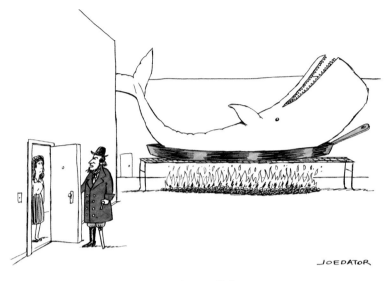

"What smell?"

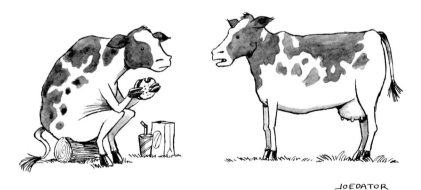

"I don't care if it's plant-based, you're creeping everyone out."

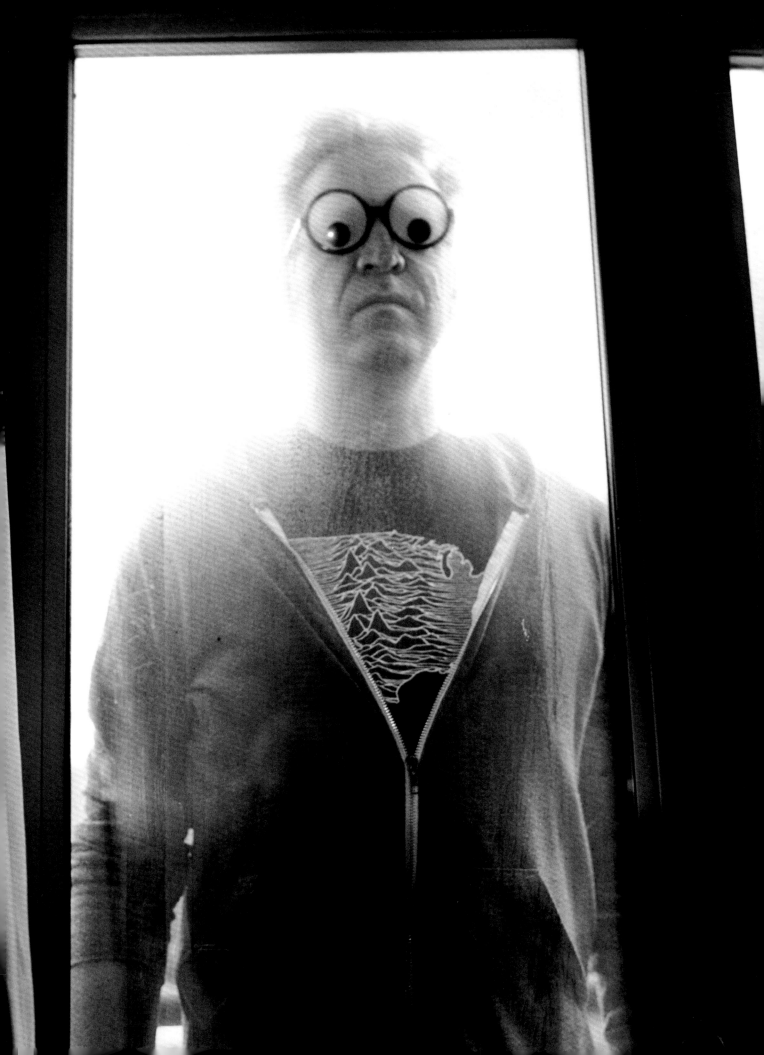

DREW DERNAVICH

Often a *New Yorker* cartoonist's style, rather than their name, becomes their calling card. Drew is "the woodcut guy" or "the guy who does the woodcuts"—except they're not woodcuts. He achieves the woodcut look by working on scratchboard. Whatever the technique, it is a style that, to this day, stands alone in the magazine.

Printmaking is a field involving a potpourri of tools and devices and inks. I know firsthand: my major in college was printmaking. Etching, or engraving, or any printmaking method that does not involve freely drawing on a surface as one might with a pencil and paper, presents all kinds of issues and opportunities. While working on scratchboard, one reverses the usual application of black ink on white paper: the artist makes white lines on a black surface. You might ask why a cartoonist would work this way instead of using a pen or a brush dipped in ink, or drawing on a computer. As he told an interviewer in 2016, his passion for printmaking led him to this style. It is fair to say that Drew has struck gold with the tools he's chosen to present his cartoons. Any piece devoted to Drew would be remiss not to mention the job that bridged college and his *New Yorker* career: he engraved gravestones— according to Drew, over a thousand of them.

When asked in an interview for his personal favorite of the hundreds of his drawings published in *The New Yorker,* he selected the one we've shown here. I did a bit of head scratching trying to understand his choice. This is purely speculation on my part, but the

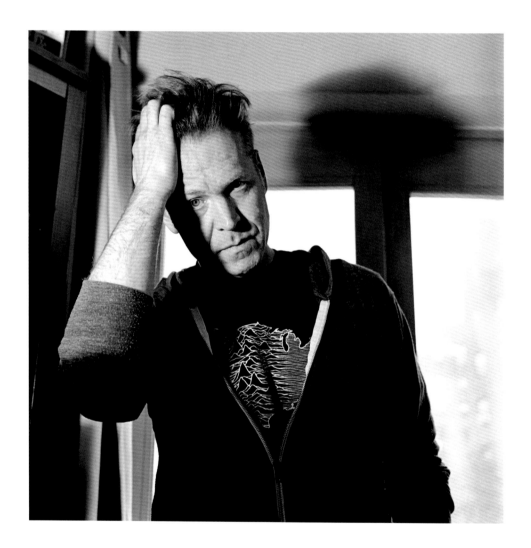

Stonehenge standing stones resemble gravestones, do they not? Could this be a reminder of the connective tissue (or stone) running through the Dernavich oeuvre?

The humor you get from Drew in the pages of *The New Yorker* does not reflect the somewhat reserved

fellow you meet in person—a person harboring a bundle of cartoonist DNA. I witnessed a public moment when Drew shed his reserve. In the spring of 2010, he went onstage at Joe's Pub, a music venue that's part of New York City's Public Theater. THE SOMEWHAT

SHY, SOFT-SPOKEN FELLOW I'D CHATTED WITH OFFSTAGE DISAPPEARED ONCE HE WALKED ONSTAGE. Seated on a stool in front of a microphone,

he seemed like a natural—as comfortable before a crowd as a clam in a clam bed (assuming clams *are* comfortable there). I suppose the same could be said for his cartoons: they seem happily at home—naturals—in the vast sea of *New Yorker* cartoons.

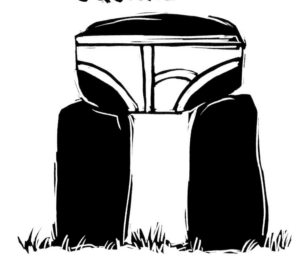

"If they turned off when you clapped, they probably weren't the northern lights."

LIZA DONNELLY

Liza Donnelly is a restless cartoonist. I know because I've witnessed her restlessness for forty years (we've been married for more than thirty-five of them). When I ask her, as I do on a daily basis, "What're you up to today?" she'll list drawings she needs to finish, and projects she's working on, and people she'll be meeting with to discuss even more projects. In between all that, she'll work on her weekly batch of cartoons for *The New Yorker*. If you look up her résumé, you'll find it's a mile long. She's a globe-trotting cartoonist who brings her pen and her voice to lands foreign and domestic. She pioneered journalistic live-drawing, bringing what she observes to social media, in real time, from such

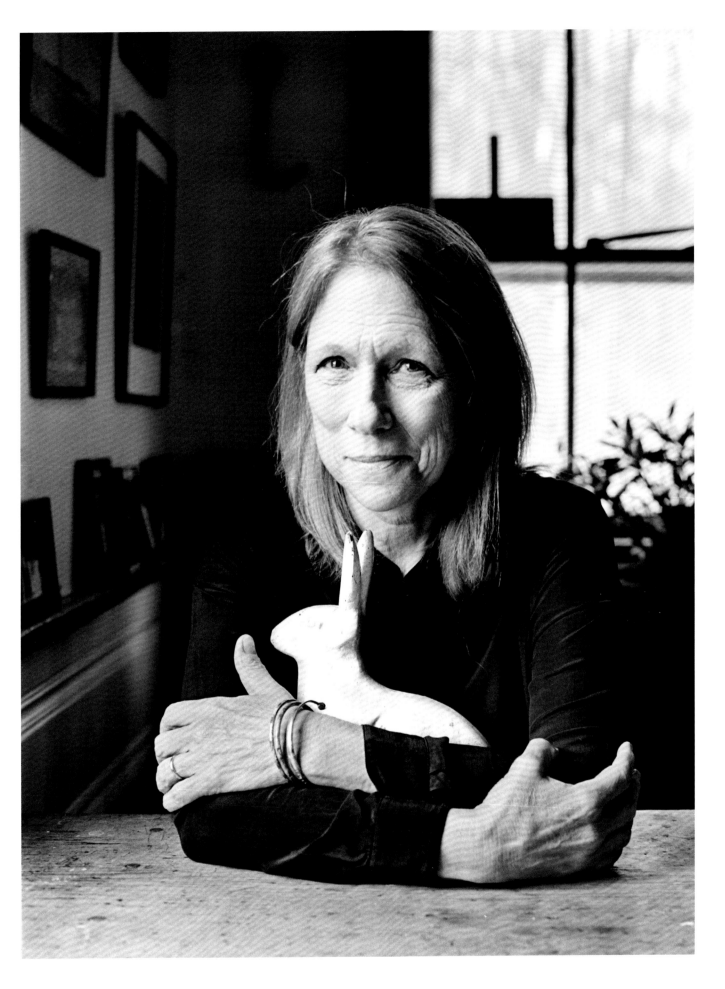

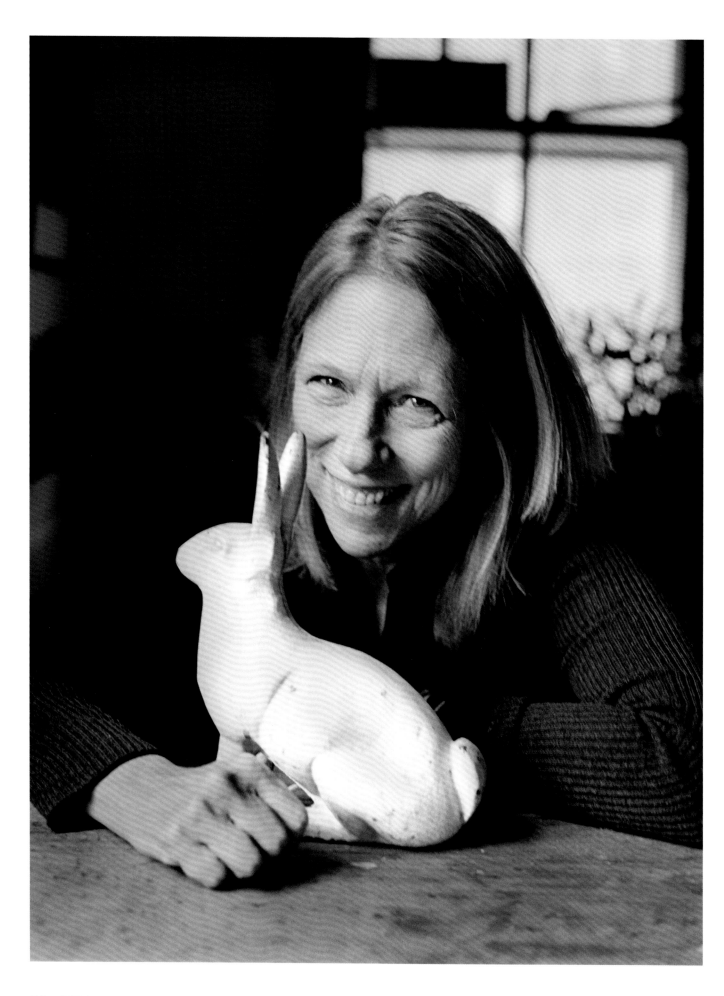

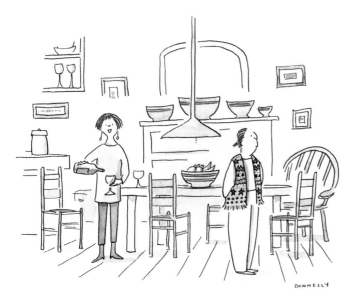

"Some wine with your vest?"

disparate places and events as the Democratic National Convention and the White House press room. She made history by being the very first person to live-draw while standing on the Academy Awards red carpet.

Tracing James Thurber drawings as a child, combined with a love of Charles Schulz's *Peanuts* and an interest in Herblock's *Washington Post* op-ed drawings, eventually led her to a forty-plus-year career at *The New Yorker*. Donnelly sold her first drawing to *The New Yorker* in 1979, joining two other recent arrivals: Roz Chast and Roz Zanengo. With Nurit Karlin, who began in 1974, this quartet represented the largest number of women simultaneously contributing cartoons to *The New Yorker* since the early 1950s.

Donnelly's work is not so much an iron hand in a velvet glove as an iron message. HER DRAWING STYLE IS NOT SHY ABOUT ITS QUAKER ROOTS. THEY INFORM HER WORK: SHE WANTS HER DRAWINGS TO BE ABOUT SOMETHING rather than just delivering a joke. In her personal life, she turns out-

ward into the fray, diving into social concerns. "Gonna change world w/ humor" is the bio on one of her social media accounts, where she has built up a large following.

The other day, while sitting across from Liza at the very table you see in her photographs, sharing a lunch of grilled cheese sandwiches, I asked her what makes her laugh.

She answered: "The things people do."

I pressed her: "Like what?"

"Like dancing. I love regular people [that is, not professionals] dancing—even though I like to dance, too. It's a funny activity."

I pressed further: "And what else makes you laugh?"

"Futile activities we sometimes do to make ourselves happy."

"O.K., everybody, let's eat before the food gets dirty!"

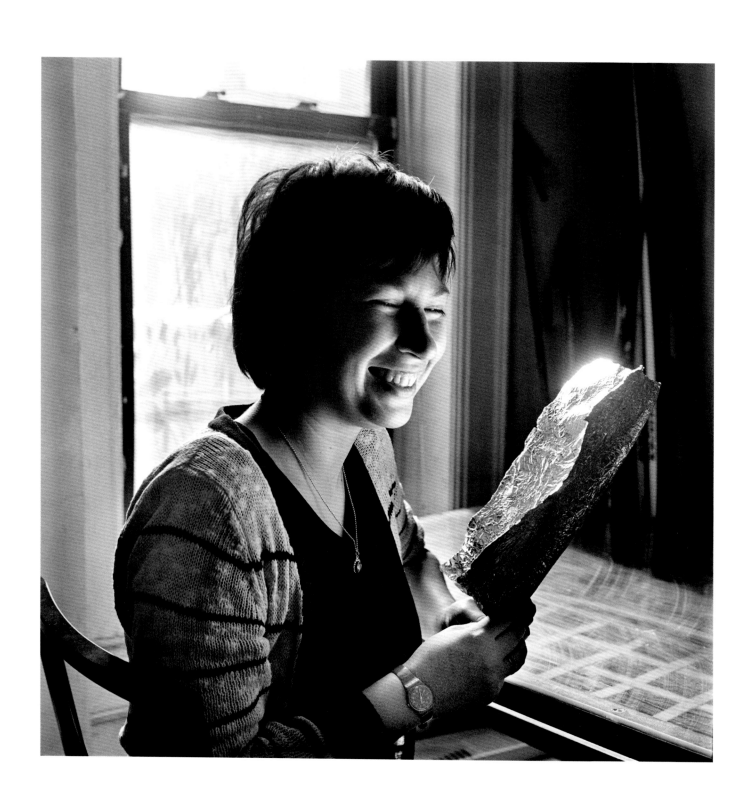

LIANA FINCK

Liana Finck stole the show. In the best moment of the 2015 documentary *Very Semi-Serious: A Partially Thorough Portrait of New Yorker Cartoonists*, the camera lingers over her nervous appearance in the cartoon department ("My voice is wobbly")—we see the novice allowing the world into her world. "I've been doing these constantly since I was sixteen . . . but I never bring them in because I self-censor. I'm getting more confident about being able to take rejection."

Work-wise, and perhaps worlds-wise, there are at least two Liana Fincks: the Instagram Liana and the *New Yorker* Liana.

On Instagram, her work appears steadily throughout the day as stream-of-consciousness missives, sometimes drawn as simply as a circle face with dots for eyes, a line for a mouth, perhaps a hint of a stick-figure body.

Her *New Yorker* work, appearing every few weeks, conforms to some of what might be considered conventional cartoon boundaries: a drawing, playing off a theme, usually with a caption, delivering the time-honored one-two cartoon punch (although *punch* may

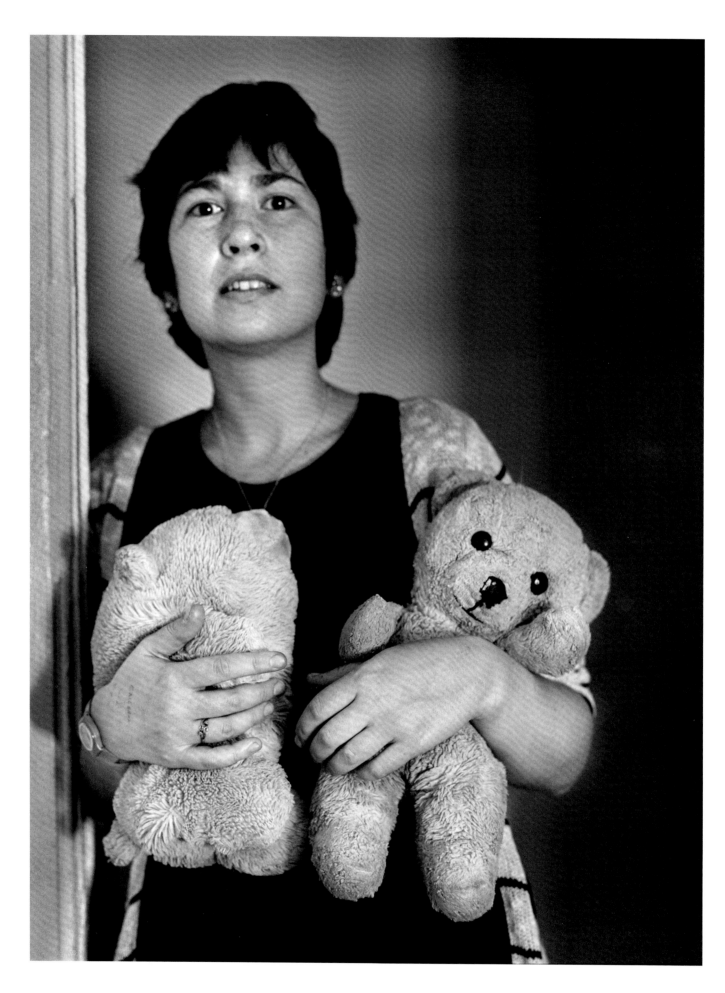

be too aggressive a word). She told one interviewer that she thinks of her style as "very messy, very quick."* Messy and quick works well for her—an appealing mix that reminds one of the late Dean Vietor's work. His drawings always looked as if they were in motion, about to unravel. LIANA'S DRAWINGS ARE DELICATE, BUT WE DON'T FEAR FOR THEIR FUTURE STABILITY. If there was a family tree of illustrators and cartoonists, her lines seem to be an offshoot of the illustrator Brian Rea. The words and ideas are another thing altogether; Mr. Rea, as an illustrator, works off texts, while Liana provides her own.

In her numerous public appearances in the past few years since her debut at *The New Yorker*, what comes through when she speaks is often what sounds like an unedited *New Yorker* cartoon caption. She catches the audience by surprise. The audience howls.

*Josefin Dolsten, "*New Yorker* Cartoonist Liana Finck Draws on the Light and Shadows of Her Jewish Upbringing," *St. Louis Jewish Light*, November 23, 2018.

"So what are you the earl of?"

GOD FINDS ALL THE PRAYERS OF MANKIND IN HIS SPAM FOLDER.

ED FISHER
1926-2013

If we were forced to divide cartoonists into two camps, we might end up with one group who mostly reach deep within themselves to create their cartoon world, and another group who bounce off the outside world. Obviously, all cartoonists do a bit of both, but some lean one way more than the other. While Ed Fisher certainly brought himself into his work, overall, it leaned in the direction of the camp that bounced. He drew "culturally savvy cartoons," according to Bruce Weber's 2013 *New York Times* obituary of Ed. It's an apt summation of Ed's thirty-five-year *New Yorker* career. The "savvy" was Ed's personality steering his take on our culture. Like it was for so many of his colleagues, for him the news of the day was a juicy ripe tomato, begging to be sliced.

In the *New Yorker* cartoon landscape Ed occupied from the years 1965 through 2000, the raw material of the days' headlines more often than not was paired with his interest in ancient times (he wrote a satirical novel, *Wine, Women, and Woad: A Tale of Decadent Rome*). An overview of Ed's entire output of 714 *New Yorker* cartoons offers

a blueprint of a cartoonist's world circa the 1960s to mid-1970s: aliens, robots, politicians, communists, flying carpets, and plenty of ancient Egyptians and Romans. Like so many of his colleagues, he tossed those ingredients—the contemporary and the ancient—into his cartoonist's blender, and *voilà*! An insightful *New Yorker* cartoon was born.

Looking at Ed's earlier *New Yorker* work, it might come as a surprise that he sometimes seemed under the spell of at least one of his *New Yorker* seniors: Charles Addams.

In Ed's earlier years at the magazine, HE WAS ONE OF SEVERAL NEWBIES WHO RELUCTANTLY GAVE OVER IDEAS TO A NUMBER OF ESTABLISHED COLLEAGUES. For instance, the classic idea handed to Whitney Darrow Jr. to draw up: *"There! A message of good will for all mankind."* The practice of supplying captions to veteran *New Yorker* cartoonists would eventually all but disappear by the late 1970s.

If you took a poll of Ed's contemporaneous *New Yorker* colleagues, you'd find he would be unanimously described as "a nice guy; a gentle, happy spirit." At Liza Donnelly and my wedding reception, he danced so wildly his hair looked as if he had backed into a wind tunnel. Ed Fisher: wild and savvy guy.

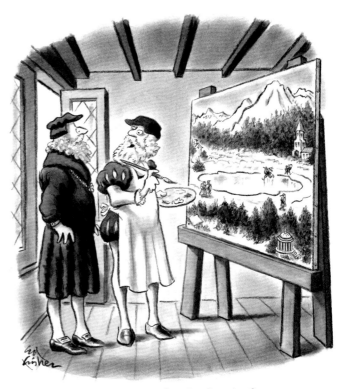

"Why no, I've never thought of putting funny little captions on the bottom."

"Back to Square One!"

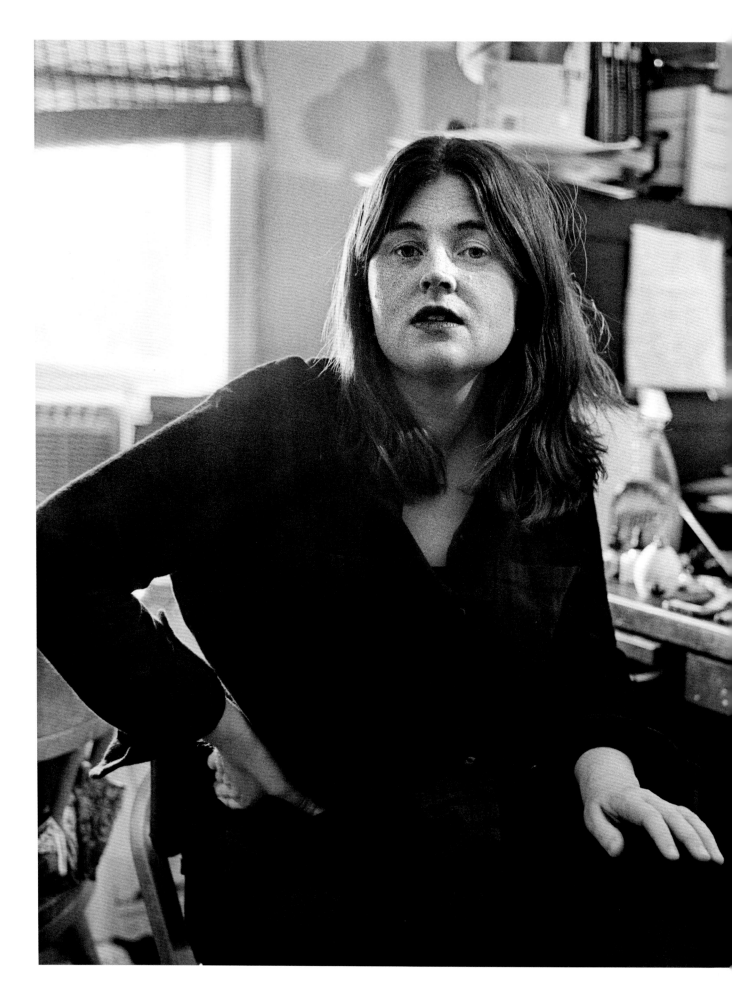

EMILY FLAKE

Emily Flake is the queen of the edgy cartoon. Take this one, for example: A woman shopping for a phone is with a salesperson. He's offered up two phones, one in each hand. She says to him, "I want whatever model will make me forget I'm dead inside."

Her cartoon characters' cookie-cutter heads atop blurry bodies, drawn with coloring book–ish lines darkened by inoffensive light gray wash, disguise the edginess of her captions.

Though her cartoon world includes both deserted islands and urban life, she frequently explores the world of parenthood (one of her books is titled *Mama Tried: Dispatches from the Seamy Underbelly of Modern Parenting*). As long as I can remember, *New Yorker* kid-centric

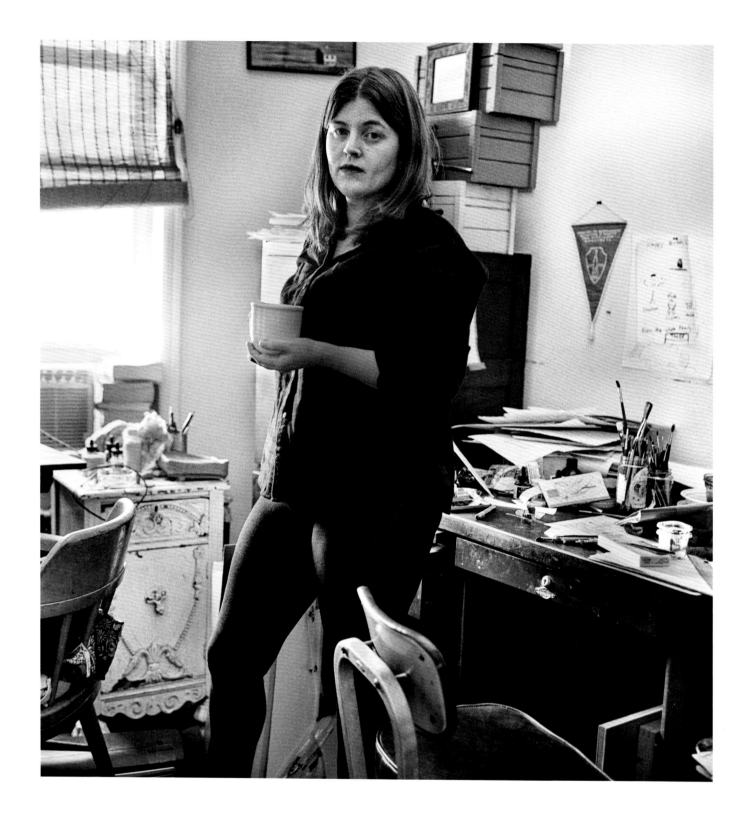

cartoons have mostly used the scenario of parent and child to reflect on the child, with the parents, at best, being supporting actors. Ms. Flake has turned that scenario upside down. In a good majority of her work, the parents themselves are the center of the universe; the most important thing in their lives is—horror!—themselves, not their children. The parents, jaded despite just beginning their parenting "journey," tend to bounce off their young-but-daily-growing children.

Of course, Ms. Flake's work is not exclusively about parents. SHE SUCCESSFULLY MINES THE BROOKLYN-ESQUE CULTURE OF THIRTY- AND EARLY-FORTY-SOMETHINGS. There's plenty of Gen X attitude conjured up within her drawings (Ms. Flake may have the distinction of being the first to use the word *turd* in a *New Yorker* caption).

In her way, she manages to successfully deliver the one-two punch—a graphic sleight of hand—we've come to hope for from *New Yorker* cartoons: you see the work and relax for less than a microsecond before the caption bangs you on the head.

"Son, if you can't say something nice, say something clever but devastating."

"Are we gonna have to scrape the Daddy decal off the minivan?"

EMILY FLAKE **67**

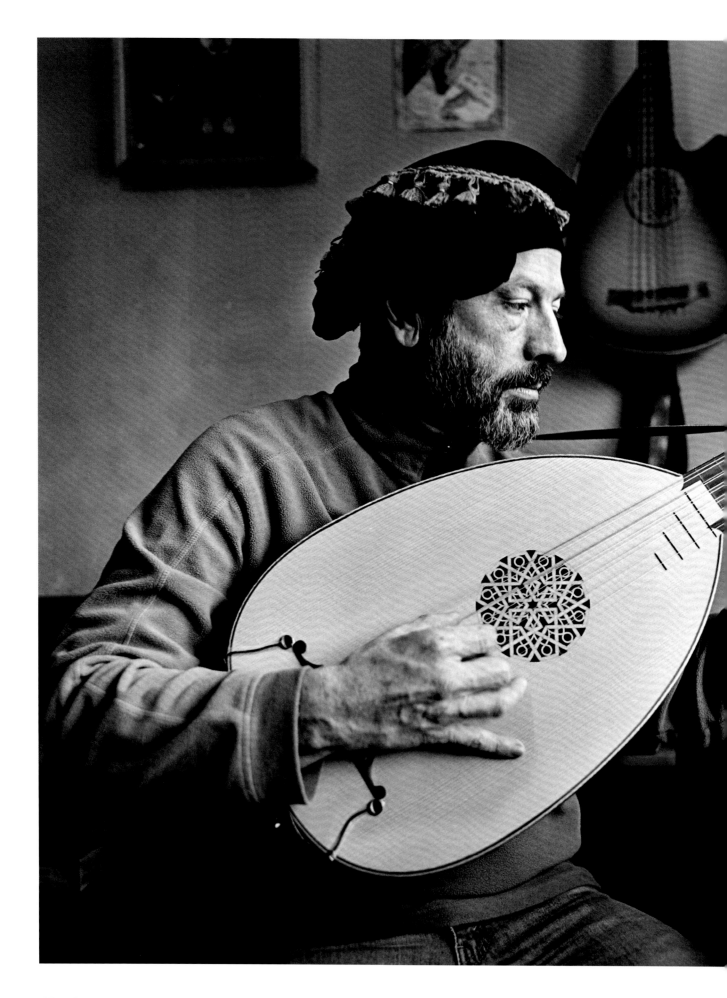

Of the more than seven hundred cartoonists who've contributed to *The New Yorker* in its one hundred years, less than a handful have specialized in the captionless cartoon. Otto Soglow was, perhaps, the first who found captionless drawings more to his way of thinking. His famous creation the Little King did have a thing or two to say every so often, but mostly, his monarch went about his cartoon adventures speechless. Then there was Sam Cobean, whose trademark was the thought-balloon cartoon, usually involving a naked woman. Skipping a number of decades to more modern times, we find John O'Brien

SETH FLEISHMAN

becoming the modern master of the captionless *New Yorker* cartoon. More recently, beginning in 2016, he's been joined by Seth Fleishman.

Seth's work is graphically stark: thin, determined lines often offset by a controlled splash of black ink. If you blur your vision while looking at his cartoons, you'll see work that looks to be in the school of the late great Gluyas Williams. Seth and Mr. Williams share the smooth line, the strategic use of black—but that's where the comparison ends. Williams used words in his work, and his drawings shook hands with the caption, not, as in Seth's drawings, the idea itself. If a typical *New Yorker* cartoon is the perfect marriage of a drawing and a caption, the captionless cartoon is the single parent, taking on the responsibility of two.

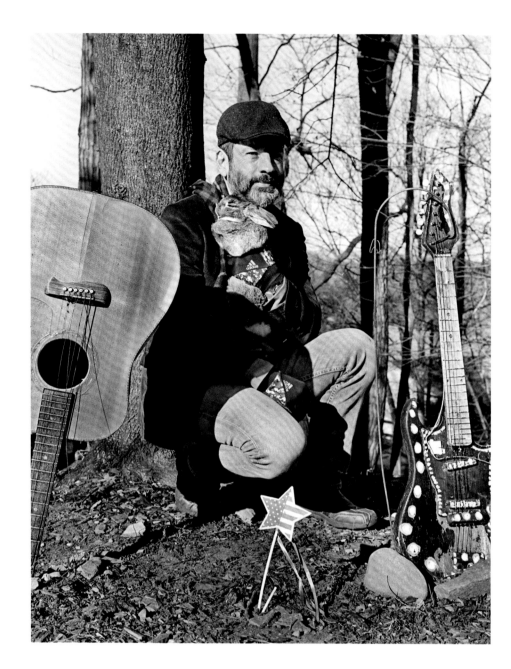

If I was forced to use the term *sight gag*, I'd use it to describe Seth's drawings. His work's success relies on the instantly recognizable visual. We show an example here, playing off a time-honored go-to for cartoonists: the chicken and the egg. When I interviewed Seth a few years ago, I learned that the work of Charles Barsotti was a big influence. Look at any of Seth's drawings and you'll see the Barsotti influence via the snaking simple line. Barsotti's line was even less complicated than Seth's—and he used words.

Seth's other passion is music. He told me that BY AGE FOURTEEN HE ASPIRED TO BE, IN HIS WORDS, "EITHER A MUSICIAN, A CARTOONIST, OR AN IMPRESSIONIST." As it turned out, cartoons and music coexist in his adult life—he writes, produces, and teaches music. I don't think it's too much of a stretch to suggest that there's a musical connection with his drawings. There's a certain lyricism to his ideas, to the lines themselves—you can almost hum to them.

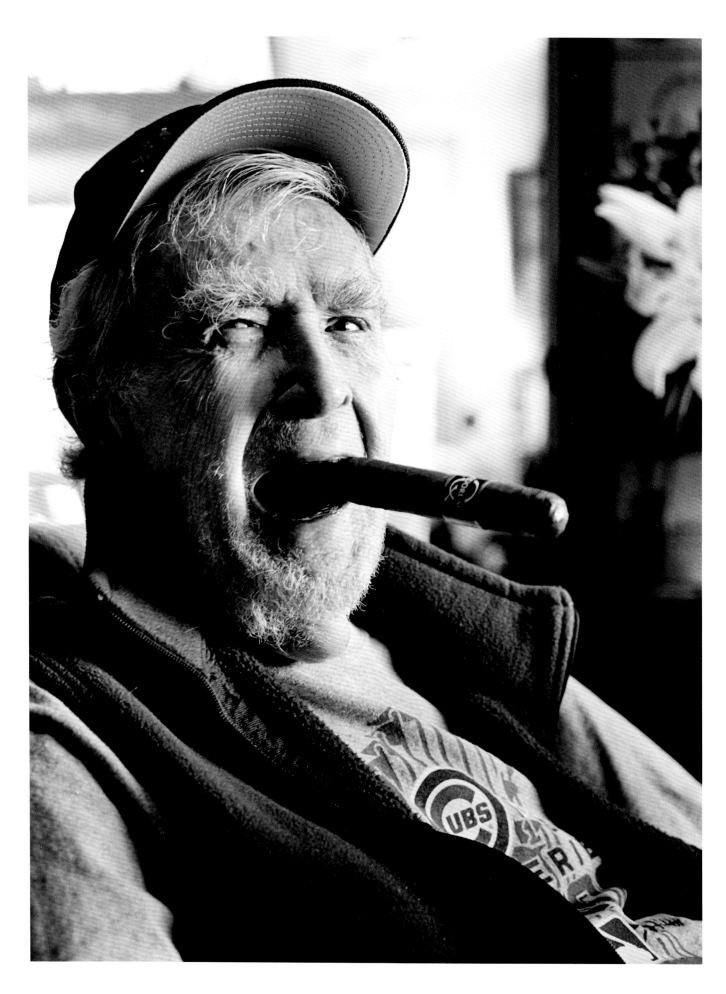

DANA FRADON
1922-2019

Dana Fradon, the last cartoonist brought in under the editorship of *The New Yorker*'s founder, Harold Ross, published over fifteen hundred cartoons in *The New Yorker* in a career that spanned five decades, from the tail end of *The New Yorker*'s golden age to the early years of the magazine's digital age. Fradon was a cartoonist's cartoonist, a workhorse, turning out approximately twenty ideas a day, six days a week. And yet, here's something he said to me just a few years before he passed away: "I'm not really a cartoonist. I'm a misplaced baseball player or something like that."

Like many cartoonists, he came sideways to his profession. "I didn't know anything about *The New Yorker*. My sister married Albert Hubbell and then I heard about *The New Yorker*. I admired Albert and

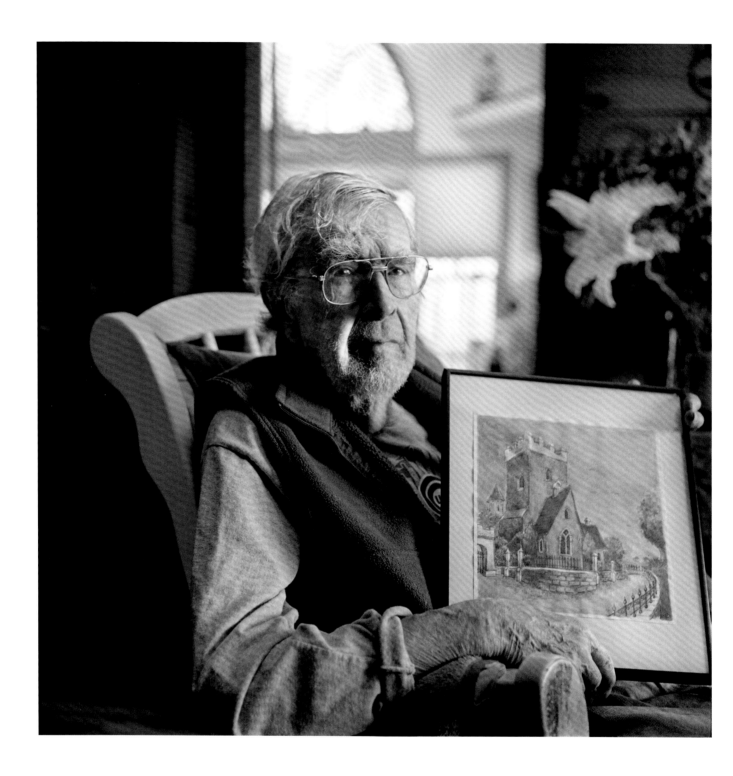

I admired some of the things he pointed out [in the magazine]. I decided that's where I would channel my work." Mr. Hubbell was a jack-of-almost-all-trades at *The New Yorker,* contributing covers and fiction as well as pieces for The Talk of the Town. He briefly stood in for *The New Yorker*'s art editor James Geraghty, when Geraghty left for service during World War II.

Fradon, along with a handful of his colleagues, was an expert in digesting current events, running them through that part of his brain that developed ideas, then laying something quite good—very good, actually—on paper. It's not an easy thing to do on a near daily basis for over half a century. Here he describes how topical cartoons became his specialty right from the get-go at the magazine:

"I guess that's what I thought Geraghty thought was funny. In the beginning I had the idea that he was buying only stuff of mine that was rather topical. And I thought that was a restriction—that I could not do the ordinary funny gag, that they were just going to want politically topical stuff. AND I THOUGHT THAT WOULD LIMIT ME. I DIDN'T KNOW THAT IT WOULD BECOME, IN A SENSE, MY HALLMARK. I thought at first it was a sign of failure—that I couldn't do the straight old cartoon. But of course I did end up doing those kinds of cartoons as well."

In 2018, at age ninety-six, Fradon was still working on "those kinds of cartoons" as well as topical drawings. They occasionally appeared online, sometimes as a joint effort with his ex-wife, the comic artist Ramona Fradon. A cartoonist's cartoonist indeed.

"So what if the First Amendment does go? We still have twenty-five more."

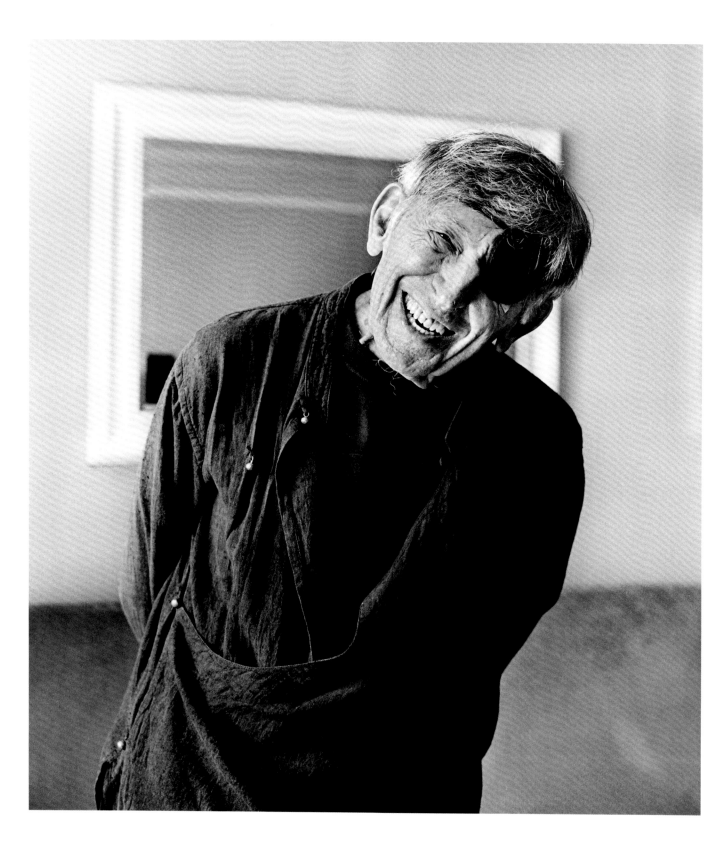

MORT GERBERG

Out of all the *New Yorker* cartoonists contributing to the magazine in the early-to-mid-1960s, three cartoonists remained contributors in 2020: Edward Koren, who began contributing in 1962; Edward Frascino, who began in September 1965; and Mort Gerberg, whose first cartoon appeared in April 1965.

From the get-go Mort was not so much defined as a *New Yorker* cartoonist as he was a cartoonist whose work appeared in *The New Yorker*; he created his own lane in the cartoon-o-sphere, spreading his talents far and wide: he contributed to many other publications, including Paul Krassner's *The Realist* and Hef's *Playboy*; he taught; he appeared

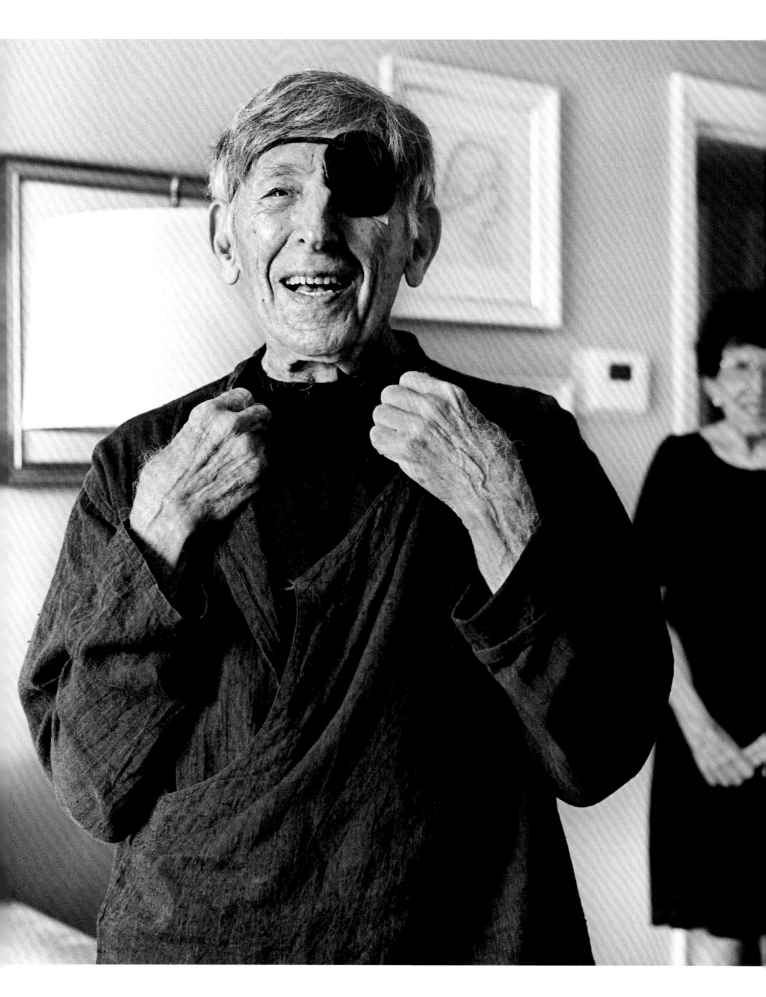

on television; he did comic strips; he wrote books.

It is the rare *New Yorker* cartoon event that does not INCLUDE MORT WORKING THE ROOM, SPARKING OFF EACH CARTOONIST PRESENT, SEEMINGLY GAINING ENERGY, LIKE A HURRICANE, as he moves from colleague to colleague.

If there is a concentration of concern in his work, it would be politics. In the one hundred years of *New* *Yorker* cartoonists, a small number have had the ability to consistently jump on a hot topic and fashion it into a single-panel cartoon. It's not an easy thing to do well, or to do for decades. Mort has said cartoonists are "wired funny"; he, of course, is among the foremost who are wired remarkably well.

His style, like the man himself— now in his tenth decade—is best characterized as "on the go." The ever-so-subtle slant of his work, his drawings, his take on our times—it's all immediately identifiable, as if he can't wait to move on and pin down the next moment.

"I've always been partial to high ceilings."

WILLIAM HAEFELI

In Bill Haefeli's drawings, there's a whole lot going on in a very small space. As I write this, I'm looking at an original drawing by Bill. It resides on an eight-and-a-half-by-eleven-inch piece of thinnish paper, but the drawing itself is five by six and a half inches. I'm somewhat startled to realize that he and I pretty much draw the same size, and on the same-sized paper. Bill's drawing style, however, is entirely different from mine. The word that comes to mind looking at his work is *articulate*. And here's one other word: *dense.* You cannot wing a precision style like Bill's. It is, in its own way, akin to George Price's "mathematical" style. I say you cannot wing it, because with one error in the drawing's construction, the piece falls apart to the eye. As Bill is a master of cartoon construction, you trust the work's stability and accept it for what it is: unique in the *New Yorker* cartoon world.

In a 2010 interview with *The New Yorker*'s Cartoon Bank, Bill spoke of a distinctive element of his drawings—his characters' prominent noses:

"These noses initially attract attention to the faces and then, like arrows, start moving the viewer's eyes around the drawing. I never consciously made a decision to do

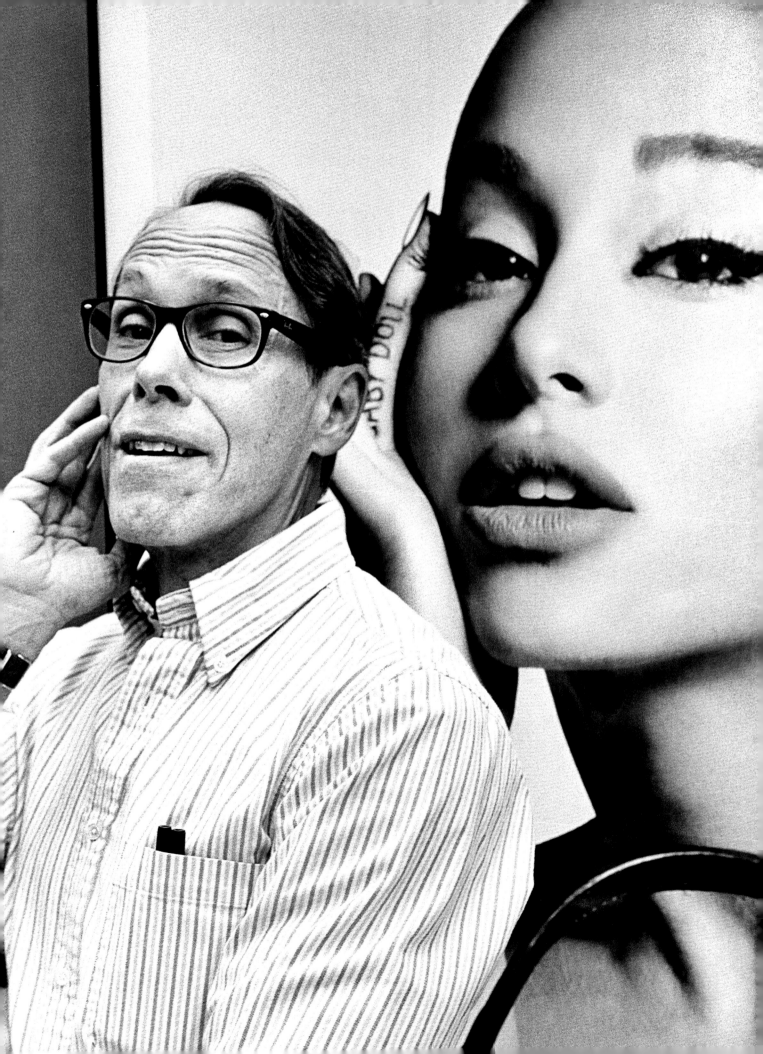

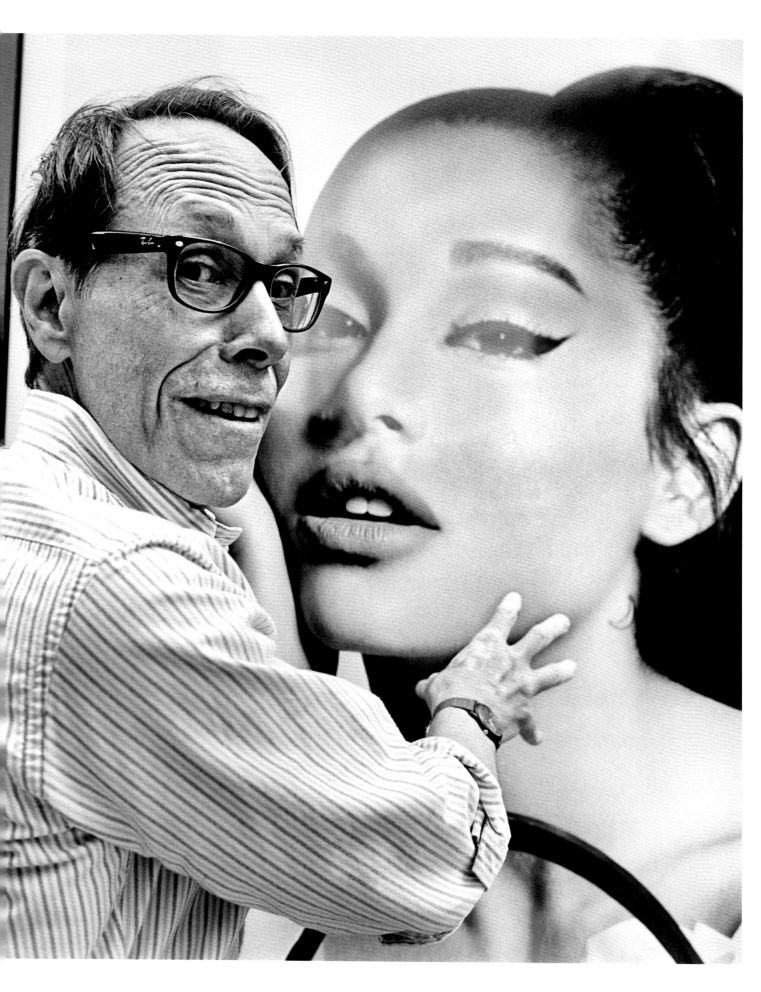

this; it just made my characters fit into the overall composition."

I somehow have not met Bill, even though he's been contributing to *The New Yorker* for over twenty-five years. More's the pity, as our brief email exchanges reveal a thoughtful, considerate artist. In various interviews he's done over his career, WE LEARN THAT CARTOONS AND CARTOONING HAVE BEEN AN INTEREST AND FOCUS OF HIS SINCE CHILDHOOD. HE ENTERED CARTOONING AS A FULL-TIME JOB OUT OF COLLEGE, but only after he'd spent four months in the corporate world of advertising. When Bill, who is gay, entered *The New Yorker*'s cartoonist stable, there was mention in the press that a number of the drawings he produced were "gay-themed." This was certainly a reflection of the times, and also a result of Bill doing the work he wanted to do and continues to do. (It used to be called "having a voice." Maybe it still is.) This is as it should be. A common drumbeat in these *At Wit's End* essays is that each artist is sharing with us their world—not a world they found somewhere else or a world that inspired them, but a world of their own. This generosity of the artist—with Bill as a modern-day shining example—is one of the cornerstones of the *New Yorker* cartoon canon.

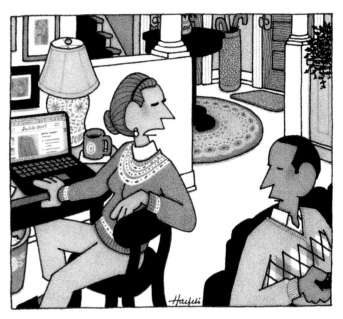

"Be honest. I don't want to order anything monogrammed if our marriage is on shaky ground."

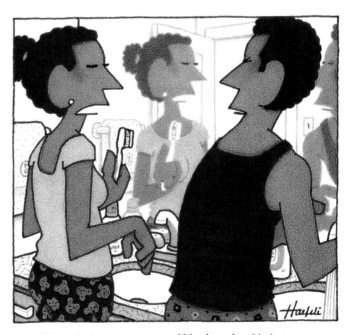

"If you don't want me to sound like that when I imitate you, then don't sound like that when you talk to me."

CHARLIE HANKIN

Charlie Hankin once told me that his drawings had "undertones of dry, quiet absurdity." Who am I to disagree. Charlie is a straight shooter: deadpan, gracious, and, yes, quiet. But we know from looking at his work that he is an artist of terrific mischief.

He is one of a handful of *New Yorker* artists who have pursued "fine art" (painting) as well as the bookends of comedy: print and film, where he is fully enmeshed with acting and filmmaking. He had this to say about his dual interests: "Maybe the merging of art and comedy finally attracted me to cartooning for *The New Yorker*."

Looking at his work for the magazine, it's the "quiet absurdity" of it that anchors what I'll call the "potato chip factor"—you have one, and then you want more. One of Charlie's very best drawings, *"Oh, no—Karen baked a cake so dense that not even light can escape,"* succeeds with a knock-out punch. At first

sight of the drawing, inner laughter quickly rolls into outer laughter. The, um, ingredients of this drawing, especially the hilarious use of the silhouetted cake, take this cartoon moment to an exceptionally funny place.

Charlie arrived at *The New Yorker* in 2013. Among his classmates were Liana Finck and Ed Steed—each and all pursuers of the absurd, with Steed not graphically quiet and Finck perhaps even quieter than Charlie.

Many cartoonists aren't compelled to describe their "process"—if they do it's usually a variation of "Well, I sit at my drawing board and wait for ideas" (oh wait—

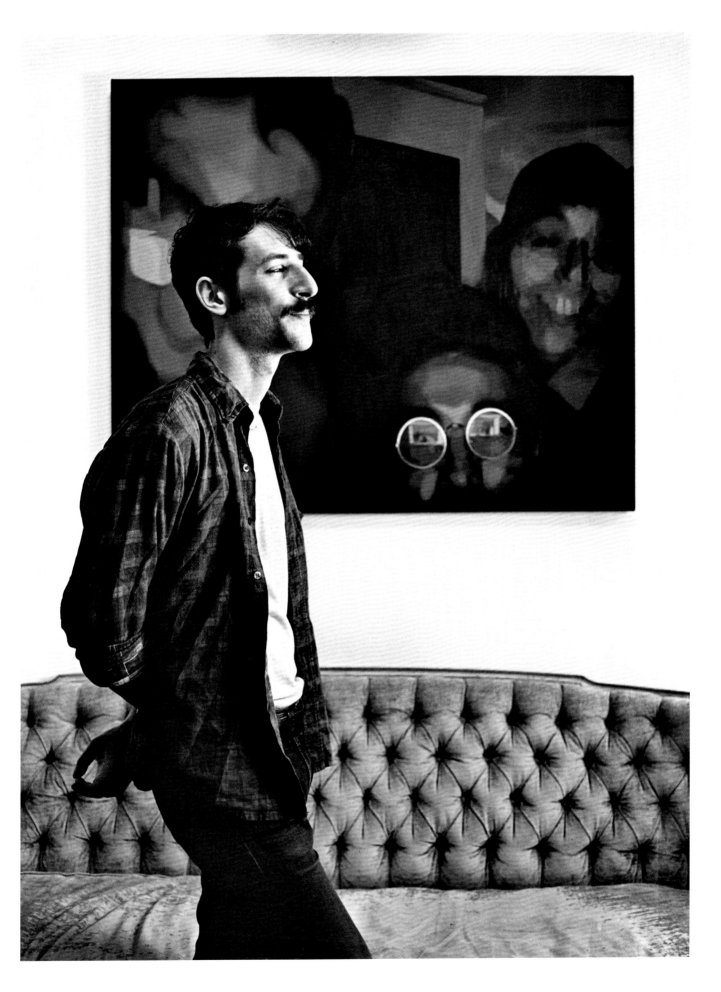

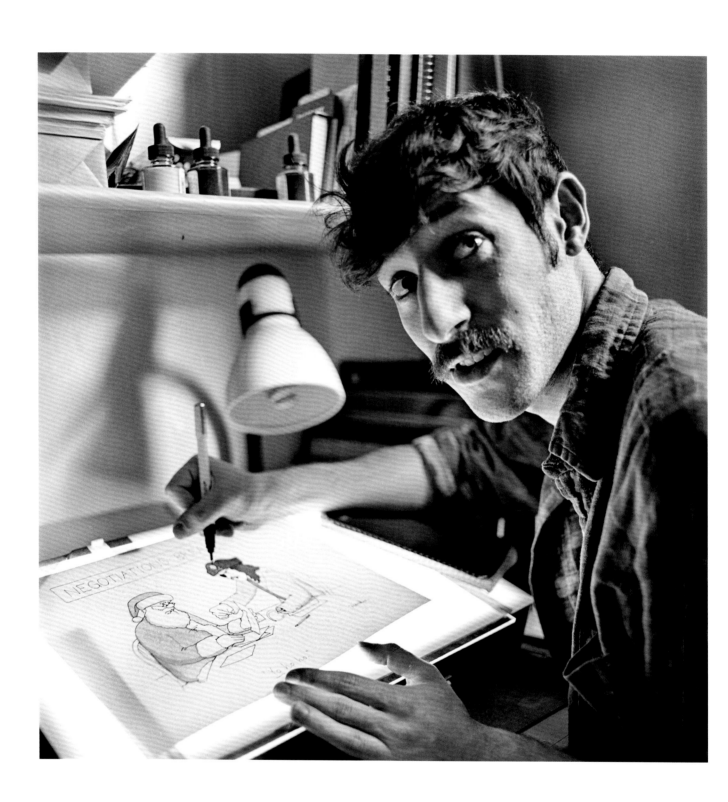

that's what I say about my "process"). I liked reading what Charlie told Tim Smith, a reporter for *The Baltimore Sun:* "WHAT'S HELPFUL TO ME IS TO HAVE THE SPACE AND TIME TO LET MY MIND WANDER WHILE WALKING AROUND ON FOOT, NO PHONES OR HEADPHONES, NO DISTRACTION." It reminded me of the great *New Yorker* writer Joe Mitchell, who spent much of his writing life walking around New York City and its environs. With Charlie as a wandering cartoonist, the humorous, unexpected things developing out on the street are in very good hands.

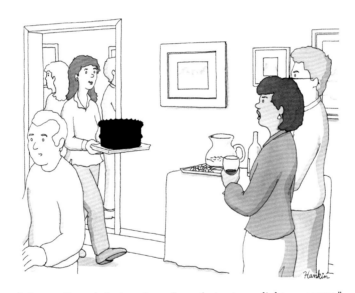

"Oh, no—Karen baked a cake so dense that not even light can escape."

AMY HWANG

Amy Hwang's first New Yorker cartoon—a sharp, crisp, funny drawing—appeared in the twelfth month of the tenth year of the new millennium: A little girl plays

with two dolls in a living room (one doll is male, the other female). The girl's father is off to the side reading a newspaper. The little girl has the female doll saying to the male doll: "Please don't tell my husband about us. I promise I'll run away with you."

Ms. Hwang is perfectly comfortable roaming terrain other cartoonists visit on a regular basis (such as parenting), but I believe her cartoonist DNA is best channeled through the lives, thoughts, and words of cats. Just like there are "cat people," there are "cat cartoonists." Amy Hwang is one of them, delivering unto us dispatches from the feline universe. One example: In her September 19, 2011 *New Yorker* cartoon, a cat (dressed as a person) stares at a Lost Cat poster attached to a tree. The cat is thinking to itself, *I'm not lost. I moved on to better things.*

Not that Ms. Hwang limits herself to just drawing cats (as her first *New Yorker* drawing shows us)— no sane cartoonist would. She is also fond of children and child-rearing drawings, dating drawings, and drawings covering our consumer culture. There's also the occasional foray into the past, or a mix of past and present. For instance: Two contemporary women, one of whom is holding a large watermelon, asks a

hooded fellow operating a guillotine if he would do them a favor.

I agree with the *New Yorker* cartoonist and cartoon historian Liza Donnelly, who has said that Ms. Hwang's work is "accessible."

THE HWANG CARTOON WORLD IS NOT SCARY OR FRAUGHT WITH COMPLEXITIES— IT'S A FRIENDLY PLACE.

The unexpected usually happens not within the drawing but in her caption, where we are handed precise puzzlements—grammatical twists and turns.

In her cartoon of two women in a gallery or museum, seated before a large painting, one might expect the caption to be centered on the painting, but nooooo: one woman says to the other, "I like this painting because it has a bench."

When I asked Ms. Hwang to name cartoonists who were influential or inspirational as she developed her style, she named Charles Barsotti and Zach Kanin. The Barsotti influence is obvious in her line work (his drawing style featured a simple black line with no rough edges)—though she allows herself more complexity than Barsotti ever showed us in his published work. The Kanin influence is subtler (in years gone by, his sense of humor might've been labeled quirky) but does show up more visibly in drawings such as the October 29, 2012, *New Yorker* drawing of three floating helium-filled "Get Well" balloons visiting another helium balloon in a hospital bed (the ailing balloon has "Thanks!" written on it). About this drawing Ms. Hwang told me, "I really like that balloon cartoon. I experimented with my style with that one, but it never stuck."

When I look at her adult people, especially the faces, they often share one distinctive feature: flounder eyes. Both eyes appear on one side of the face no matter the position of the face. In other words: the nose is off to the side. When I asked Ms. Hwang about the way she draws eyes, she said, "That's how I draw! It never dawned on me that others do not draw faces the same way."

There've been a handful of *New Yorker* cartoonists in the magazine's hundred-year history who have drawn distinctive eyes (Richard Taylor, Sam Cobean, Leo Cullum, and P. C. Vey come to mind), but no one has drawn flounder eyes; Ms. Hwang owns the arrangement.

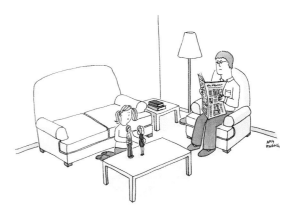

"Please don't tell my husband about us. I promise I'll run away with you."

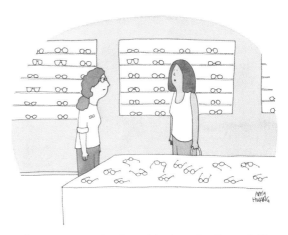

"Have you seen the glasses I had on when I came in?"

ZACHARY KANIN

A basic tool of cartoonists is envelope pushing, whether it's in the drawing itself, or the caption, or both. I've noticed that every cartoonist has a sort of built-in push range. At the less pushy end of the range are the cartoonists who rely on subtlety—they're often thought of as "quiet" (think Jean-Jacques Sempé). Cartoonists at the opposite end are often thought of as "zany" or even "weird" (think Jack Ziegler). Zach seems to be at the Ziegler end of the spectrum and then some. I believe that the degree of the push is, in itself, the secret sauce in Zach's work. You look at one of his cartoons and you guffaw as you think, *I can't believe he said that.*

Fresh out of Harvard (and *The Harvard Lampoon*), Zach was working as then–cartoon editor Bob Mankoff's assistant when his work suddenly blasted like a circus cannonball up into the rarefied air of "the next big thing" in the magazine's cartooniverse. His very first *New Yorker* drawing—titled *The 40-Year-Old Virgin Olive Oil*—had few hints of what was to come. But before long he had found his groove. His work, like so much that has come before it (and since), was built on the sound footing of our own set of *New Yorker* cartoonist founding fathers and mothers. The result

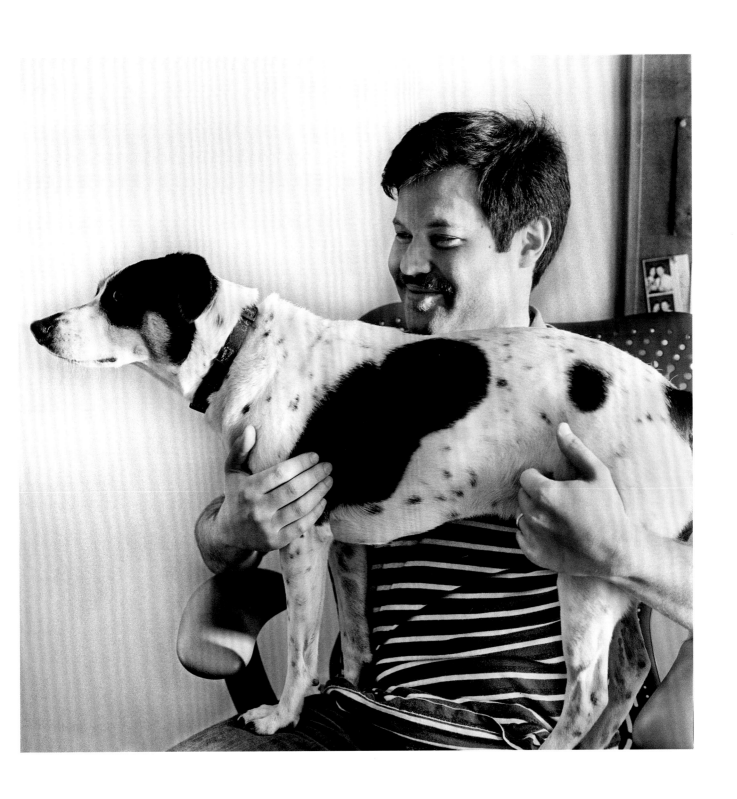

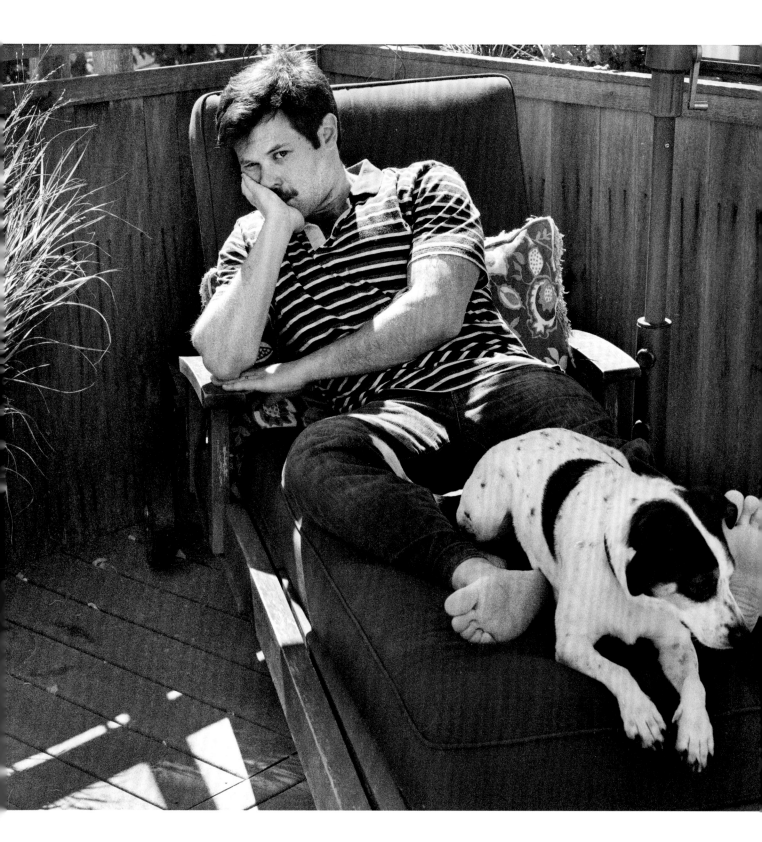

was a brand-new stew of drawings combining Addams's dark, friendly fun and Gahan Wilson's funny edginess. Zach's work is, dare I say, lovable. There's a compactness to its design, a welcoming sparseness and feel. As with Addams's work, no matter how out-there the content, one does not suppose the cartoon characters peopling the drawings are ever really in harm's way.

In recent years, Zach's attention has turned more fully to the world of television (he wrote for *Saturday Night Live* in his nascent *New Yorker* years and more recently is co-creator, writer, and producer of *I Think You Should Leave with Tim Robinson*). In that, too, he parallels such cartoonist colleagues as Bruce Eric Kaplan and Alex Gregory. The two worlds—

THE CARTOON WORLD AND THE WORLD OF COMEDY–INTERSECT IN THE MOST BASIC WAY: A CARTOONIST SETS A SCENE, INTRODUCING A SITUATION IN A FROZEN MOMENT;

television (at its best) unfreezes the moment, staggers it, prolonging the laughter. Zach's work works exceptionally well, both frozen and defrosted.

"Remember, he created us in his image a really long time ago."

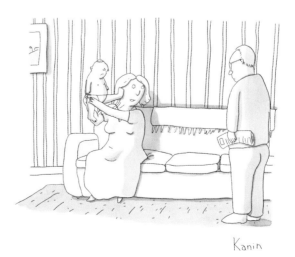

"I can feel the baby kicking."

ZACHARY KANIN **95**

BRUCE
ERIC
KAPLAN

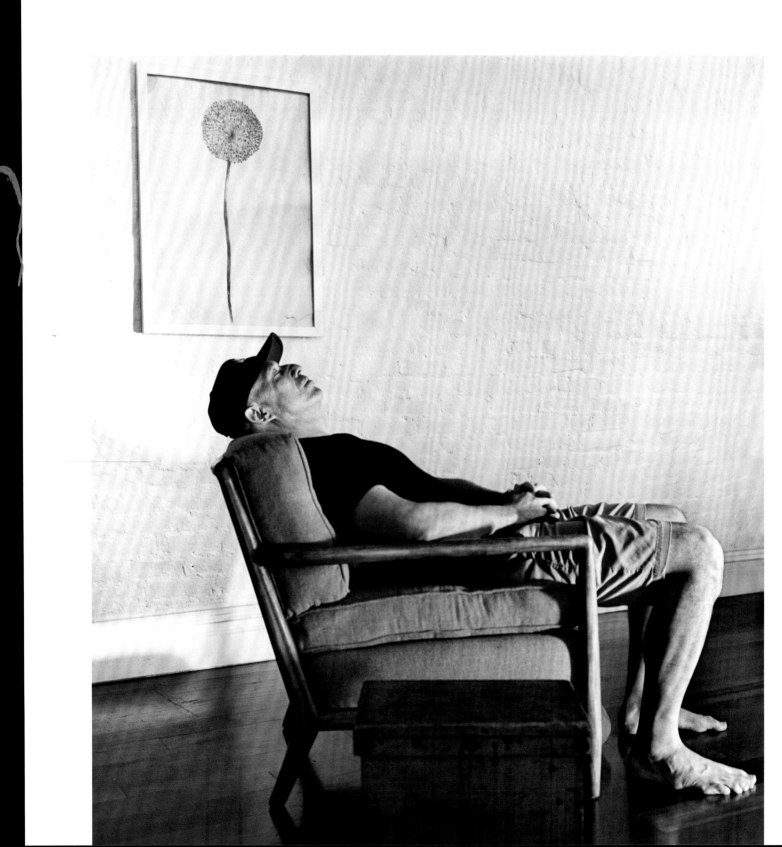

The New Yorker's Rebecca Mead said of Bruce Eric Kaplan in 2004: "Kaplan is the most convincing and funniest portraitist we have of a postmodernist psyche still stumbling out from the shambles of the fading twentieth century." That's quite a mouthful. Ironically, it's the opposite of the concise captions and pared-down drawings of Kaplan's that we've enjoyed over the years. Since I have difficulty with absolutes such as *the most,* can we please turn off the modifying phrases for a while and agree to agree that Kaplan was, and is, one of a number of funny and convincing *New Yorker* artists ("portraitists" muddies things)? I mean, after all, that's what we're here for.

Am I the first to note that Kaplan resembles some of the people in his drawings? The shaved head, the well-defined features repelling inquiring eyes (his characters' eyeballs are sans pupils).

Someone should make a list of artists who look like their work. Bruce's drawings seem to be made up of fluidly drawn people existing in almost mechanically drawn environments. And then there's the thick black edge that appears on every one of his drawings. I'd been wondering about that edge for quite some time and finally got around to asking him, "Why the edge?" He replied:

"It should be easy to answer, but oddly it isn't.

I am partially just guessing here, but my memory is that I

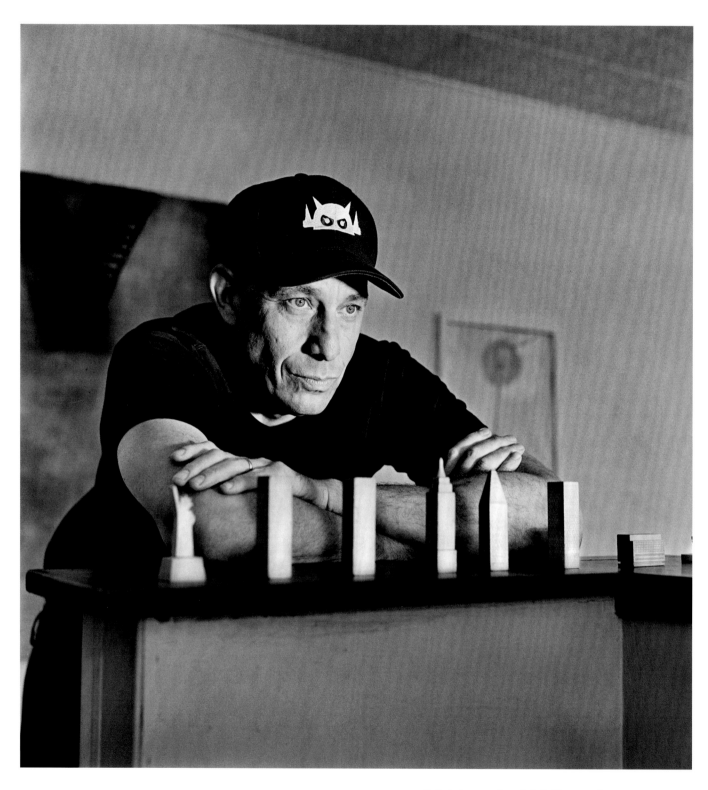

didn't have the thick line at first, and it just didn't feel right, like the drawings weren't quite landing. I needed something to ground the drawing, to . . . give it a little more heft, like it was weighted down on the page. A lot of what I do is instinctive, and this is definitely

one of those cases. It just feels more right for me to have the thick black line, and without it, it would feel that something was wrong."

There's usually not a lot of clutter in a Kaplan drawing (a place for every line, and every line in its place). Individuals exist in exterior or interior environments; figures, be they human or nonhuman, are drawn sparsely. THEY DO OFTEN SEEM LIKE WEIRD BLUEPRINTS OF CLAY MODELS, WEIGHTED TO THE GROUND. As someone in the school of Thurber, I'm really pleased that that's the case. It only works when the artist has command of his work, and luckily for us, Kaplan does.

What Kaplan is good at—very good at—is delivering a succinct zap of words below his trademark drawing style. As is the case with cartoonists we remember, his style is unforgettable. Kaplan's people remind me—in a very good way—of the lovely blobs we witness moving within a lava lamp. His folks don't float, though—they're well tethered to the ground with a Gumby-esque solidity around their ankles and feet. There is a wham effect with BEK's cartoons, as with a hammer hitting a nail just right.

"A lot of them I only pretend to watch over."

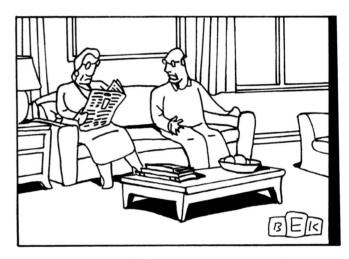

"I'm sixty-six—I don't want to see puppets in anything."

FARLEY KATZ

Farley Katz arrived on the *New Yorker* scene in 2007 as an assistant in the cartoon department. In an era of cartoon department assistants becoming cartoonists (including three of Farley's predecessors, Zach Kanin, Marshall Hopkins, and Andy Friedman), Farley was no exception. His first cartoon in the magazine, in the December 10, 2007 issue, immediately caught my eye.

It looked like a frame out of an early-2000s animated cartoon. Like with all cartoonists, the style is a sum of influences. Farley's eclectic bag includes Dr. Seuss, Edward Gorey, *The Ren & Stimpy Show, Krazy Kat, The Simpsons, The Far Side,* and, of course, *New Yorker* cartoons. His figures somehow look both stiff and rubbery, with a fluid line meandering within its own take on three-point perspective. There is also some kind of geometry going on in his work—geometry all Farley's own. The work itself has a modern, post–Charles Addams feel to it, not unlike Zach Kanin's work.

MOVING HELP

PROFESSIONAL MOVING LABOR SERVICES

YOU RENT THE TRUCK
& WE DO THE MOVE

CHOICE OF 2 to 8 MOVERS

LOAD·UNLOAD · Truck · Pods · Storage
WALK UPS · PACKING · DISASSEMBLY · INTERNAL ROUTES
PICK UP · RETURN UHAUL FOR CLIENT

NYC 5 BOROS & LONG DISTANCE · FLAT RATE - NO HIDDEN FEES

929-244-0082

NYC 5BOROS & JERSEY CITY

Lost Diamond Necklace

My elderly mother lost a necklace that is both valuable and profoundly sentimental - it has a lot of family history and she has worn it every day for decades.

It is a gold chain with a diamond pendant. It is likely that the chain

Strange things happen in Farley Katz's drawings. **EVEN IF NORMAL THINGS HAPPEN IN THE DRAWING, FUNNY AND ODD THINGS HAPPEN IN THE CAPTION.** A good example is the drawing of what appears to be a Santa Claus on a sidewalk speaking to a little girl. He says, "I'm not Santa, kid—I'm just an overweight hipster with a bag full of dumpster garbage" (*New Yorker*, December 16, 2013).

As a person, Farley is as polite as they come. His handlebar mustache does indicate some inner shenanigans going on. Shenanigans we see played out with a determined, eccentric energy on the page.

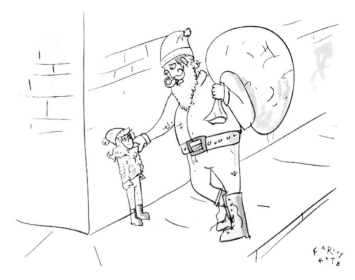

"I'm not Santa, kid—I'm just an overweight hipster with a bag full of dumpster garbage."

"I just realized everyone I know is fake."

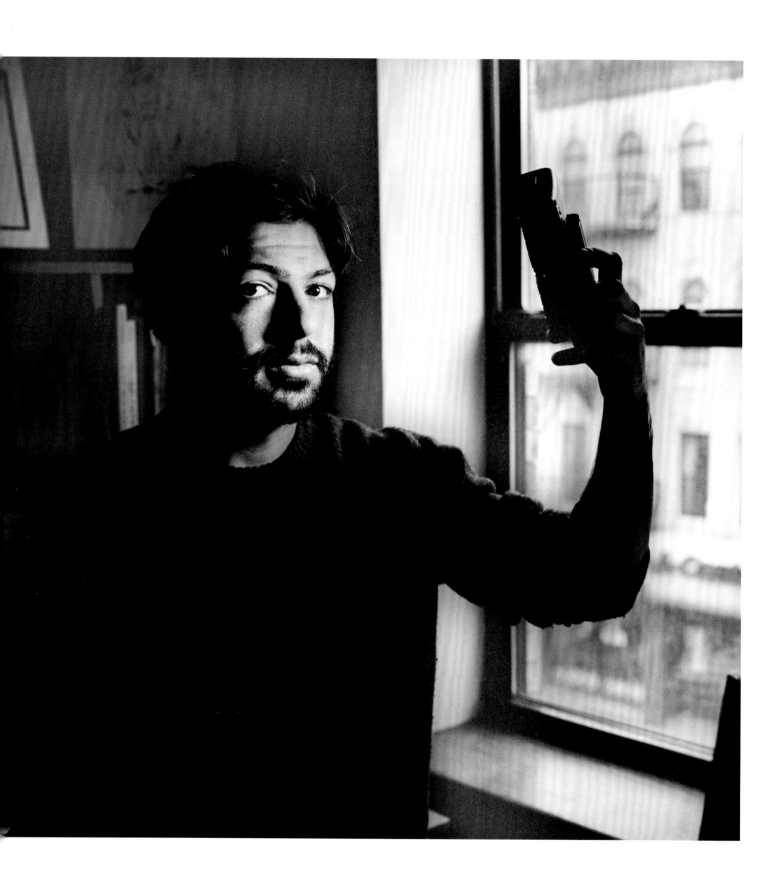

JASON ADAM KATZENSTEIN

For those of us who rely on the word of the day, or the week, or the politician- or celebrity-capturing headlines, there is nothing like a hot topic to fire up the imagination—what cartoonist among us can resist a good buzzword? For some, these are the building blocks of the day's work. It's no secret that J.A.K. (as Jason signs his work) is adept at spinning off of a good word and, sometimes, as shown in one of his most popular drawings, *"Let me interrupt your expertise with my confidence,"* encapsulating a cultural moment.

I've always felt that certain cartoonists relish the challenge. Looking through Jason's *New Yorker* work—he started contributing in 2014—I see him as a modern-day counterpart to, among others, his *New Yorker* colleague Ben Schwartz.

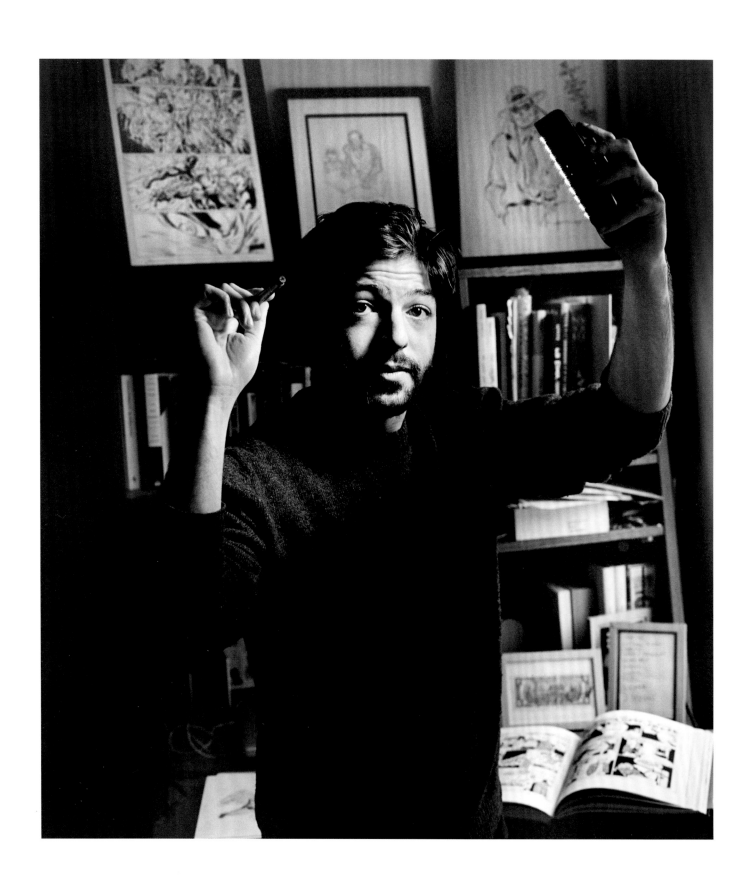

106 JASON ADAM KATZENSTEIN

Both enjoy the infrastructure provided by a pop reference or a social media moment. AS JASON TOLD US ON A LIVE SOCIAL MEDIA BROADCAST SOME YEARS BACK, HE CARRIES A SKETCHBOOK EVERYWHERE HE GOES. THAT HABIT SURELY RESULTS IN RECORDING REAL-TIME CULTURE. As for style, I'm going to suggest that Jason enjoys using color in his *New Yorker* work more than just about any other cartoonist from his wave.

Looking through his work for the magazine, two drawings stand out as distinctly different: a couple of rabbits arriving at a big hat and one saying, "Well, this is me" (August 22, 2015), and two ships passing in the night, with one ship saying to the other, "But drinks soon?" (March 29, 2021). The first has a Charles Addams–y feel to it, while the second has, for me, a Lee Lorenz sensibility. Both drawings feel evergreen: works that will endure no matter how times change. *The New Yorker* has always thrived on both chyron cartoonists and artists who produce evergreens. Being able to deliver both is unique.

"*Let me interrupt your expertise with my confidence.*"

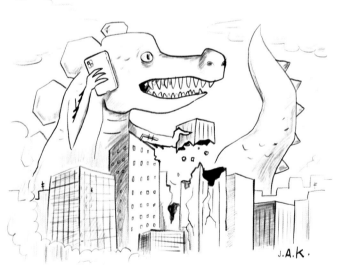

"*Sorry for the short notice, but I'm actually destroying New York this evening—are you around for a drink?*"

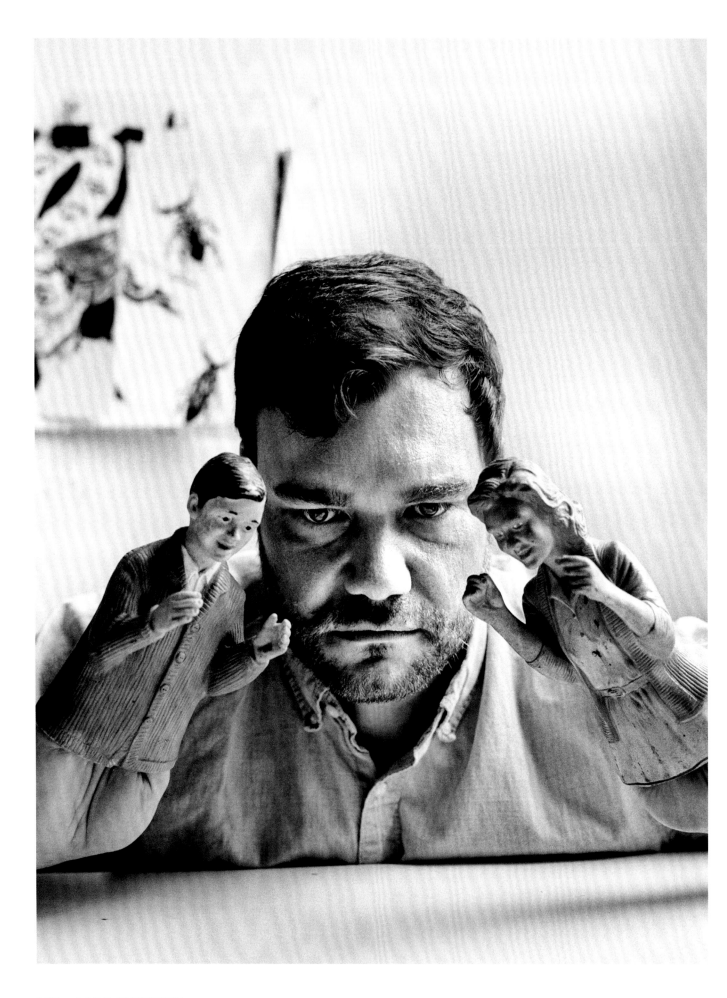

LARS KENSETH

One thing's for darn sure: Lars Kenseth's world is his and his alone. And thankfully, he's been kind enough to invite us in to look around. Lars has come up with a drawing style never seen before in *The New Yorker*'s one hundred years. That is no easy thing. His characters are as unusual as Edward Koren's hairy beasts. When I interviewed Lars about his people, he had this to say about them:

"I love hearing people try to describe the characters I draw. I've heard everything from deodorant roll-on people to egg people to blobs to Weebles to gelcaps to jelly beans to lozenges."

Any one of these descriptors will do nicely; each gives you the idea that Lars's human figures are not in the Leonardo da Vinci school of cartooning (or any other school of cartooning I can think of). I detect a sweet innocence in Lars's cartoon world—coming across an angry or

mean Lars cartoon character is rare. When something happens within his cartoon world, his characters seem to accept it without a trace of drama. However strange the circumstance, the situation, although odd, is all good.

As if coming up with a new style wasn't enough, Lars made *New Yorker* cartoon history in 2016 by doing the very first *New Yorker*

cartoon referencing itself *as a New Yorker* cartoon: *A Creepy Clown Ruins a Perfectly Good New Yorker Cartoon.*

Lars arrived at *The New Yorker* in 2016—among his classmates were Ellis Rosen, Amy Kurzweil, and Seth Fleishman, all of whom appear in this book. If we are what we eat, in many cases, cartoonists are who they draw. LARS, LIKE SO MANY OF HIS COLLEAGUES, FINDS COMEDIC GOLD IN EVERYDAY LIFE, IN THE ORDINARY (WORK, HOME, PLAY); OCCASIONALLY, HE JOURNEYS INTO THE PAST. There is an instant likability factor about his work, and about him. I first met him at a party held at *New Yorker* editor David Remnick's Manhattan home, where two score cartoonists had gathered to welcome Emma Allen as *The New Yorker*'s new cartoon editor. Lars, a ball of energy, suddenly was standing in front of me; he seemed to be having the time of his life, outwardly happier than anyone in the room. This is how I feel about his cartoon characters: they seem to be having a blast as cartoon characters functioning in Lars's world. Carry on, Lars Kenseth!

"Mom? For my birthday, can I have a jerk kid ride me in a circle?"

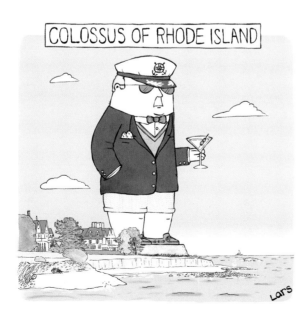

Ed Koren contributed to *The New Yorker* for just over six decades—a remarkable milestone met by only five of his colleagues: William Steig, Al Ross, Mischa Richter, Chon Day, and George Price. One other impressive milestone: of the seven hundred and fifty or so cartoonists who've contributed to *The New Yorker* in its lifetime, he is one of just two dozen who have sold more than a thousand drawings.

When he started out, way back in the late 1950s, he tried, as so many do, to draw "*New Yorker* cartoons"—something that didn't quite work out at first. It wasn't until he began drawing how and what he wanted to draw that he became, along with a select few in the 1960s, one of the magazine's cartoon gods.

His furry or fuzzy people and beasts are instantly recognizable—much like George Booth's dogs. He found a style that no one had ever found before, a conjuring up of figures out of scritchy-scratchy lines. Magnify a Koren person and it's like looking into a cartoon kaleidoscope. What's amazing to me is that he drew large—how difficult it seems to hold a cartoon's structure together with all those far-flung lines on a page. But this was his genius. In an interview with him about a year before he died, I asked him about his drawings:

MM: The way I draw, I'll draw a line, and then another line, and they often connect end to end. But you layer.

EK: I think I've always been sensitive to disarray, to disorganization. Animals with elaborate fur have always intrigued me. It probably comes, somewhat, from my fascination with animals, mammals, and creatures of all sorts. Their exteriors are so varied, so interesting, so chaotic, and so unplanned. They're also more interesting for me to draw because I have a nervous predilection in my hand—I just keep moving along.

In a way, "just keep moving along" was the thread of his work life, spent in his fabulously crammed-with-art studio. Visiting with him in his last year, I watched him sweep his arm through the air, taking in his workspace, saying, "I don't want to leave this."

He said many times that he did not do political work—it wasn't what he was about. Yet politics

EDWARD KOREN
1935-2023

seeped in—cultural politics—as it seems to in many nonpolitical cartoons. The cartoon can "mean something" without overtly meaning to.

Koren was one of the most immersed-in-art *New Yorker* artists of our time. HE TOOK BREAKS FROM CARTOONS TO WORK ON ETCHINGS; for many years he traveled to France to work on lithography presses from another century. He knew his art history, as well as his *New Yorker* art history, and he knew what came before *The New Yorker*'s cartoons. All of this informed his work. Over the course of the interview, I asked him about influences, and he called attention to a favorite quote of his (by Giorgos Seferis):

Don't ask me who's influenced me. A lion is made up of the lambs he's digested, and I've been reading all my life.

"Your father and I want to explain why we've decided to live apart."

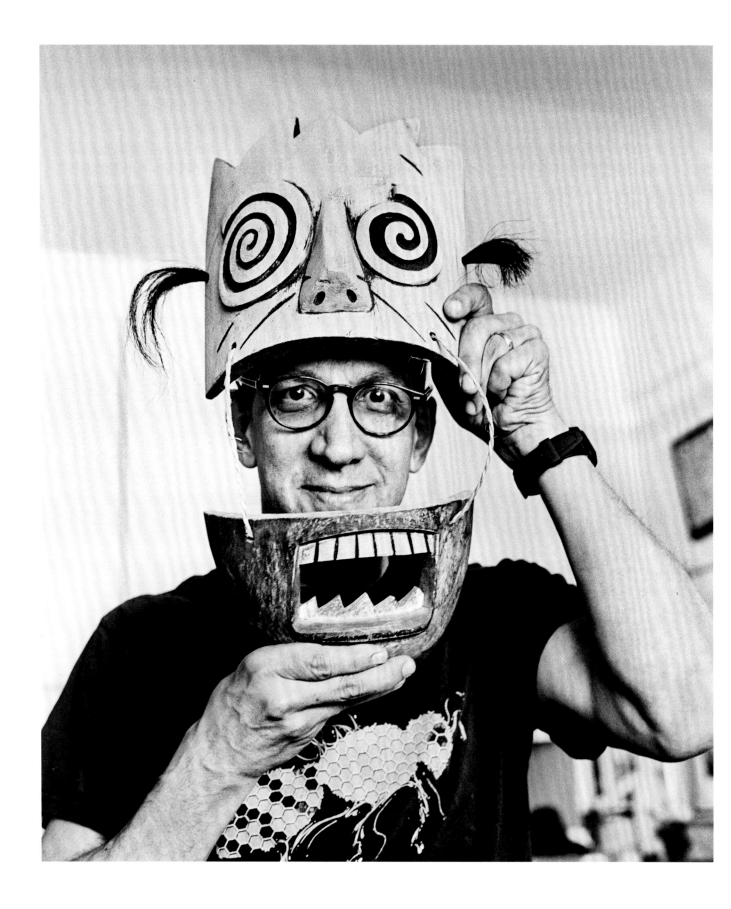

There are a number of *New Yorker* cartoonists whose work mode seems set on "high"—these artists are constantly on the move, appearing at events, producing books, being involved in projects beyond *The New Yorker*. Peter Kuper is one of those cartoonists.

Whether it's a one-person exhibit at the New York Public

PETER KUPER

Library (*INterSECTS: Where Arthropods and Homo Sapiens Meet*) or a graphic take on Kafka's stories, or an illustrated journal from his time living in Mexico, or an adaptation of Joseph Conrad's *Heart of Darkness*, he is ever in motion. Until recently, he was also the artist behind *Spy vs. Spy,* a regular feature in *MAD* magazine (he inherited *Spy* in 1997).

In an interview he gave at Comic-Con in 2011, he said of his early career, "I found that I actually was really interested in much more alternative comics, and mainstream was less and less interesting to me." His co-founding of the political comix magazine *World War 3 Illustrated* in 1979 "allowed [him] to do more political, personal . . . comics about dreams."

As for his *New Yorker* work, Peter began appearing in 2011. Peter's graphic signature is precision

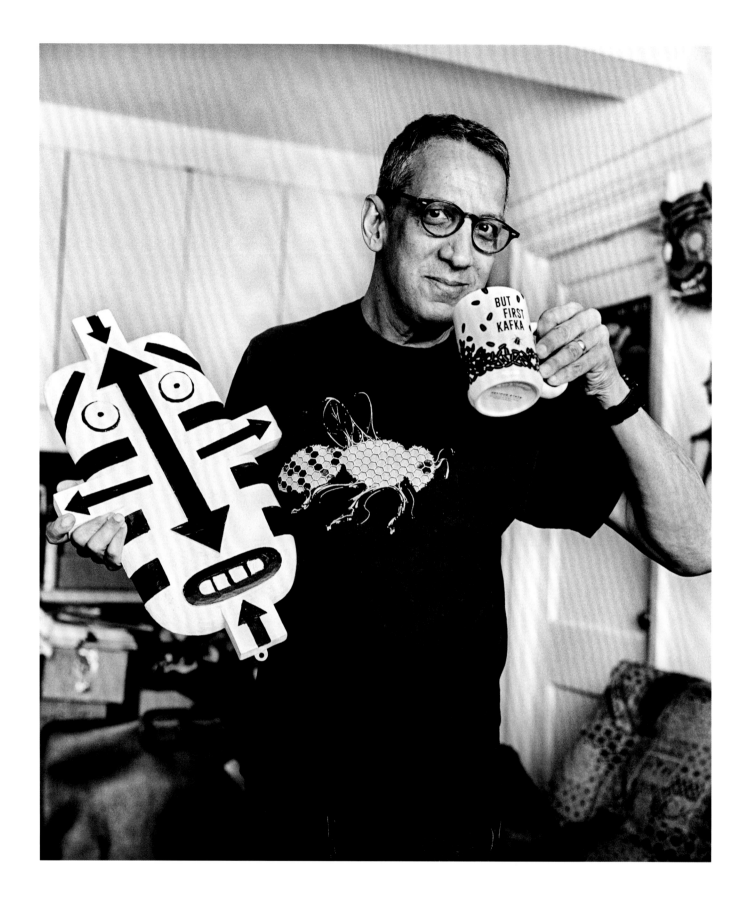

drawing. THERE ARE SOME ARTISTS WHO EITHER FLAUNT THEIR GRAPHIC WEAKNESSES OR CLEVERLY DISGUISE THEM (it's possible I do both in my work). Peter's draftsmanship expresses an ease and a confidence born of a lifetime of loving to put pen to paper.

"It's with a heavy heart I'm stepping down as CEO and retiring."

There's a determined quality about Peter's work and about him. Not too long ago, while driving home late at night through rural upstate New York, I listened to a recording of a talk Peter gave. The energy with which he spoke must've extended to my foot on the gas pedal. I turned off his talk when a state trooper's red flashing lights appeared in my rearview mirror. I would've loved to have blamed my excessive speed on Peter: "I'm sorry, Officer—I was just trying to catch up with Peter Kuper."

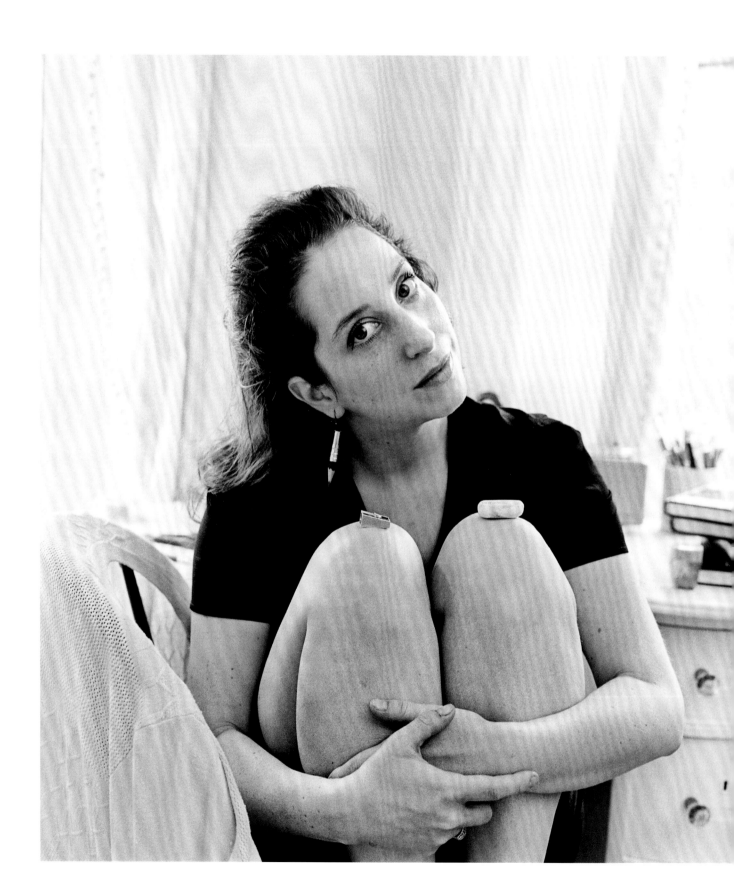

AMY KURZWEIL

Almost all cartoonists are storytellers. Some of us—perhaps most of us—find the single panel the best way to tell a story. The freeze frame of a single-panel cartoon is the bedrock form of the art. In a way, it is the litmus test for any cartoonist wishing to break into *The New Yorker*. Master the single-panel, get published, and . . . your cartoon life goes on and flowers. Some artists regularly expand into multi-panels (see Roz Chast). And then there are those who, at times, go beyond three or four panels to a book-length story. Although Amy Kurzweil, who began contributing cartoons to *The New Yorker* in 2016, has now settled into the single-panel, she began her *New Yorker* career with a three-panel drawing (originally conceived as four panels but edited down). Readers wouldn't have known it then, but the panels hinted at Ms. Kurzweil's history as a writer who had recently morphed into a cartoonist. In that same year of her first *New Yorker* cartoon, she published a graphic novel, the well-received *Flying Couch*. Indeed, as she

told Liza Donnelly in an interview, she learned to draw by working book-length.

The year 2016 was, in the *New Yorker* cartoonist world, one for the record books. When Amy got her foot in the door at the magazine, fourteen other newbies got theirs in as well—the largest

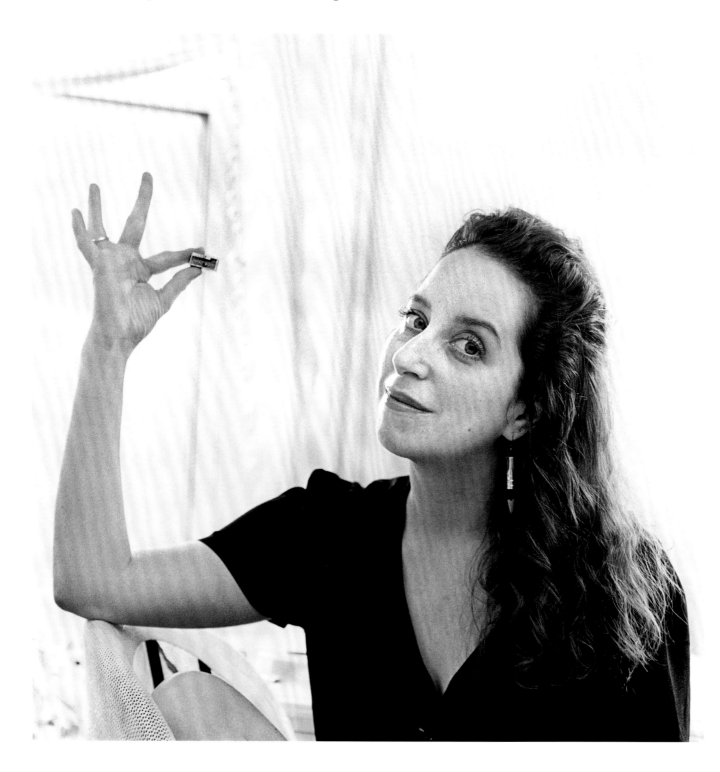

freshman class (up to that point) in modern times.

All cartoonists' work is personal, of course. What you see in *The New Yorker* is who you get. Yet there are varying degrees of what each cartoonist allows on the printed page and computer screen. While Amy's book-length graphic work is highly personal (the list of artists who have inspired her is topped by graphic artist–writers such as Craig Thompson, Alison Bechdel, and Art Spiegelman), her cartoons often summarize the wider world—the now. This cartoonist modus operandi has its roots in the very beginning of *The New Yorker*, when artists were encouraged to leave their studios and wander the streets of New York. THEIR MISSION WAS TO TELL US, THROUGH THEIR CARTOONIST BRAINS, WHAT WAS GOING ON. OVER THE DECADES, CARTOONISTS HAVE WANDERED FAR, far beyond Manhattan to reflect the state of things.

One of Amy's drawings perfectly expresses this: We see a conversation among four planets of our solar system. Each of the four—in its own orbit of course—has a very contemporary, very relatable, very human reason for not getting together. This is exactly what we've come to expect from *New Yorker* cartoons: playful juggling of au courant language and behavior, mixed up with an unexpected twist.

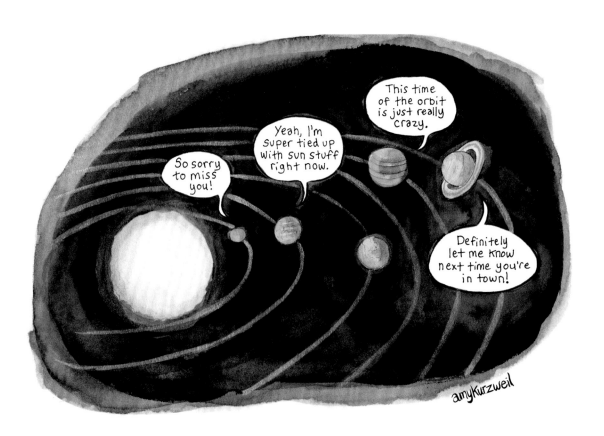

MAGGIE
LARSON

Maggie Larson sold her first *New Yorker* cartoon in March of 2017, just as the magazine's cartoon department was about to experience a spring of change. In May of that year, Emma Allen became the so-called gatekeeper, overseeing whose work and what work would go to *The New Yorker*'s fabled Art Meeting. Maggie was one of the most recent contributors, selling a drawing just before Ms. Allen took the reins and was published (for the first time in *The New Yorker*) almost immediately after.

Throughout the hundred years of *The New Yorker*'s lifetime, a handful of its cartoonists have drawn with a thin line accompanied by a well-chosen dose of black ink, with no gray wash: Otto Soglow, I. "Izzy" Klein, and Seth Fleishman among them (Gluyas Williams, the most published of the fine-line/dose-of-black group, used a gray wash from time to time). Maggie, using a technical pen called a Rapidograph, is one of that select handful. Drawing as she does requires the artist's "eye" to maintain graphic balance. It will come as no surprise then that she

lists the great Al Hirschfeld as an inspiration. The simple-line/black-ink effect, done well, is a pleasure to behold. Maggie's drawing of May 12, 2023, *"First mortarboards of the season,"* is an excellent example.

With Soglow and Fleishman already in the conversation, it should be noted that their work is, for the most part, captionless. Maggie's body of *New Yorker* work is not nearly as captionless, but the inclination is there (she's on the record as preferring cartoons sans captions). HER FIRST CARTOON, WHICH RAN IN JULY OF 2017, OF A RAT WITH ITS HEAD STICKING OUT OF A NEW YORK CITY SUBWAY CAR, CAME OUT OF HER LOVE OF THE CITY-STREET LIFE (AND BELOW-STREET LIFE).

She told Liza Donnelly in an unpublished interview: "I didn't see a rat hanging out the window on a subway car, but I saw rats having a party as the subway came down [the subway tracks] and I thought, *Yes, something's happening here."* I like to think of all the humorous opportunities the city holds—and readers will continue to enjoy—as Maggie makes her way around the isle of Manhattan, her cartoonist antennae up, taking note of the city scenes and the city's citizens.

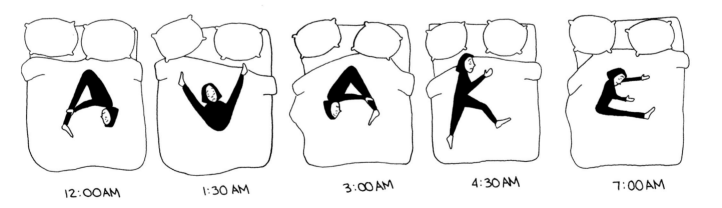

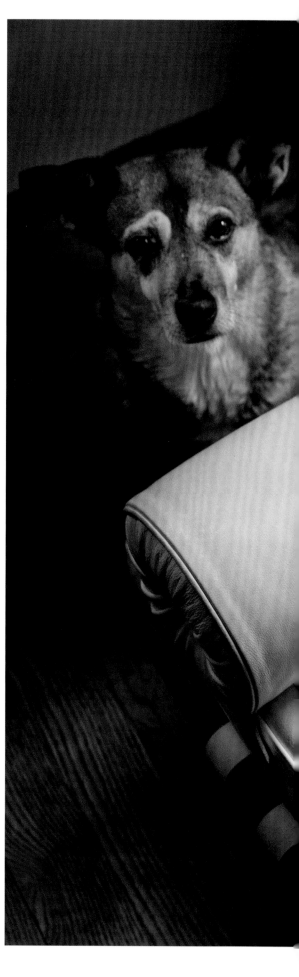

Not many cartoons are shown on the walls of the Empire State Building. Not only is a Robert Leighton drawing exhibited there but it's enlarged, mural-sized, and affixed to the wall. You can't and won't miss it when you visit that iconic skyscraper. The drawing in question is his classic *New Yorker* cartoon published on February 4, 2013: *"Escher! Get your ass up here."*

ROBERT LEIGHTON

Robert wears at least two hats in his day-to-day professional life: cartoonist and puzzle maker. In the Escher drawing we see his two hats combine. He told me: "My Escher drawing grows out of my puzzle maker's interest in optical illusions and visual puns."

He's a self-taught artist who wanted to be a strip cartoonist since he was in his teens. Along the way, with a sort of sidestep into the classic *New Yorker* single-panel format, he came to the magazine.

Robert's drawing style is one of the friendliest in the magazine. His cartoon language is friendly as well, and sharp. In his January 1, 2016 drawing of a couple in a theater, we see regular folks just settling into their seats to enjoy the great Yo-Yo Ma but finding disappointment:

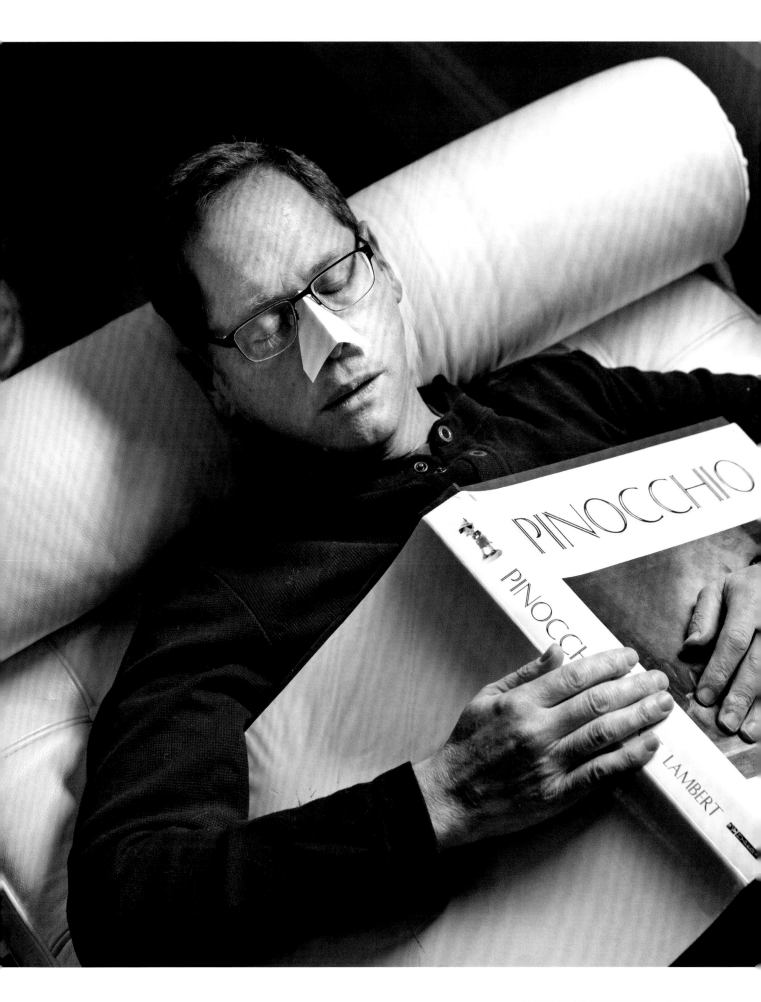

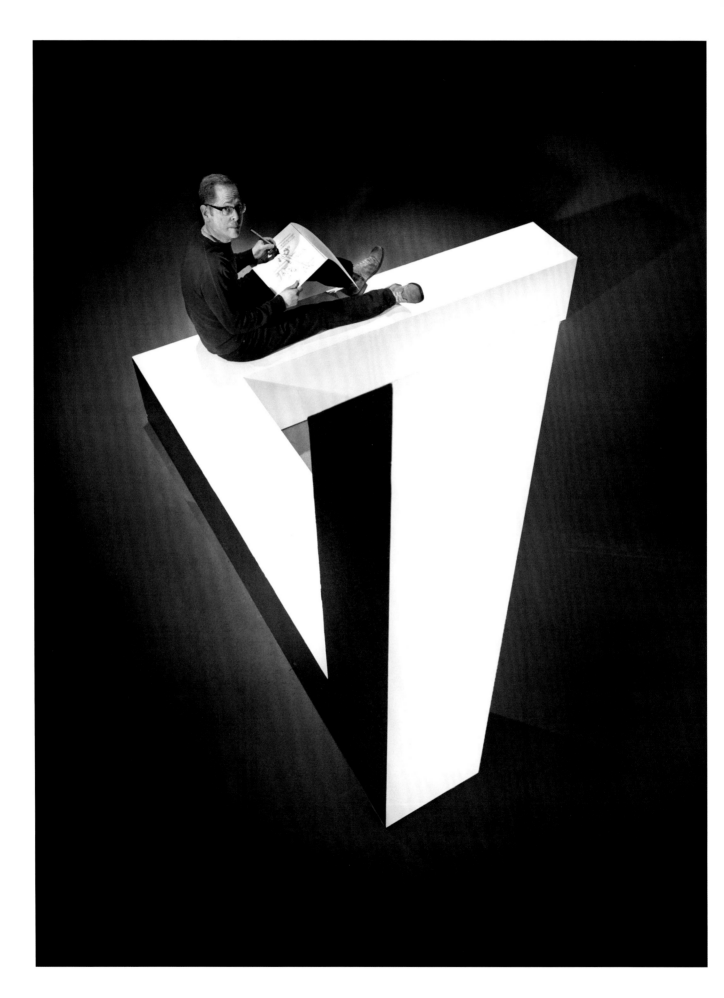

model of cartoonist: **A TRUE GENTLEMAN, EVER ENGAGED, CURIOUS, ABSORBED IN HIS ART.**

At a *New Yorker* party some years back, he and I fell into conversation out on the sidewalk a few steps from the party venue. We spent the evening there, nodding to colleagues who passed by. The only extended interruption in our talk was when then–cartoon editor Bob Mankoff joined us and began expounding on the features found in his new Tesla. I do believe that Robert recognized the moment as a living cartoon, ripe with possibilities.

"No wonder these Yo-Yo Ma tickets were still available. He's going to be playing the saxophone."

Like the best cartoonists, he's caught you way off-guard as the caption closes. In other words: you never saw *saxophone* coming. In Robert's two decades at the magazine, he has consistently excelled at the one-two punch that Peter Arno laid out as the necessary foundation of a great cartoon.

The territory Robert covers involves mostly ordinary folks living their lives in the present day. Take, for instance, another of his Hall of Fame drawings, *"Can you hang on a sec. I think I just took another picture of my ear"* (February 16, 2004). We are shown a moment with an ordinary Joe out on a city sidewalk. We surmise by the slump of the fellow's body that he's a bit weary. When he tells the person on the other end of his call that he's taken at least one picture of his ear before, we're given a peek into this fellow's ongoing small burdens.

I've been fortunate enough to get to know Robert a bit over the course of his *New Yorker* career. I think of him as the heir to the *New Yorker* cartoonist Henry Martin's

"Escher! Get your ass up here."

"Well, if it isn't the dawn of civilization."

ROBERT MANKOFF

My introduction to Robert "Bob" Mankoff was in the courtyard of a turtle enthusiast who lived on the Upper West Side of Manhattan. It was the year Bob first sold to *The New Yorker*—the year I finally sold as well. His sale was a drawing; mine was an idea.

Bob's style, pointillist-like if not pointillist, charmed the heck out of me. No other cartoonist at *The New Yorker* (or in any publication known to me) worked that way. I suppose that an element of my fascination with the style was intrigue. Why oh why would someone spend all that time creating a drawing out of dots? The answer, I realized, is less interesting than the result—he was inspired by both the work of Seurat as well as the discovery that magazine photographs, if enlarged, were actually made up of tiny dots. When Bob decided to draw with dots, he created a signature style that worked beautifully.

He has what some would call a large personality, seemingly unsuited for the patient construction of cartoons out of dots. Strangely, that personality was not

evident when we met, or through some of the earliest years of his run at *The New Yorker*. I once sat next to him at a cartoonists' lunch, and he barely spoke a word. Unimaginable now.

Bob arrived at *The New Yorker* benefiting from the debut of Jack Ziegler's work several years earlier.

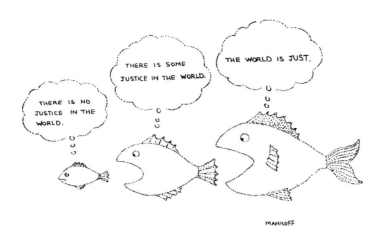

Once Lee Lorenz wedged Jack's work into the magazine, the *New Yorker* cartoon universe was brought, once and for all time, into the modern world. Bob's humor was not as out-there as Jack's, but culturally, it was as modern as tomorrow's headlines. One of his drawings in particular managed to do what so many others never do: it broke away from the pack and became famous. *"No, Thursday's out. How about never—is never good for you?,"* published in the issue of May 3, 1993, was Bob's signature cartoon. It went on to become, along with Peter Steiner's *"On the Internet, nobody knows you're a dog,"* one of the most reprinted cartoons in the magazine's history.

Twenty years after his arrival at *The New Yorker*, BOB GRABBED HOLD OF THE CARTOON EDITOR'S CHAIR AND STAYED SEATED FOR NEARLY TWO DECADES. Under his watch, David Sipress finally found success after many, many years of rejection. In fact, a number of cartoonists whose work and whose selves could stand the test of rejection arrived and thrived. Among them: Emily Flake, Joe Dator, Farley Katz, Zach Kanin, William Haefeli, Liana Finck, Paul Noth, and Kim Warp.

When the magazine felt it was time for a change and installed Emma Allen as its new cartoon editor, Bob left to revive the cartoon scene at *Esquire* (a position he held for two years). He recently said in an interview, "I don't know that I will go back to doing cartoons." His focus now, as it has been for many years, is the financial side of cartooning, making dollars, not dots.

"No, Thursday's out. How about never—is never good for you?"

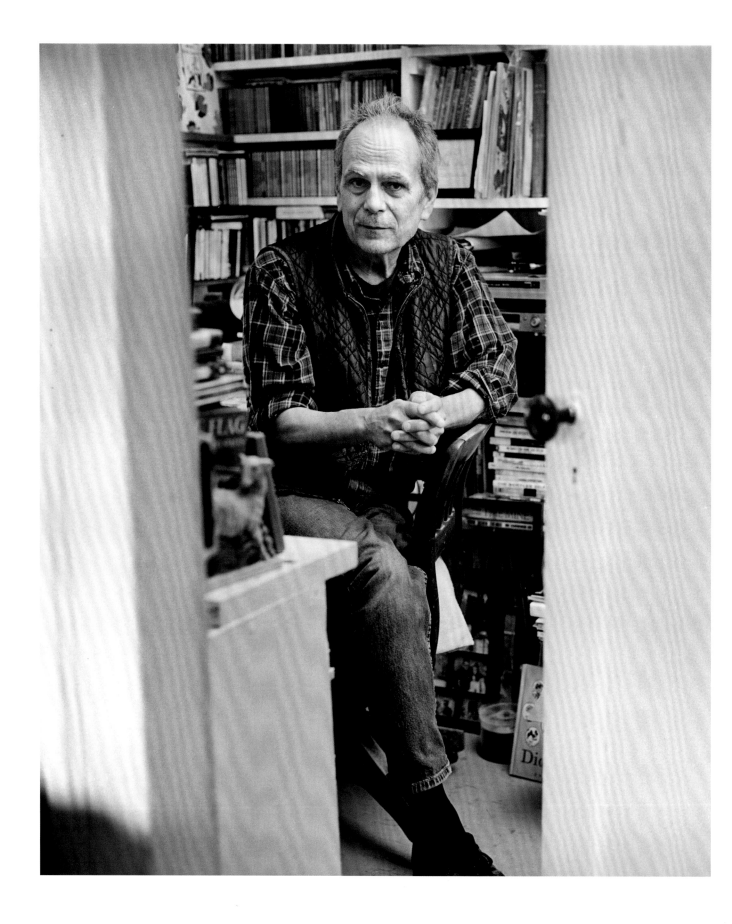

You could say the *New Yorker* germ somehow found its way into Michael Maslin's New Jersey soul when he was very young, and it flourished there. I can imagine him poring over the magazine, not sure what was going on there but liking what he saw. As a young man, he began submitting cartoons to *The New Yorker* and eventually sold them an idea that Whitney Darrow drew. Then he sold them a drawing that appeared in the April 17, 1978 issue. (I was going to just say "in 1978," but Michael likes exactitude.) I have met and know a lot of cartoonists, but none of them identifies with the world of *The New Yorker* as thoroughly and as deeply as Michael does. It is therefore only natural that his *Ink Spill* blog (funny, because I'd bet Michael never spills ink) has become the go-to chronicle of all things *New*

Yorker cartoon. Biographies of cartoonists, statistics, happenings—it's all there. He is to the *New Yorker* cartoon what Boswell was to Johnson, what Robert Caro is to LBJ.

Michael's own drawings are like small theater pieces in which the characters, with their identical heads—round eyes, one if in profile, two if facing you, and one ear on the back of their heads—go about their business in a not-quite-parallel universe. We watch it all at some remove from up in the balcony. The rooms and furniture, roundish and askew, are way too large for the people. The doorways and windows have a weird but friendly configuration; they're often arched with points. *Friendly* is the right word for these drawings. And funny. The people in his universe with their

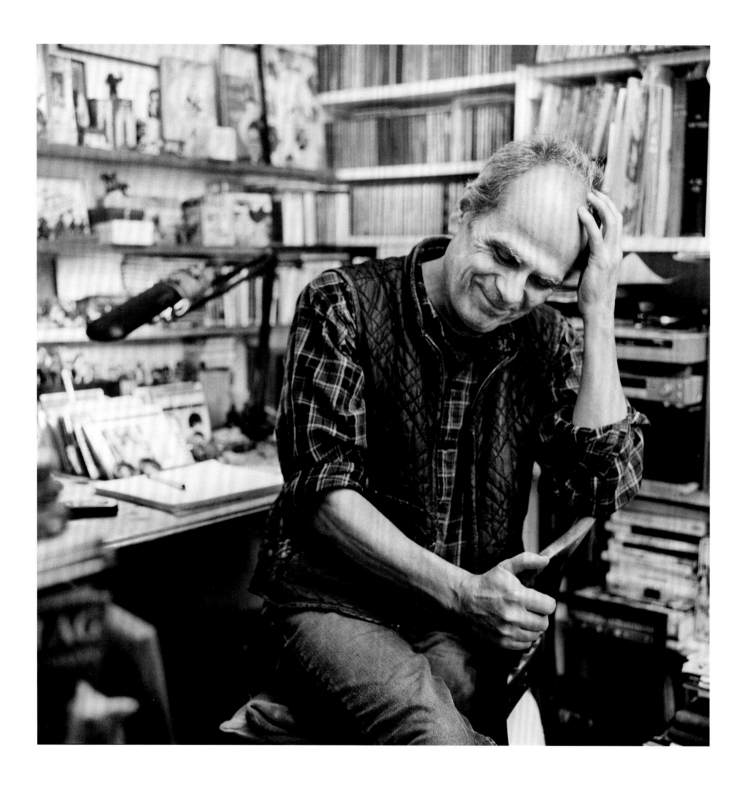

noodle limbs are friendly, too, even when they're slaying a dragon or serving as the dragon's attorney. His simple spidery line is economical, even minimal, but his drawings are light, not dark. They lift you up as they make you laugh. If some malevolence does happen to lie somewhere behind these lovely drawings, it remains permanently out of sight.

IT ISN'T WIDELY KNOWN, BUT CARTOONISTS COME HERE FROM ANOTHER PLANET. THIS ALLOWS THEM A BROAD VIEW OF HUMANKIND, which is why normal human behavior shows up as hilarious. When Michael was a boy, he was ordered by his school to visit a barbershop or not come back. His mother took him to a barbershop, and that was likely the last time Michael went inside one. His hair is short and neat, and he cuts it himself.

Michael travels *very* reluctantly. Putting together his weekly batch of cartoons is all the journey he desires. Imagining and drawing cartoons is as much a part of his life as breathing is. It is impossible to imagine Michael without drawing.

I don't think I have ever seen him wearing anything other than blue jeans and a flannel shirt. I've never seen his clothes closet, but I imagine eight hangers, neatly and widely spaced, with four pairs of slightly worn jeans and four identical blue and gray flannel shirts. I try to imagine Michael in a suit and tie, or a tuxedo, or fancy trousers and a turtleneck, and in my imagination they just fall off him.

For a long time—before caller ID—Michael wouldn't answer the phone. Michael and I have been friends for over forty years and I don't think we have ever spoken on the telephone. I understand he takes phone calls now, but I haven't tried.

"C'mon! You want a piece of me?"

"Giddydown."

JEREMY NGUYEN

It was while leafing through a July 2020 issue of *The New Yorker* that I came across a drawing by Jeremy Nguyen. This wonderful drawing of three pandas settled in to eat bamboo flooring, and another coming in through a window to join them, begged me to stay for a while and enjoy what I was seeing. The palette-like field of wash, which could've gone terribly wrong in lesser hands, sits just right. And the caption hits exactly where you'd want a caption to hit. For me, it's highly memorable—and will always be my go-to cartoon when I think of Jeremy and his work. Having said that, I should add that I do not have a go-to cartoon for every single *New Yorker* cartoonist; obviously, the pandas made a very, very good first impression.

Looking through Jeremy's *New Yorker* work, it's clear he's a fan of the wash field—it's not used on every single drawing, but it makes enough appearances to be considered a trademark element. When I asked him about it, this is what he told me:

"I wanted to use my gray tone as a graphic element, while also keeping the characters in the cartoon black-and-white for the most part. It has also been fun using the blob as a way to restructure the

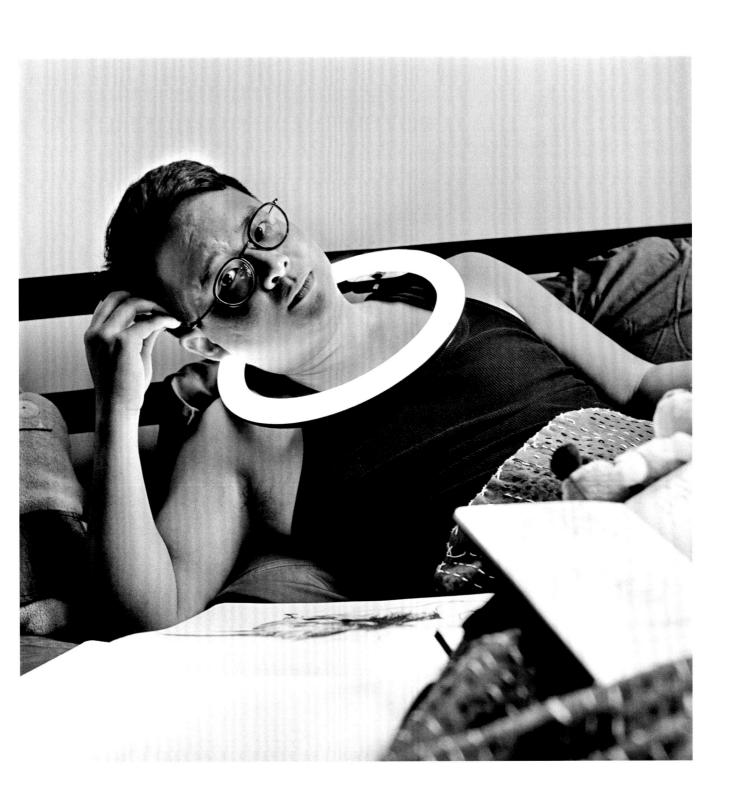

composition, change the flow of eye movement, after the drawing is done.

I was inspired by a Japanese illustrator, Satoshi Hashimoto, who has a very midcentury-American illustration style.

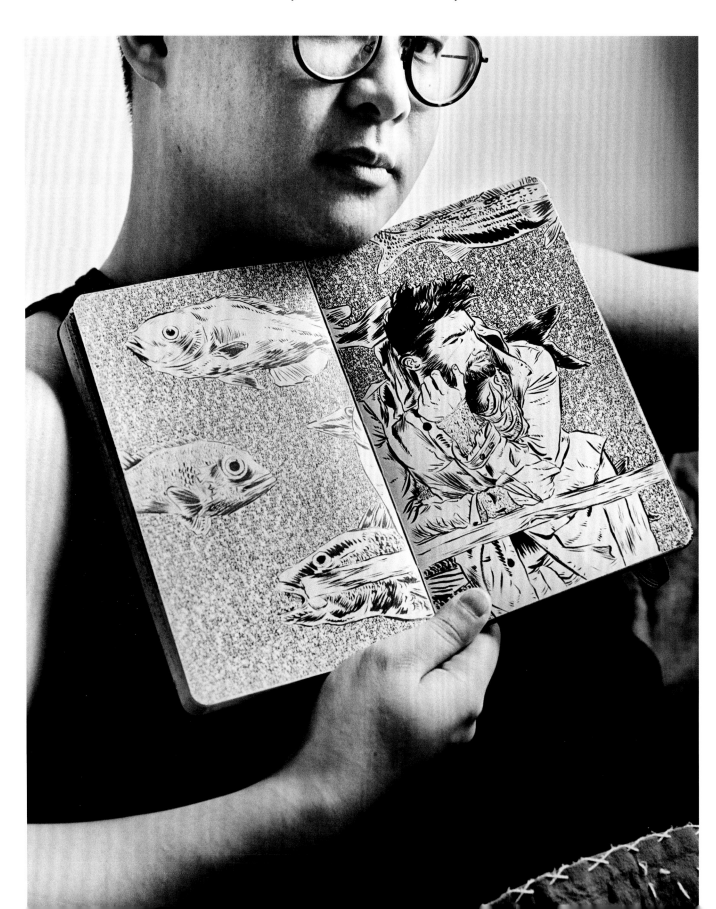

"This is the precise reason I didn't want bamboo flooring."

It felt very editorial to have a blob as a background element or a framing device. It's very common in fifties-to-sixties illustration. I really like that era of *New Yorker* cartoons, and I always try to bridge the feeling of nostalgia and modernism in my work. So, the blobs stayed!"

Jeremy was one of the last cartoonists brought into the fold by then–cartoon editor Bob Mankoff, who departed in the spring of 2017. In a 2023 appearance on the *New Yorker Cartoon Caption Contest Podcast*, Jeremy relayed

THIS BIT OF CHILDHOOD HISTORY: HIS MOTHER SAID THAT "THE ONLY WAY TO GET HIM TO STOP CRYING AS A BABY WAS TO PUT A PEN OR PENCIL IN HIS HAND."

A childhood of drawing led to a desire to draw comics (as opposed to single-panel drawings). It was the giant *Complete Cartoons of the New Yorker* that became his "way into" his interest in *New Yorker* cartoons. He sold his very first *New Yorker* cartoon out of his third submission. Long, long ago, selling so soon was a rarity (it took David Sipress twenty-five years of submitting before he sold his first), but in modern times, entry into the fold has become much less of an odyssey.

In late 2019, Jeremy, along with his *New Yorker* colleague Amy Hwang, curated an exhibit titled *Asian Babies*, the first exhibit showcasing Asian *New Yorker* cartoonists.

PAUL NOTH

Back in 2004, when Paul Noth's drawings began to appear in *The New Yorker,* I thought of him, graphically speaking, as an heir to Stuart Leeds's busy pen style—the lines appeared to be applied on paper by a shaved bamboo stick. A lot of layering—not Edward Koren's wild blowin'-in-the-wind kind of layering but a sort of haystack look: somewhat organized. In time, Paul's haystacks gave way to a different look, less Leeds, more Leo Cullum. You might ask: How many *New Yorker* cartoonists have not-so-subtly altered their styles? The answer: Not many. Charles Addams undid the look that accompanied his rise to stardom, trying a pen-and-ink line for a short time. It was, in his words, "a misguided effort." In Paul's case it was a development born of a conversation with the one-time cartoon editor Bob Mankoff. I asked Paul how the change of style came about:

"Bob didn't directly suggest I change my style. But he did let me know that improving my art would get more of my cartoons into the magazine. He avoided being directly prescriptive as to how I should improve. After I changed it to a less busy style, Bob reacted with approval, and I found that more of my work got published."

The "less busy style" meant smoother lines—no more hay!—and a gray wash. Whether he's using haystack line work or smooth line work, it's Paul's captions that steal

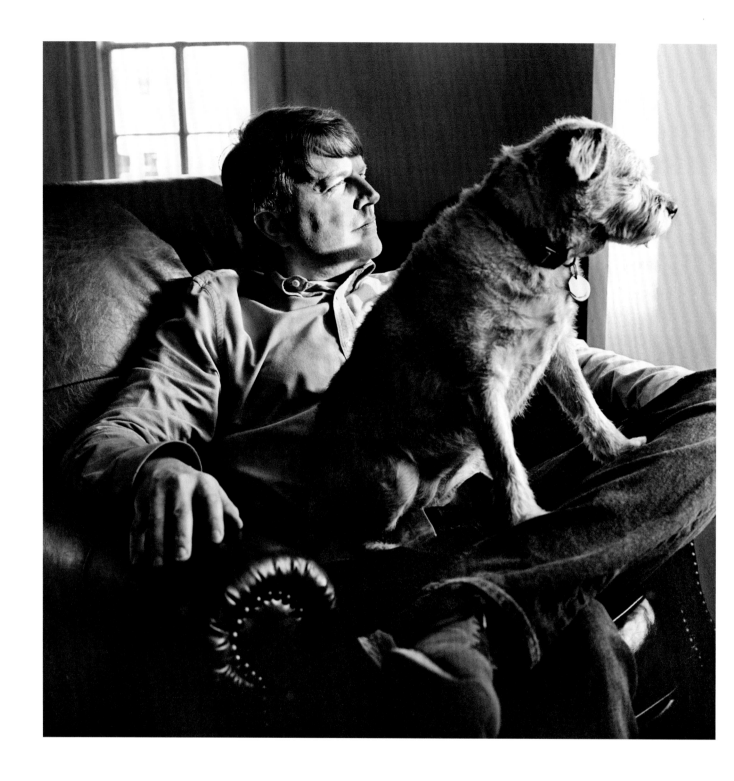

the day. Some cartoonists have a wonderful flow to their writing—the words fall just right. Paul is one of those cartoonists. A good example is one of his most popular cartoons (it appeared in *The New Yorker* of August 29, 2016). The caption's economy (six words) is perfectly in

sync with the billboard's six words: "I Am Going to Eat You." And, of course, it's very funny.

The New Yorker has a subset of contributors who began, pre–New Yorker, as writers turned cartoonists, and cartoonists who turned into writers (think John Updike). NOTH FALLS INTO THE FORMER CATEGORY, A FICTION WRITER WHO MADE HIS WAY INTO THE MAGAZINE VIA HIS CARTOONS. He has cited Charles Schulz as an early favorite, but Charles Addams was his first favorite New Yorker artist. Learning Addams was a first favorite has led me to thinking that Addams is a school unto himself, just as MAD magazine is responsible for inspiring the work of many contemporary New Yorker cartoonists (including several in this volume). In Paul's case, the Addams cartoon DNA is sometimes ramped up, as in his July 9, 2007 drawing of a fairground clown speaking to a young girl who's noticed the clown's teardrop tattoo. The clown says to the child: "It doesn't mean I'm a sad clown. It means I killed a man in prison." At the other end of the spectrum from Addams—let's call it the school of Charles Schulz—there is Paul's discarded Christmas tree on the curb in front of the house, being spoken to by a living tree: "Well, well, well, if it isn't Mister Fancy-Pants." Like that of every cartoonist who lasts at The New Yorker, Paul's work—whether edgy or something less than edgy—is reliably unpredictable.

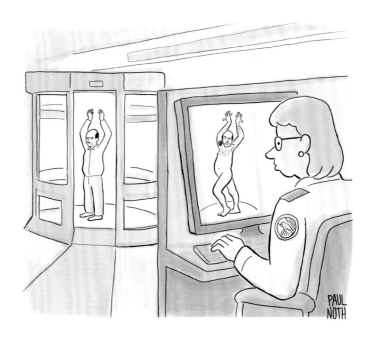

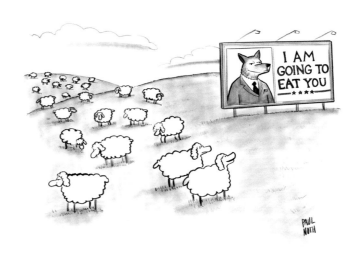

"He tells it like it is."

JOHN O'BRIEN

On *The Dick Cavett Show* in March of 1976, Charles Addams said of captionless cartoons: "I prefer them that way." John O'Brien's arrival in the August 3, 1987, pages of *The New Yorker* marked a near full-time revival of that kind of drawing. The last great captionless master before him was Nurit Karlin. And before Ms. Karlin, there was Sam Cobean and Otto Soglow. That I can name just these few tells you how rare a cartoonist it is who eschews the caption. I've long considered the captionless cartoon the most difficult type to perfect. Standing with John at a bar on Manhattan's Upper East Side some years ago, I opted to take a shot at understanding his pursuit of this kind of cartoon. Said I to John: "I don't know how you do what you do—it's so difficult." John replied (a perfect return volley): "I don't know how you do what you do."

And that was that.

It would be fun and awfully convenient for me to try to connect John's longtime summer job as a lifeguard (forty-five years with the North Wildwood, New Jersey, beach patrol) with his lifelong pursuit of drawing. Is there a connection? The first and only thing that comes to mind is this: lifeguards spend most of their time sitting, waiting, hoping something doesn't happen; cartoonists spend most of their time sitting, waiting, hoping something does. The connective tissue is identifying or spotting. For the lifeguard it's spotting trouble; for the cartoonist, it's humor.

Among the original *New Yorker* drawings I've traded for over the years, one I particularly treasure is

John's from the issue of October 9, 2000. The drawing perfectly combines stars and a soft drink. Most cartoonists, at one time or another, mash up two (or more) seemingly incompatible elements to see what happens. It's one of the building blocks of the trade. Often the result overtakes the humor; the drawing is so obviously constructed, the construction itself gets in the way of enjoying the piece. In John's work, the drawing itself and the idea supporting it are uber-sophisticated.

HE LURES YOU INTO BELIEVING THAT WHAT YOU'RE SEEING IS A NORMAL SITUATION, AND THEN . . . YOU NOTICE THE MASH-UP.

Another master of the visual surprise: the aforementioned Charles Addams.

There's a calm zaniness about John's work. His finished pieces somehow seem just right—as if they've always been there, waiting for John to spot them.

GEORGE PRICE
1901-1995

The geometric cartoonist George Price, who, in his sixty-two-year run at *The New Yorker*, contributed 1,279 drawings and one cover, drew as if each cartoon were a blueprint, a schematic; he fit lines together as if we, the reader, were intended to follow instructions. There isn't a stray line in sight, not one that looks improvised.

The lines themselves are peculiar: put a Price line under a microscope and you will see DNA-like strands—he did not accomplish a solid straight line—the lines are often split. They are sometimes abrupt, not flowing. And yet, when the piece was done, and published, it presented an illusion of smooth-as-silk draftsmanship.

Price was one of the great *New Yorker* artists who relied 100 percent on others' ideas for his cartoons. Of all his *New Yorker* work over all those years, only one piece, that we know of, was fully conceived of by Price himself: his *New Yorker* cover. And yet, the seams never showed in his cartoons. There were no indications we were seeing work built on others' ideas; he was a great interpreter. And so, it stung, but just for a moment, reading him criticize younger colleagues in a *New York Times* piece back in November of 1988:

"As a member of the magazine's old guard he speaks generously about the work of contemporary cartoonists, but feels 'their draftsmanship leaves much to be desired; although so did mine, when they began using my drawings.'"

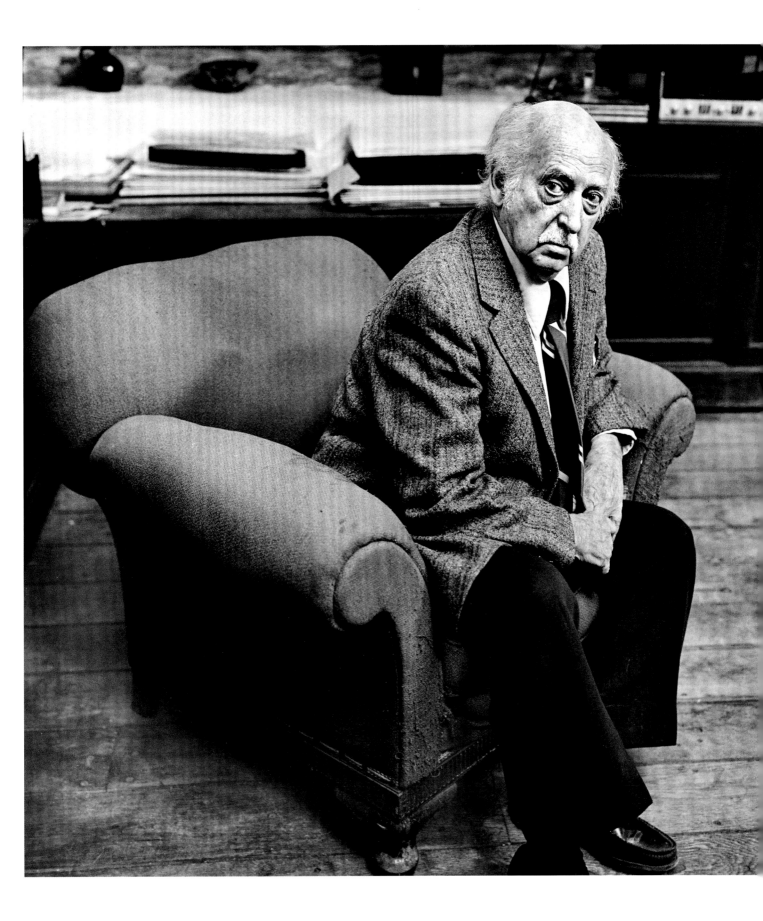

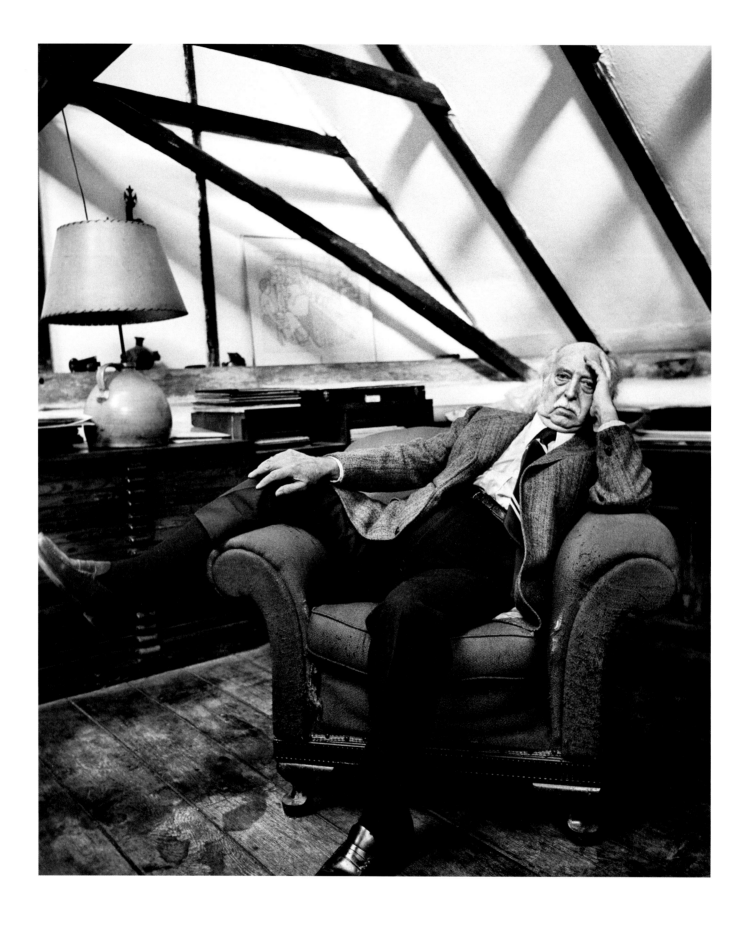

"Are we all ready for an energy survey by Con Ed?"

"Zero to sixty in seven point eight seconds."

In a way, he was reinforcing a long-held belief among a number of contemporary cartoonists that since Price was not pulling out his hair daily trying to come up with ideas, it freed up a great deal of his time to fuss over his drawings. I learned of Price's reliance on idea writers from, of all people, Lee Lorenz, who, it should be said, championed the idea of cartoonists writing their own captions. Lorenz also said, in a spot-on assessment, that Price was one of the magazine's great stylists, citing Peter Arno, Helen Hokinson, James Thurber, and William Steig as other greats. It's tempting to suggest that Price was the *New Yorker*'s greatest stylist. NO ONE DREW LIKE HIM, NO ONE EVEN APPROACHED DRAWING LIKE HIM; THERE HAS NEVER BEEN AN HEIR TO HIS STYLE. I focus on style more than substance in Price's drawings because his use of a "family" of characters was not unusual. They were an interesting bunch, but, I believe, our interest in them was enhanced by the way they were drawn and not so much by who these people were. It was Price's style that became as identifiable to the magazine's readership as *The New Yorker*'s mascot, Eustace Tilley. Price cornered the blueprint-like cartoon—it will forevermore be his.

AKEEM
ROBERTS

I haven't heard too many stories over the years of a cartoonist simply minding their own business, working away on a nascent career in one field having nothing to do with *New Yorker* cartoons, only to be discovered by the magazine's cartoon editor and eventually become one of the magazine's contributors.

If memory serves, it happened with Stephanie Skalisky back in the late 1980s when Lee Lorenz, then the *New Yorker* cartoon editor, came across her work in a gallery in California. When Lorenz began buying her work, she was, as Liza Donnelly wrote in her history of *The New Yorker*'s women cartoonists, "completely

surprised." She continued: "Cartooning was the last thing on my mind and especially not for *The New Yorker*." Ms. Skalisky went on to contribute cartoons as well as covers.

Fast-forward to 2018, and cartoonist Akeem Roberts is at a comics festival in New York City. He is standing behind a table of his work when the current *New Yorker* cartoon editor, Emma Allen, stops to explore his displayed pieces. Akeem remembers: "I believe I had [on the table] a copy of the *Corpus* anthology, the *Regular Show* 2018 comic special, and a short black-and-white comic called *Report* with a collection of some of my Instagram comics from 2018." As luck would have it, she later emailed him asking if he'd like to submit to the magazine. Mr. Roberts submitted drawings, Ms. Allen bought work from his first and second batches, and Mr. Roberts was on his way in a career he never really considered having. As he told the *New Yorker Cartoon Caption Contest Podcast* in a 2023 interview, until Ms. Allen showed interest in his work, "*The New Yorker* [was] not on [his] radar at all." He hadn't even read an issue.

With that in mind, it's quite something that Akeem's first *New Yorker* cartoon appeared, graphically, as if he'd been drawing that way for years. Cartoonists usually (but not always!) arrive at *The New Yorker* with a style in process, one that develops over time, but occasionally a newbie appears with a fully formed style. Akeem, who was working on multipanel comics until his initial *New Yorker* submissions, joined that small "fully formed" crowd with his "*You must be the super!*" piece, which appeared in the issue of July 8, 2018.

In the summer of 2021, Akeem, along with Victor Varnado, Jerald Lewis II, and Yasin Osman, PARTICIPATED IN THE HISTORIC EXHIBIT CARTOONING WHILE BLACK in Manhattan at Chashama—the very first exhibit by Black *New Yorker* cartoonists. Coming almost a hundred years after the founding of *The New Yorker*, it was obviously way overdue. In the magazine's earlier days, there was, as far as we know, just one Black *New Yorker* cartoonist, E. Simms Campbell, whose work appeared in the magazine from 1932 to 1942. It took until 2004 and the arrival of Emily Richards Hopkins for the magazine to begin publishing its second Black cartoonist. There is no one ready-made answer as to why it took so long for the magazine's stable to open up to diverse voices (and thus diverse worlds). The addition of numerous Black artists (Akeem among them) to *The New Yorker* in the past seven to eight years only enriches the magazine's comedic landscape.

"Don't worry, a lot of them don't stay ugly."

"You must be the super!"

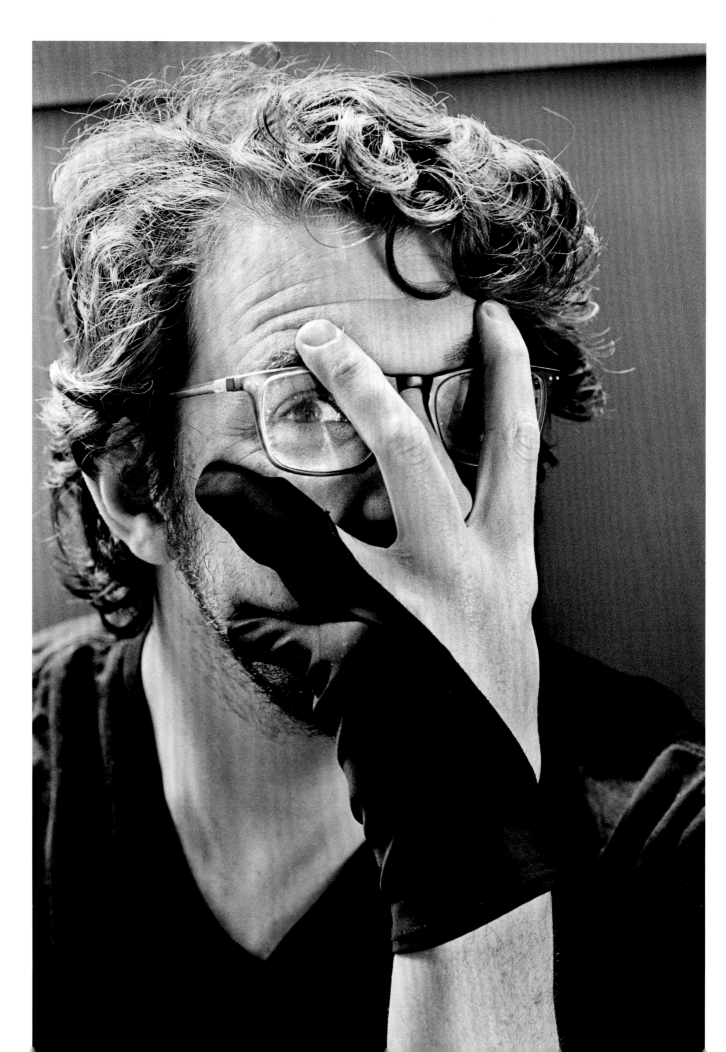

ELLIS ROSEN

Two thousand sixteen was a good year for *New Yorker* newbies. Fifteen cartoonists entered the fold, a number of which are included in this collection. Ellis Rosen was one of the fifteen. In his half dozen years of contributing, he's shown himself to be steady at the big wheel of cartooning ups and downs—in other words: he's consistent. Consistency may sound somewhat like an uninteresting quality—a simple thing—but in this *New Yorker* cartoonist biz it's anything but. It's not easy to hold on to one's style, one's—dare I say—sensibility, during this supercharged period we're in. Consistency isn't everything, but it's a big part of everything. It's especially difficult in the early years when the pressure to get a foothold at the magazine seems all-consuming (by the way, that pressure never lets up).

Ellis, in his understated way, has found a good place. His July 29, 2019, *New Yorker* drawing titled *Ned*

Helped Out is a standout drawing in which he has refined into a single drawing, society's perception of the "Me Generation." The drawing itself is not flashy—no big scene (although in another's hands it could've handled one). Ellis isolates Ned, who stands passively. We've no idea where he is—but it doesn't matter. What matters is what we see

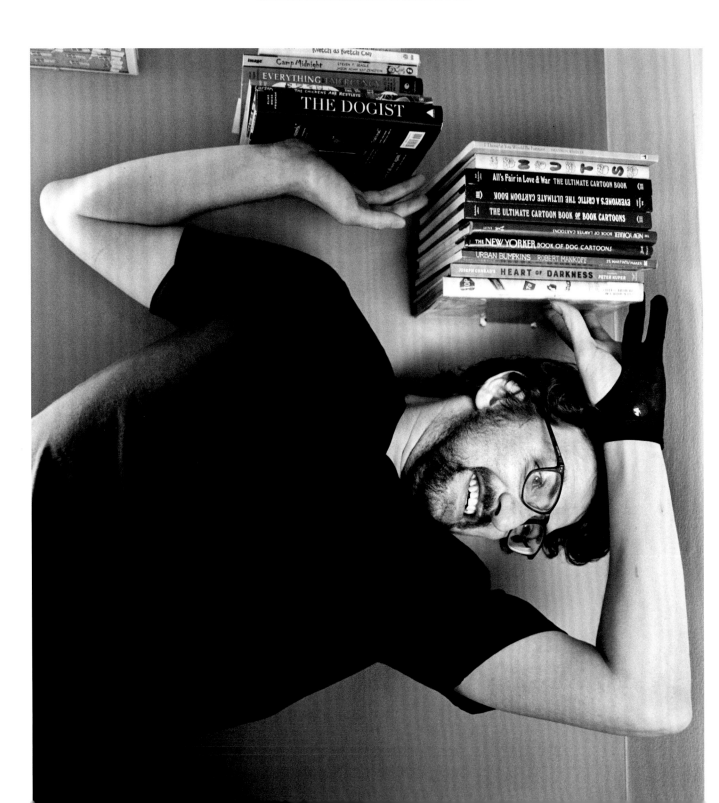

in Ned's thought bubble. There's a celebration going on. A big to-do with a banner and tossed confetti for Ned, who either has just used his carpet sweeper or is about to.

To meet Ellis is not to meet Ned—THE ARTIST IS NOT HIS WORK IN THAT WAY. HE (THE PERSON, NOT THE CARTOON FIGURE) SEEMS AN ISLAND OF BEMUSED CALM. If I could compare him, personality-wise, to any of the magazine's cartoonists, it would be Ed Fisher. Ed, one of the nicest *New Yorker* cartoonists ever, was steady through close to a half century's worth of cartoon contributions.

Not to overuse a word I've tossed around in this collection, but having one's "world" is, I believe, almost essential for staying power: staying power both as a contributor and as a cartoonist (cartoonist, know thyself!). Ellis's very interesting world has remained true. He is, I foresee, a career cartoonist.

Let me count how many *New Yorker* cartoonists I know of who had (or have) another job unrelated to cartooning—a *real* job, that is, not a stepping-stone job leading to what one believes will be one's life's work. There was Leo Cullum, who worked as a commercial airline pilot while contributing his cartoons to the magazine from 1976 through 2010. Ali Solomon and Edward Himelblau, two relatively new *New Yorker* cartoonists, are teachers. And then . . . there's Benjamin Schwartz, a doctor, who in 2011 turned into Ben Schwartz, *New Yorker* cartoonist.

Looking through Ben's *New Yorker* work (which includes a lot of Trump-era drawings), you'll notice a preponderance of Moses drawings, a lot of pop culture references (including *Star Wars*), doctors (of course), and some good old-fashioned single-panel funny cartoons, mostly tied into "the now."

The work tied into "the now" seems to be in the school of Mort Gerberg, who was drawing cartoons nearly half a century before Ben's work arrived in the pages of *The New Yorker*. Like Gerberg, Schwartz is a quick picker-upper of pop culture's low-hanging fruit, turning it into something we all (or most of us) will recognize as a cartoon of our time. Many cartoonists specialize in cultural fruit-picking—one might be fooled into thinking it's the road more traveled. I assure you it is not an easy path if it's well done. But Schwartz possesses a scalpel-sharp ability to blend "the now" with "the

BENJAMIN
SCHWARTZ

then" in a way that takes the work to an interesting place.

Though Schwartz's style is reminiscent of Gerberg's, there is another sensibility mixed in: not so much comic book as comic outline. Many of his drawings have a blurred background, with his figures set apart by a heavier line. The effect is Colorforms-ish—of a figure or object you could peel off the page.

If I were to select one of Ben's drawings from his body of work to focus on—and look at me: I am!—I'd

call your attention to his *New Yorker* drawing of May 27, 2013, *"I'm afraid it's two, three months, tops, before you're all pants."* Here is a drawing that could've been done by Arno or any of the *New Yorker*'s grand masters. It's what's called an evergreen. This drawing will amuse and resonate for as long as there are fellows wearing their pants way too high up.

When I asked Ben if he wouldn't mind SHARING HIS INFLUENCES, HE REPLIED, "SOME OF THE FIRST NAMES THAT CAME TO MIND THIS TIME: AL HIRSCHFELD, PETER ARNO, GARY LARSON, BERKELEY BREATHED, BILL WATTERSON, MATT GROENING, Tex Avery, Steve Ditko, John Byrne."

Notice the preponderance of comic book or comic strip influences, with only one influence from the *New Yorker* school: Peter Arno. For a cartoonist, influences aren't what you wear around town for all to see—they're more like undergarments. And that's the case with Ben's work. If there's some Arno and Hirschfeld in his drawings, I don't see it, but that's really the way it ought to be—no one wants their work to be thought of as a carbon copy. As with so many of the subjects photographed for this book, the style they present to the world through their cartoons is theirs alone. The mountain of influences that led them to their style remains invisible.

"Aw, man, that's never coming out."

BENJAMIN SCHWARTZ **167**

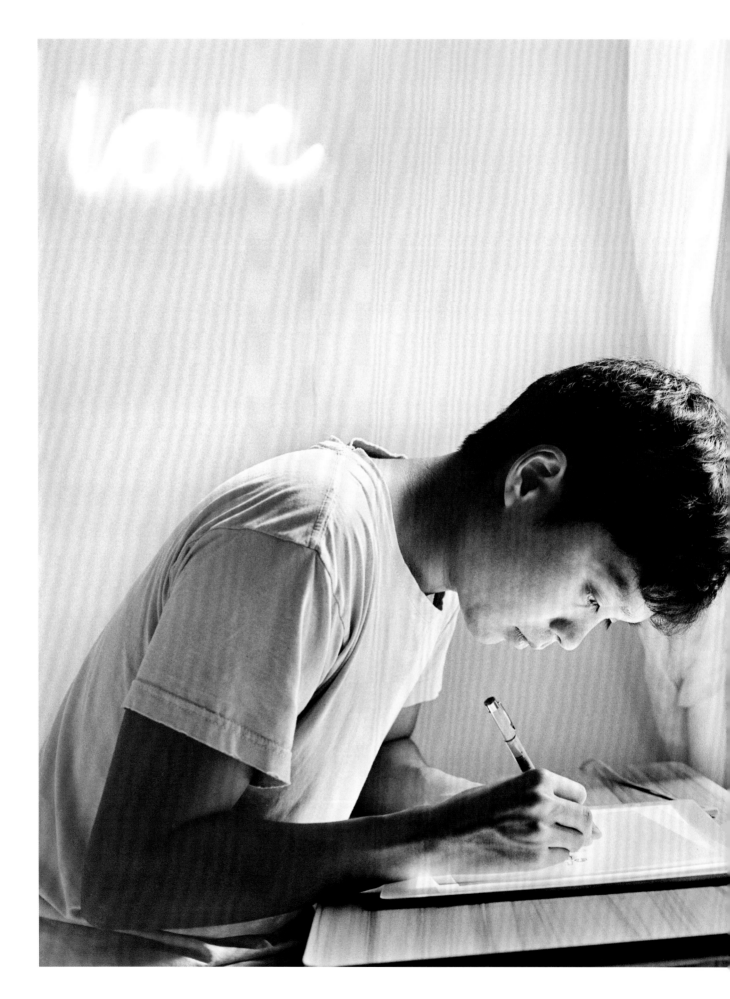

Like so many of his colleagues, Justin Sheen drew as a kid, reading and enjoying newspaper comics. (*MAD* magazine, so often cited by *New Yorker* cartoonists as a gateway publication to their later interest in cartoons, never enticed him.) When he decided to submit to *The New Yorker*, he spent "nine months" doing "ninety cartoons" before the magazine's art department door swung open. His first drawing—an accomplished piece—"*I wish we had an in-ground moat,*" appeared in the issue of April 6, 2020.

Style, for a cartoonist, is potentially a loaded subject. I once asked the late great Mischa Richter how Peter Arno may have influenced his earlier work (I asked because it obviously had). Mischa practically roared: "He had no influence on me at all!" Whereas Roz Chast will tell you, without hesitation, that Charles Addams's work was a huge influence. As with Ms. Chast, it's refreshing to hear Justin easily list his early influences, like Kanin, Steed, and Finck. As I chatted with him one day, he defined his own work as a "flat diagrammatic style." My ears perked up: *Ah, a new way to talk about how cartoons look on the page*. Justin suggested that that usage had to do with his background in science ("But I don't do chemistry anymore"). When I asked him to elaborate, he said he wanted to "see all the pieces [in the drawing]—nothing extra." His *New Yorker* drawing of August 3, 2020, "*Do you have any more eggs I could borrow?,*" perfectly captures and expresses that desire. It succeeds as is—we don't really need to see more than what he's shown us.

His college years spent hovering around poetry and short stories (as well as "long involved stories") show an interest in language that serves him well as a cartoonist. AS DOES HIS INTEREST IN MUSIC, WHERE HE WAS ESPECIALLY INTRIGUED BY "THE CLEVERNESS OF A SONG." There's a clarity and easy flow to Justin's captions. One of the younger *New Yorker*

JUSTIN SHEEN

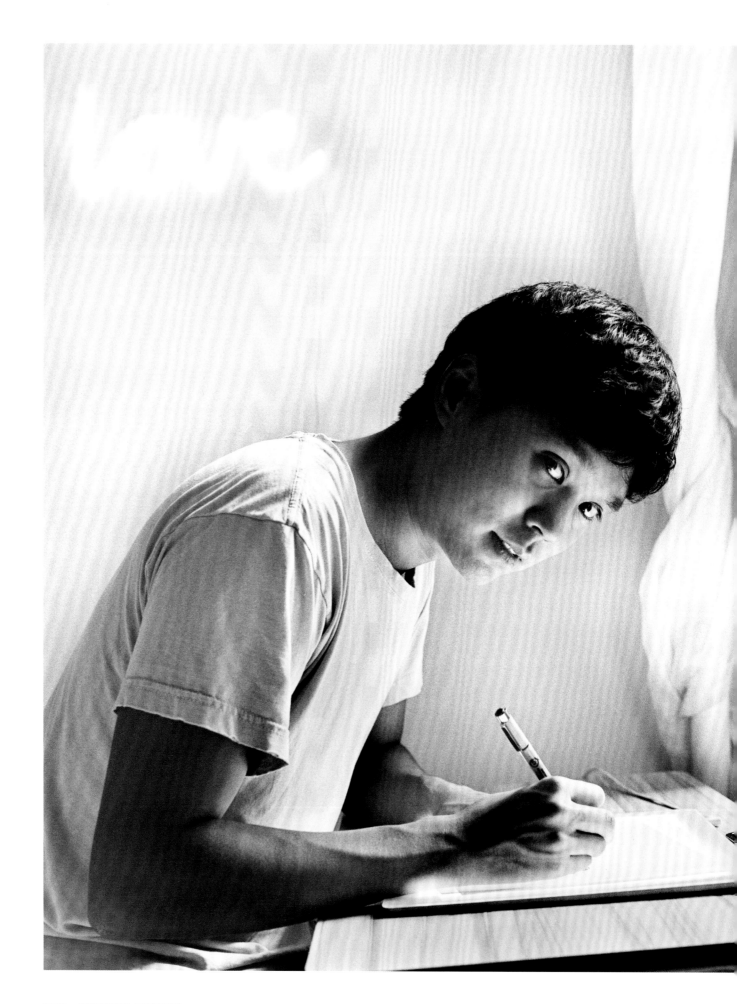

contributors, he readily acknowledges being "in a transitionary period," which, for a cartoonist, is actually a lifelong thing. Impressionable beings that we are, it's hard to stay put, though some of us do just that: stay put graphically.

Speaking to him about his photo that appears here, and his workspace, I asked if that is how he works, on a small desk in a sparse setting. I mentioned how so many cartoonists have Superman figurines or cartoon knickknacks around their desks. He replied that it is pretty much how it looks (the photo was taken a few years ago), but that there are now more things nearby. He paused, then said: "I have to get some action figures."

"I wish we had an in-ground moat."

"Hey, I got married."

David Sipress's drawings seem on their way to collapsing; the scritchy lines of varying widths appear in need of adhesive tape to hold the whole thing together. But the truth is: the drawings work just fine, thank you, without tape. There is an air of expediency about the lines, as if the artist is afraid the ink in his pen will blob out onto the paper at any moment; the quicker the drawing is laid down on paper, the better.

In person, the effect is the opposite. Mr. Sipress will glide toward you at a party, holding his drink glass with two hands, his face expectant, smiling. This will be a pleasant, fun chat. There's no rush to say a few words and move on. No, we can settle into a small discussion until another partyer—as in a dance—cuts in.

Few cartoonists (that we know of) waited longer to realize the childhood fantasy of being published in *The New Yorker*. It took Mr. Sipress twenty-five years before he was handed the golden ticket, otherwise known as an "OK."

Mr. Sipress has left a paper trail of an autobiography on the web, and more recently, a published memoir. Here is moment number one that pertains directly to what he hoped his future would be when he was a child:

"My fantasy as a child was always to be a cartoonist—maybe a cross between Don Martin and Saul Steinberg. And to be published in the *New Yorker*."

—From the blog, *A Case for Pencils*

Moment number two: If you ask cartoonists to talk about their work, most will try to change the subject, or go very deep but on a confusing path. But Mr. Sipress has been exceptionally concise: "Many of my cartoons are about—directly or indirectly—perceptions of shared human experience that are rooted in my lifelong love of history."

DAVID SIPRESS

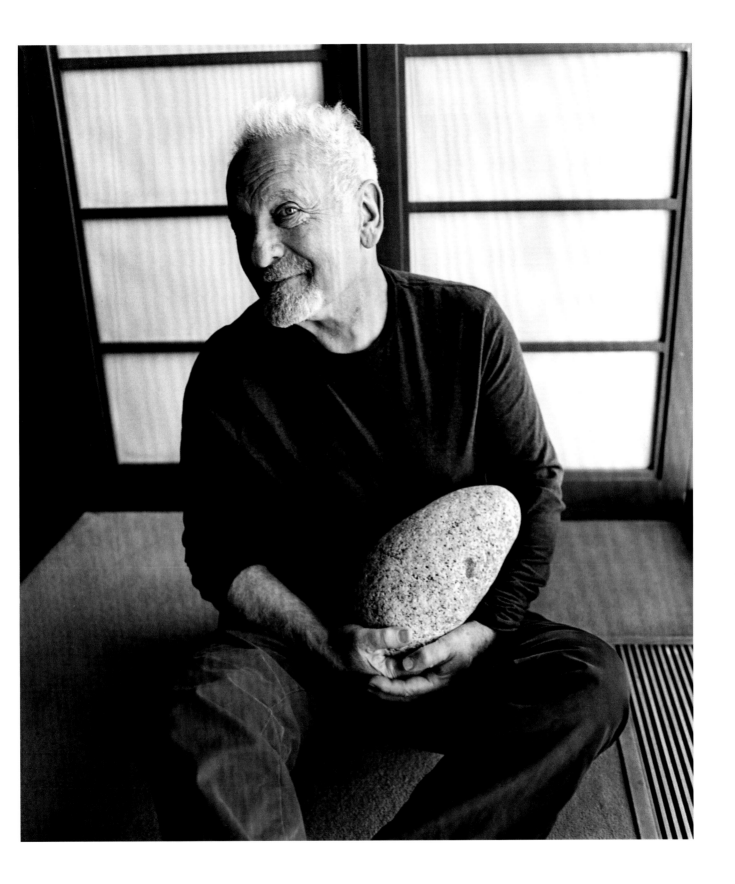

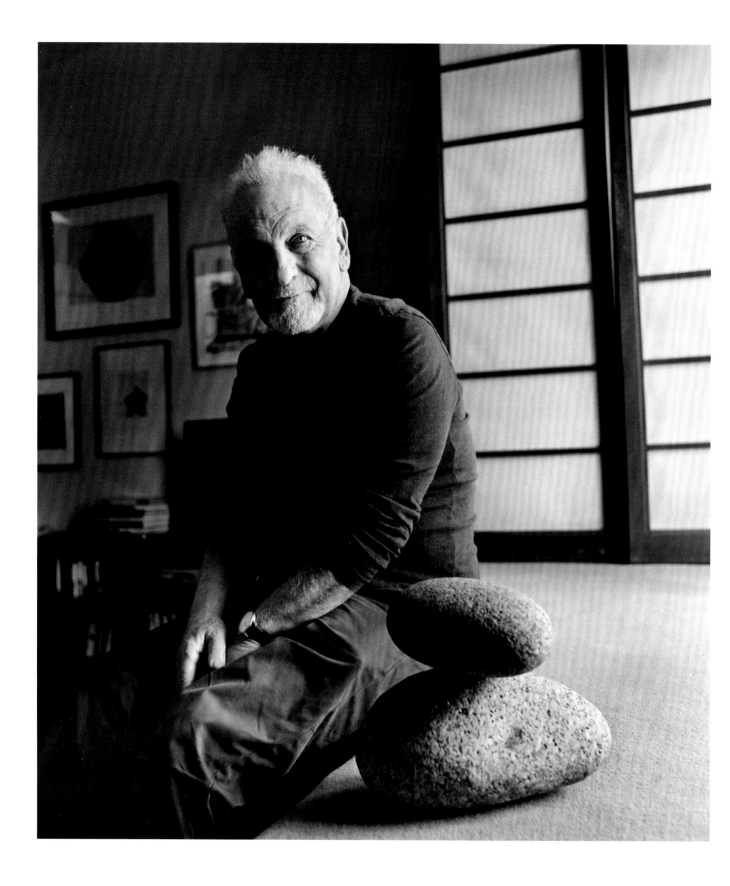

The New Yorker has always published cartoonists who are in the real world; they balance out the cartoonists off in private worlds. WHAT *NEW YORKER* READERS SEE WHEN THEY COME ACROSS A SIPRESS CARTOON IS A DRAWING ALMOST ALWAYS TIED IN TO THE MOMENT. It may, for instance, be set in the Middle Ages, but it is undoubtedly bouncing off something trending in the news. Sipress has become one of our everyday chroniclers, following in the grand tradition of some of *The New Yorker*'s past masters, James Stevenson and Alan Dunn.

Perhaps all cartoonists are, using a cartoon metaphor, icebergs. What we see of them and their work is truly a fraction of it. What sets Sipress's work apart is that he's invited us to swim along with him below the surface.

"Remind me what I was talking about—I wasn't listening."

"What should I say this is about?"

BARBARA SMALLER

There were no cartoonists added to *The New Yorker*'s stable in 1995, and just one in 1996: Barbara Smaller. Ms. Smaller, Chicago born but a longtime New York City resident, arrived at the magazine nano-months before a change of cartoon "gatekeepers." Lee Lorenz, in his last year of a twenty-four-year run as cartoon editor, brought her work into the magazine; she's been publishing in *The New Yorker* ever since. The first Smaller cartoon that appeared in the magazine did not necessarily herald what was to come (a sign in a window

announcing "Only 1,248 Shopping Days Till The Millennium"). It was her second drawing (and her third, fourth, and so on) that provided the blueprint—a postmodern use of language and a sensibility that Bruce Eric Kaplan had perfected in *The New Yorker* five years earlier than Ms. Smaller's debut.

Barbara credits a book, *How to Draw Cartoons*, with jump-starting her cartoon career:

"I'm a big believer in books, so I decided that was how to do it. I came up with a bunch of jokes and drew all these cartoons, and it was so obvious that that's what I should do."*

Unable to pin down the possible roots of Barbara's drawing style, I went to the source: her.

"When I was sixteen, I ran across a book with an oddly succinct title, *Men, Women and Dogs*. This book was, of course, a collection of drawings by the great James Thurber.

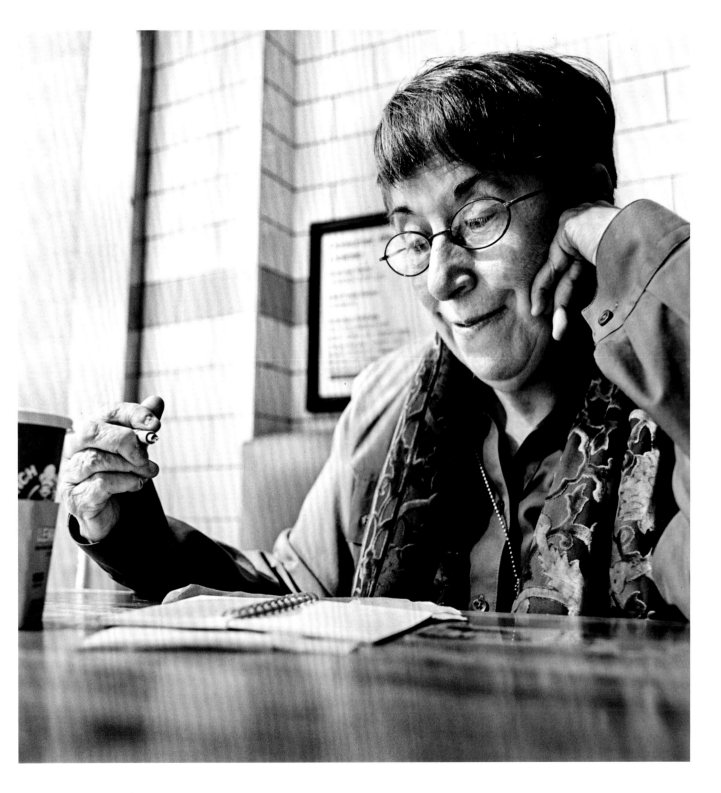

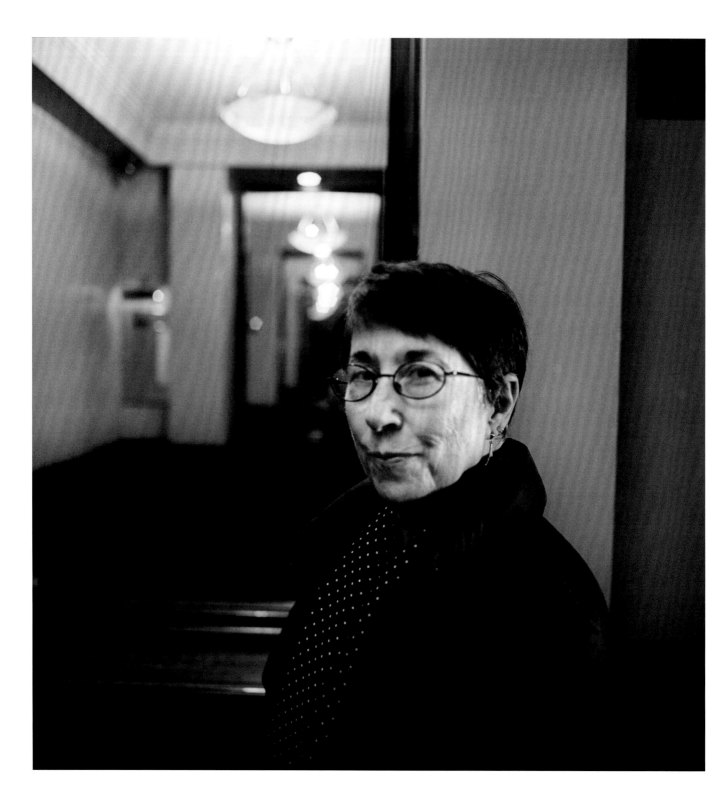

FOR SOMEONE WHO ONLY KNEW CARTOONS FROM THE FUNNY PAGES IN THE NEWSPAPER AND THE NEW YORK POST, it was a revelation. Later, as I became familiar with *The New Yorker* and spent time poring over the cartoon annuals, I found I was especially attracted to the work of George Price, Charles Saxon, and Helen Hokinson. I think primarily due to their fully realized drawings and the humanity of their characters. Lee Lorenz introduced me to Mary Petty, who was very influential because of her drawing style and her themes. Lastly, I must add George Booth, because who knew there could be so much comic timing in a panel cartoon?"

And so there we have it. Like so many cartoonists, her influences are many, with a few standouts that influence more than others.

*"Meet the Artist: Barbara Smaller," *The Cartoon Bank Blog*, October 29, 2009.

"I can afford to die or I can afford to be sick, but I can't afford to be sick and then die."

"No, I can't give any of them away—they're part of a collection."

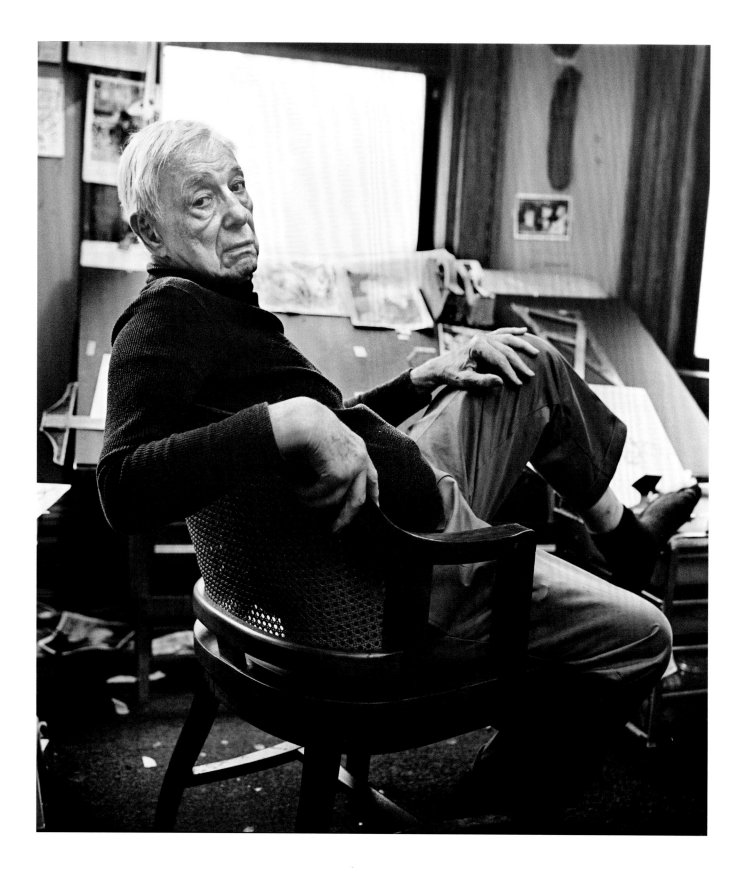

EDWARD SOREL

Ed Sorel has spent well more than six decades inking paper with graphic authority (an early Sorel collection is appropriately titled *Superpen*). He is one of the few modern *New Yorker* artists who easily and convincingly fills a page with his art and, often, his take on our world; the printed page barely contains Ed's energetic and enthusiastic strokes. William Grimes, in a 1993 *New York Times* profile of Ed, called him inarguably "one of America's foremost political satirists."

It has been my great pleasure to know Ed for the past fifty-five years and watch him rise from "one of America's foremost political satirists" to icon, as he planted his graphic flag atop the magazine world's Mount Everest, otherwise known as *The New Yorker*. Tina Brown, hired to succeed Robert Gottlieb as editor-in-chief of *The New Yorker*, fell in love with Ed's cover submission of a punker in a New York City hansom cab, running it on her debut issue. It was a boffo moment for all concerned parties.

Of the numerous other Ed Sorel highlights, his Frank Sinatra *Esquire* cover comes to mind, as do his wonderful, ofttimes autobiographical strips for *The Nation*. For a panoramic view of his life, best to read his memoir, *Profusely Illustrated*.

Not to be found in his memoir are a few Ed Sorel moments I'll never forget:

. . . In 1993, walking into the Society of Illustrators for the opening of a one-man show of Ed's work and spying Ed amidst a colorful, grand swirl of family, friends, and colleagues. I'd never seen him happier. The celebrated artist at his peak.

. . . A few years later, I sat near a roaring fire in the living room of an old Connecticut home as Ed and his dear friend Jules Feiffer bantered as very good friends do. I kept quiet as they rolled along, teasing each

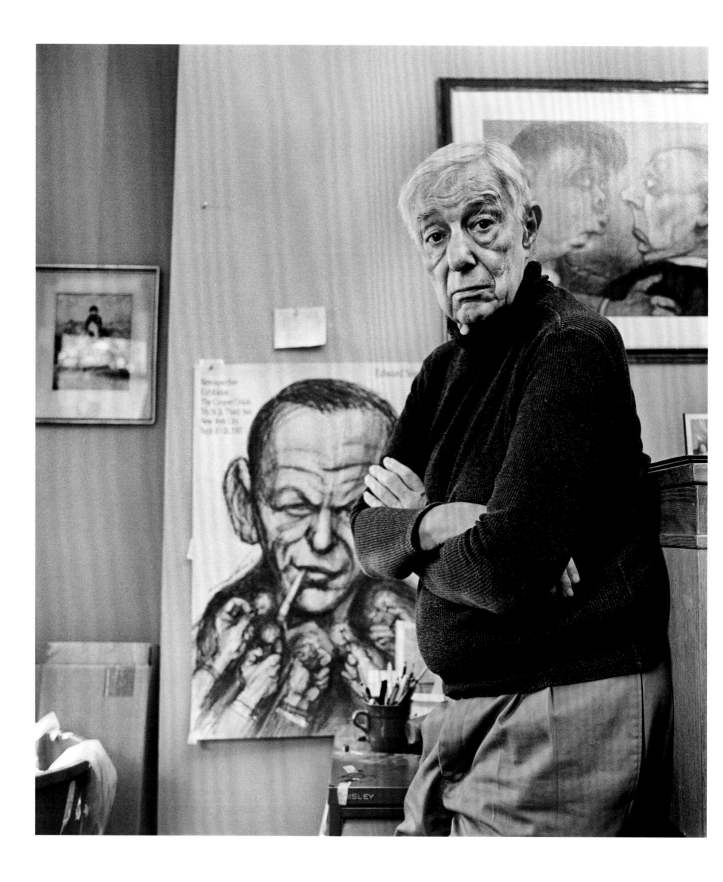

other, engaged in ironic bravado; for me, a most wonderful fly-on-the-wall experience.

... Standing in his upstate New York studio as he walked around pulling books off of shelves. "YOU SHOULD HAVE THIS," HE SAID AS HE HANDED ME A COPY OF FRANS MASEREEL'S *THE CITY.*

It was not lost on me that one of the greatest caricaturists of our time had handed me a book of work by an artist beloved by Peter Arno, the greatest caricaturist of the early twentieth century.

As I write this, I'm recalling a conversation with Ed not long ago. Now ninety-four, he was talking about getting a few folks together at his home. It's something he's been doing for years—bringing artists and writers to his home for a lively lunch or dinner. Then he began talking about *The New Yorker* and *New Yorker* covers. "I have one I should work on," he said.

"On the other hand, the examined life doesn't seem to produce much income."

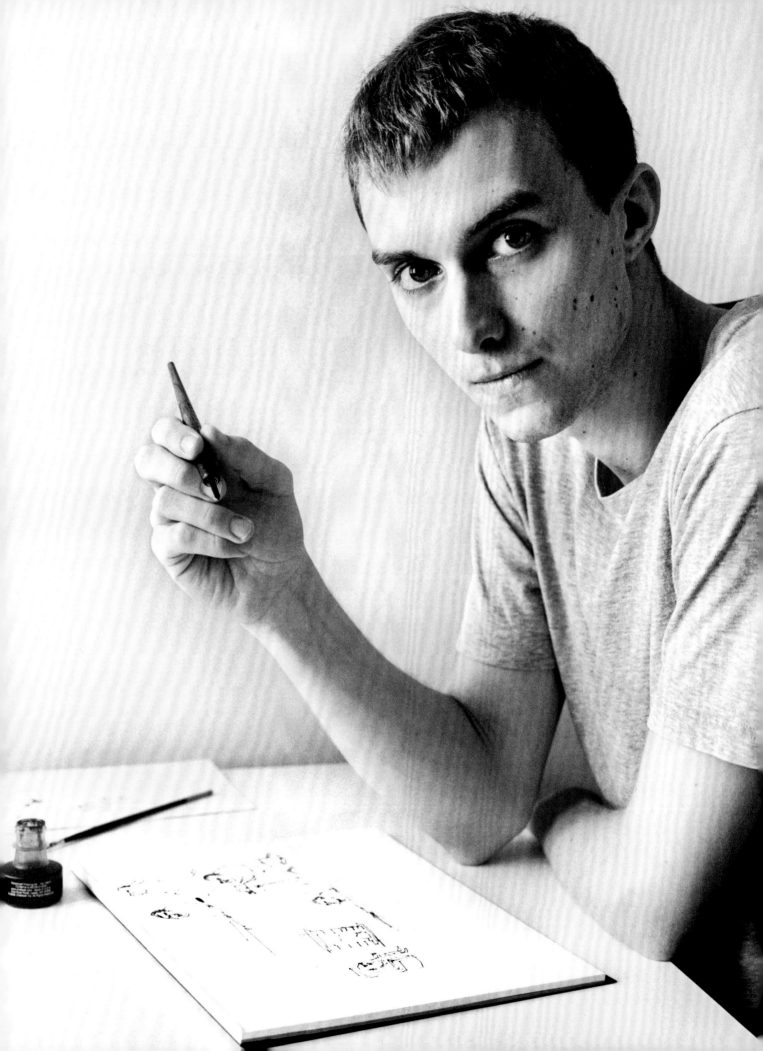

There's a lot of blatant Sturm und Drang in Ed Steed's work; there's a fair amount of bloodletting, too. You don't expect that, or maybe you wouldn't expect it if you'd met him.

His journey to *The New Yorker* was perhaps not unusual—being that he's English, it just took more miles than most to get there. In 2014, less than a year after he began his *New Yorker* run, he told me how he came to the magazine:

"I discovered *New Yorker* cartoons recently, just a couple of years ago. I saw them online and decided I would like to do that too. I hadn't been interested

EDWARD STEED

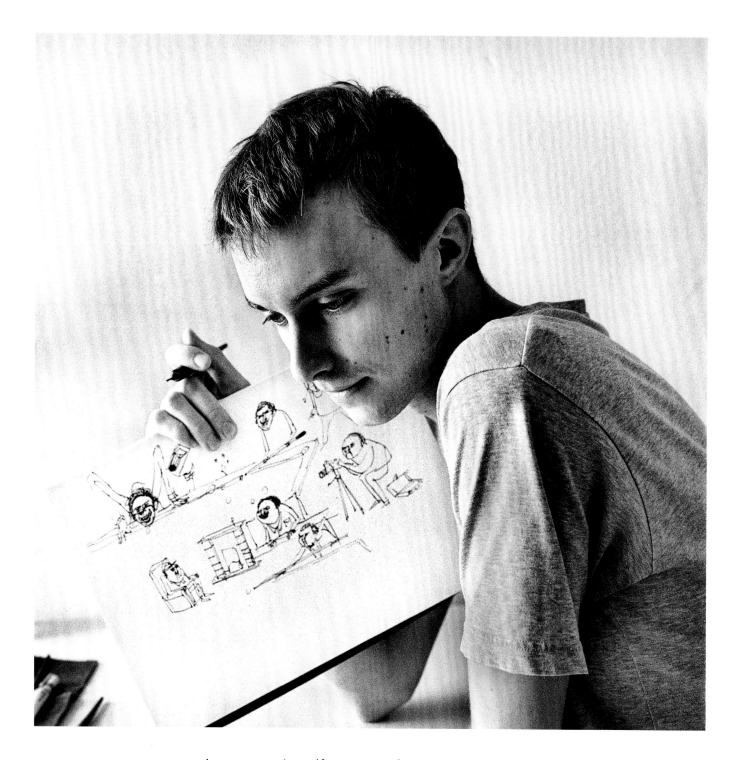

in cartoons since I'd outgrown the
stuff I looked at when I was young,
but these were clearly different.
I started writing down ideas
straightaway. When I had a bunch
of what I thought were good ones
I sent them in."

The "good ones" are humor-
ous night-lights glowing in a dark-
ened hallway. He takes on, like all

his colleagues, the desert island, the sidewalk robbery, the police lineup, superheroes— BUT HE ISN'T SATISFIED WITH THE STANDARD SCENARIO AND A GOOD CAPTION; HE'S BROUGHT SOME MEASURE OF UNEASINESS TO THE PAGE.

All cartoonists offer up a stew incorporating shifting ingredients. Steed's contains teaspoons of Ralph Steadman (without the splashes of ink), Edward Gorey, Gahan Wilson, and Charles Addams. In other words: work that doesn't lightly amuse.

And then there are the occasional freewheeling graphic essays appearing on the *New Yorker*'s website. In one, he visits Chairman Mao's tomb in Beijing. Not able to draw on-site, he memorizes while visiting, then, later, commits to paper what he remembers. He returns again and again to see Mao and memorize until he's filled in the details. It's like a short silent movie.

Steed's people—his cast of characters—are cramped folks. It might take a lot of looking to find one with a neck. Their circular heads sit tight to their shoulders. Their faces feature scrunched eyebrows, grimacing mouths, and scritchy-scratchy hair. These people seem perfectly content in the world Ed's created for them.

"Don't be fooled—they're faster than they look."

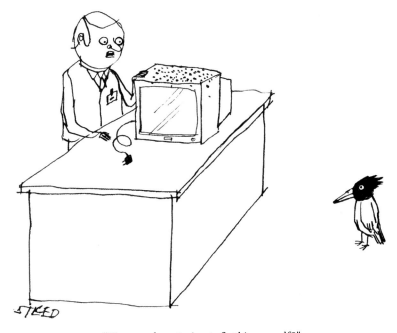

"Have you been trying to fix this yourself?"

PETER STEINER

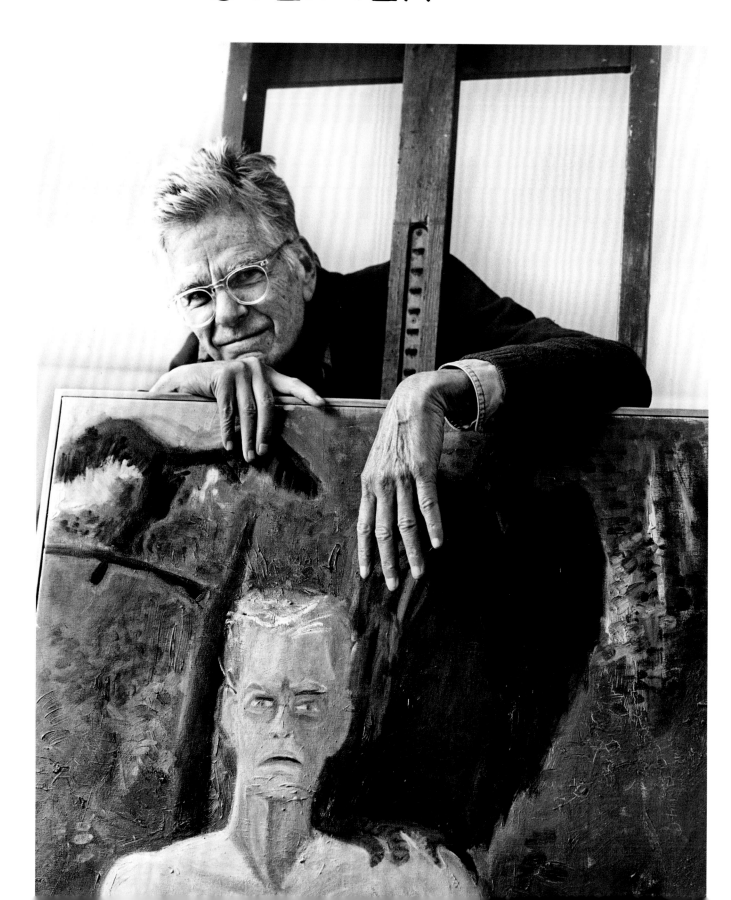

Peter Steiner has one of the best and wisest laughs in the *New Yorker* cartoon world. When given the opportunity to do so, he puts his all into it. It's a wonderful thing to see and hear.

Much like his laughter, Peter's approach to his work life has been a delight to witness over the forty-some years I've known him. But you don't need to know him to enjoy his *New Yorker* work, or his novels and paintings. These three prongs of his creative life seem an ever-revolving wheel. Peter stops the wheel and digs into his next novel. With that done, he spins the wheel and stops it at painting, and so on. I don't know how many times I've asked him, once a new novel is on its way to being published or he's completed a series of paintings, "So, what's next?"

On a recent visit to his studio, we stood near crates of portraits he'd done a few years back. A stack of his latest book was near a window. I asked him how many portraits were in the series. Fifty? Sixty? He answered, "Well over a hundred." Cartoons are a constant thread through his work life; he posts an online cartoon semiregularly under the heading *Hopeless but not Serious*. In his studio is a tall cabinet with glass doors through which you can see stacks and stacks of drawings. I asked if those were his original *New Yorker* drawings. He replied, "No, I don't even know what's in there." With the exception of the late Sam Gross, I bet that any *New Yorker* cartoonist who has been contributing to the magazine as long as Peter can relate.

The New Yorker has published the work of just over seven hundred cartoonists. One might think that out of all the work these artists produced, more than just a few specific drawings would capture the reading public's fancy. Charles Addams

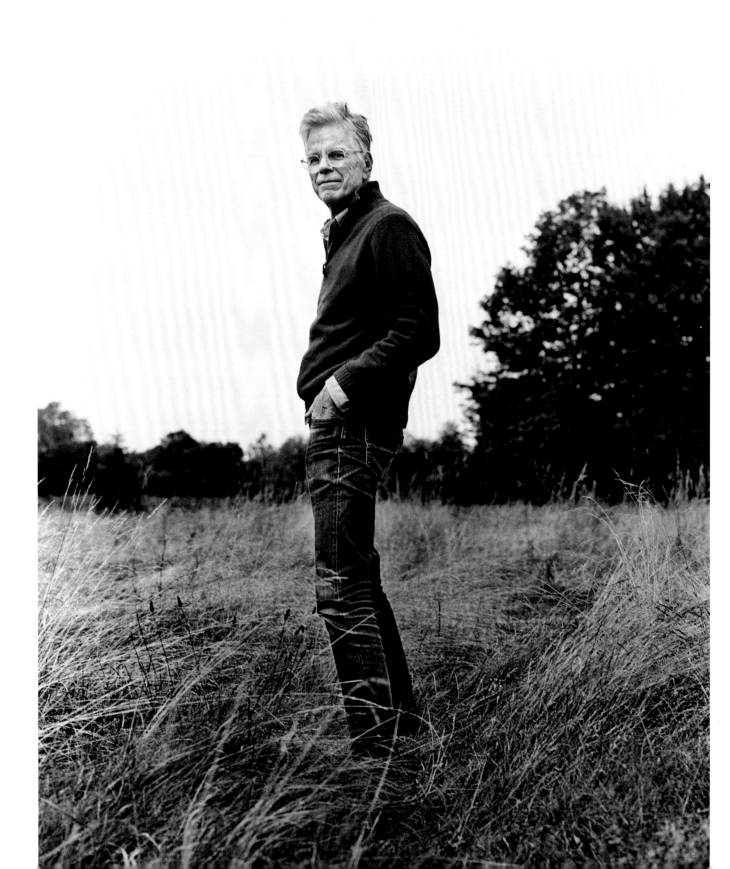

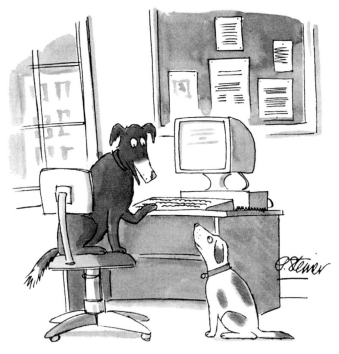

"On the Internet, nobody knows you're a dog."

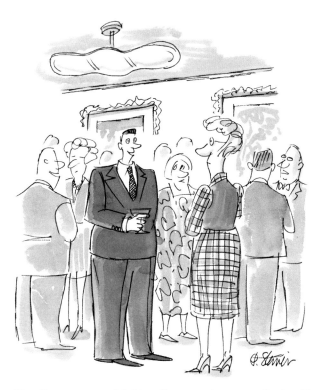

"Smaller, more powerful chips allow me to have a smaller head."

produced at least two (the skier around the tree, and the pot of boiling oil about to be poured on unsuspecting Christmas carolers). Other drawings, or at least captions, that have remained in the cultural consciousness include Peter Arno's *"Well, back to the old drawing board"* and Bob Mankoff's *"No, Thursday's out. How about never—is never good for you?"* AND THEN THERE'S PETER'S *"ON THE INTERNET, NOBODY KNOWS YOU'RE A DOG."* Steiner's internet dog and Mankoff's *"How about never?"* have sparred for decades for the title of most reproduced *New Yorker* cartoon ever. I'm not sure there's any point in declaring a victor. Let's just say they've both achieved a special place in the *New Yorker* cartoon canon and leave it at that.

Peter's reverence for the master artists of *The New Yorker*'s golden age is apparent in his work. His captions zing and bounce naturally—as captions ought to—off his crisp drawings. You don't "see" the effort in the work; as all successful *New Yorker* cartoonists know, you're not supposed to.

MICK STEVENS

Oregon-raised Mick Stevens's first *New Yorker* drawing appeared just as time had run out on the 1970s. That first drawing, *Life Without Mozart,* a terrific debut, was published in the issue of December 17, 1979. It followed, by approximately five years, the debut of Jack Ziegler's work. These two artists would become very good friends, buddies, and—as far as their work was concerned—cartoonists-in-arms. One cannot think of Mick's work without also thinking of Jack's. In a written piece contributed to Lee Lorenz's *The Essential Jack Ziegler* collection, Mick wrote of Jack: "I loved his stuff. He was the last artist I tried to imitate." And in a 1989 article in *The New Haven Register,* Mick credited Jack for "opening the door at *The New Yorker* to his type of humor."

Describing cartoons is not one my favorite things to do, but, oh alright, I'll take a swipe at describing Mick's work anyway. His style comfortably fits the Henry Martin classification of cartoonists who "draw funny." My bet is that readers are more than halfway to a laugh just by laying eyes on one of his drawings. His cartoon playground is stupendously large (conjuring up a stupendously large playground is in itself somewhat Stevensesque). Cartoon conventions (some call them "tropes") are but vehicles for his off-the-wall, offbeat, off-center, off-kilter (you get the idea) comedic master strokes. A few for instances: Two fellows are on a desert island. One walks off the island only to find

194 MICK STEVENS

solid ground, not water. He turns to his desert island companion and says, *"Hey! Guess what."*; the freshly shorn caveman exiting a barbershop cave; the cat wearing mouse ears waiting patiently by the mousehole doorway. Each drawing is infused with a particular kind of innocence;

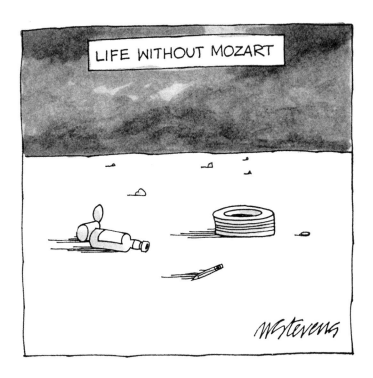

STEVENS'S CARTOONS DO NOT PERPLEX US, NOR STRESS US OUT—THEY WERE BORN TO AMUSE. IN MY TOO-MANY-TO-COUNT INTERACTIONS WITH MICK OVER THE YEARS (WE'VE KNOWN EACH OTHER FOR OVER FOUR DECADES), I WOULD ARGUE THAT HE TOO WAS BORN TO AMUSE. In public, he usually seems at the ready to laugh, or, in his case, chuckle—he's a chuckler. He is also a world class quipster. In conversation, he is often the first to identify comedic prey and pounce on it.

It's interesting that the first Stevens *New Yorker* drawing was anchored in music. Interesting because another of his passions is playing the saxophone. Back in 2010, on the blog *David Wasting Paper*, Mick was asked what he'd do if he wasn't an artist. He replied: "Play the saxophone in Grand Central Station and become a legend."

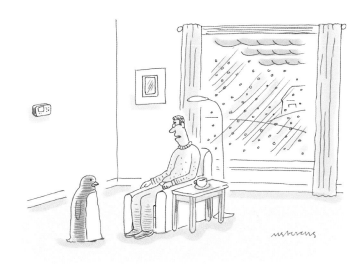

"Can we please not have the same old argument about the thermostat?"

TOM TORO

Tom Toro's road to *The New Yorker* was littered with rejected cartoons. Some of the magazine's artists submitted just once and were given the golden ticket, while others struggled for years. In Tom's case, we know the exact number of his rejected cartoons: 609. No other cartoonist, as far as I know, has ever accounted for their strikeouts so precisely. Once cartoon number 610, a bowlegged cowboy, was greenlit in 2010, Tom was on his way, as much as one can be in this pursuit. In an interview a few years ago, I asked Tom about the rejection that is a huge part of this cartooning life:

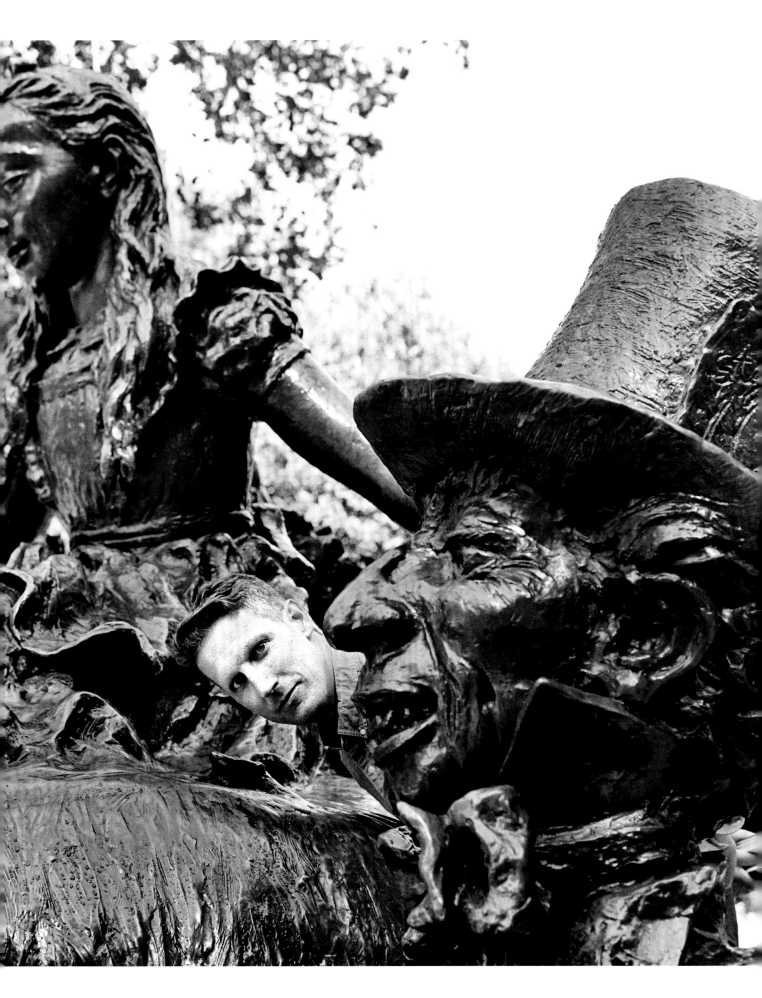

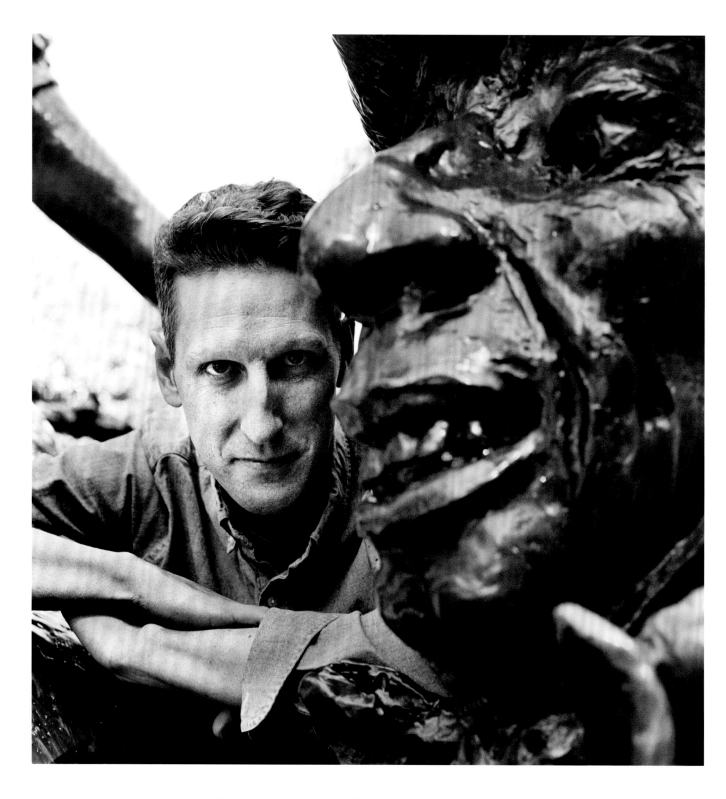

MM: I wonder if the struggle is part of the fuel for us. In other words, would working be less interesting if it was all green lights ahead?

TT: We're all flagellants to a certain degree. I think the rejection and suffering is a perversely attractive part of the job. If anything, it forges a community of survivors.

We're all pushing that boulder up the hill together, shoulder to shoulder, over and over and over again."

As the reader of these essays will know by now, success as a *New Yorker* cartoonist is usually due to a cartoonist's finding a world and, within that world, a voice. Tom's work

does not look like any work that has appeared in the magazine. He has, like most, if not all, of his colleagues, absorbed his inspirations and given us something new. HEARING THAT CHARLES ADDAMS IS, IN TOM'S WORDS, HIS "IDOL" CAME AS A COMPLETE SURPRISE. He said to me: "If I can even get close to touching the furthest reaches of [Addams's] cartoon cosmos, I'll be a happy camper."

And therein lies the beauty of what we *New Yorker* cartoonist folks do. The cultural currents continue to course through our work. Our intent is not to settle in but to keep moving. There is, in Tom, a determination that stokes his cartoon world. I do believe we are only beginning to see the comic fruits of his labor.

"Find a patch of sunlight, my boy.
Find a patch of sunlight and bask in it."

"Wow—she is stunning."

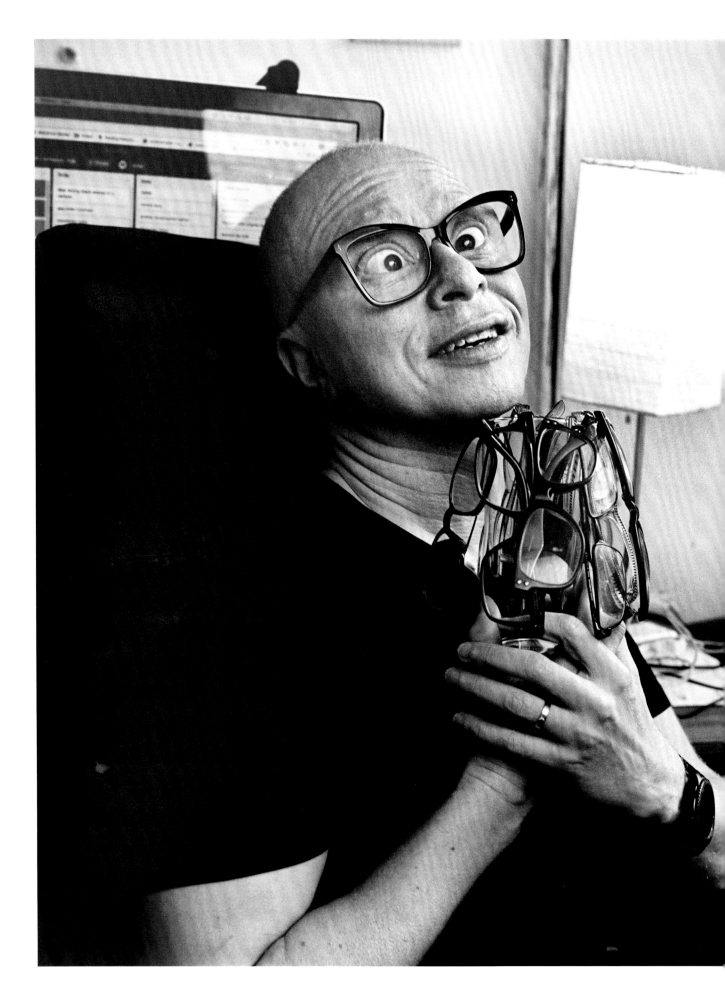

VICTOR VARNADO

Victor Varnado, who, in 2021, organized the very first exhibit by Black *New Yorker* cartoonists, considers himself an "accidental pioneer." He told me at the time of the opening of *Cartooning While Black* (the exhibit included work by Victor as well as Akeem Roberts, Yasin Osman, and Jerald Lewis II):

"I didn't set out to make the first all-Black *New Yorker* cartoonist gallery exhibit in history. I initially wanted to create an event to promote my book and theorized that filling out the ranks of the show would be a good idea since my fame is marginal at best. Since *The Anti-Racism Activity Book* was about—you guessed it—racism, I thought asking other Black cartoonists would be a good idea. As I was working on the press release, it dawned on me what I had done. I was both happy something momentous had been created and saddened such an occurrence was unusual."

Victor is an actor and stand-up comedian as well as a cartoonist.

Speaking on his podcast about doing cartoons, he likened it to doing improv: "In improv you're always dealing with a situation." And that's exactly right; cartoonists are always dealing with a situation (a situation, it should be said, that they've gotten themselves into, graphically speaking). Resolving the situation is the cartoonist's challenge and reward.

Victor's path to getting his foot in the door at *The New Yorker* took somewhat over a year. I've always thought of that pre-acceptance period, however long it takes for individual cartoonists, as a sort of apprenticeship. Some apprenticeships take longer than others—we know of cartoonists whose work was accepted on the very first submission, and we've also heard of the apprenticeship taking twenty or more years.

His very first drawing was of an older fellow sitting next to a younger man at a counter saying, "I hope you're ready for some unsolicited and shortsighted advice,"

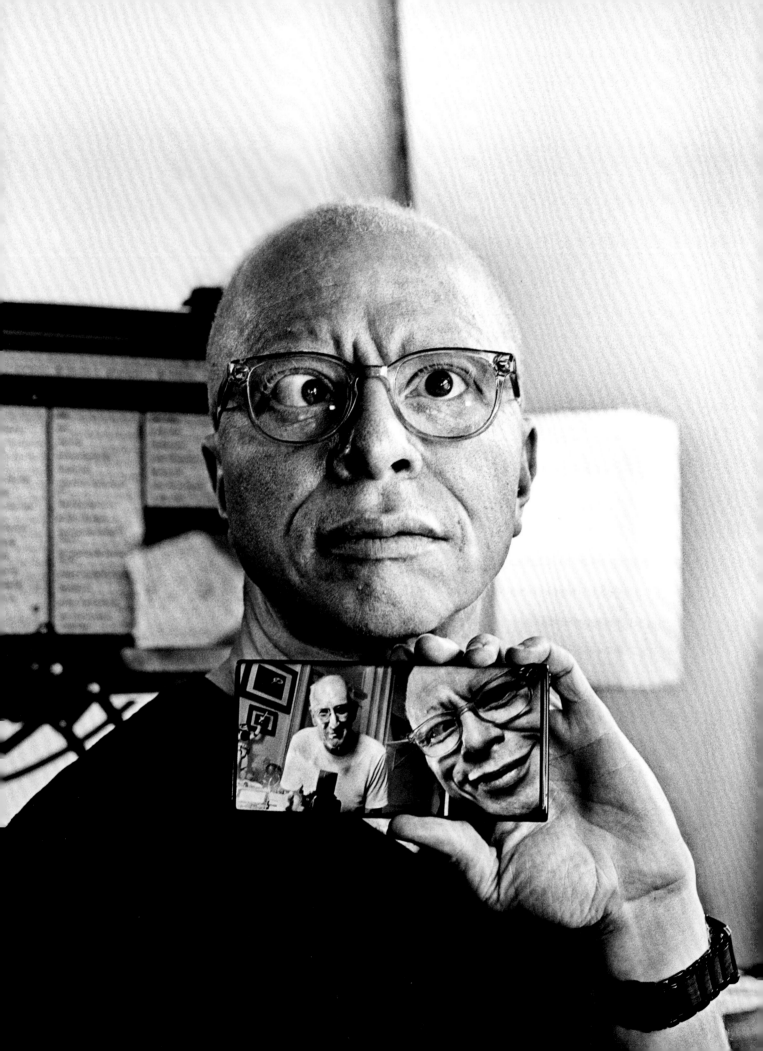

which appeared in the July 8, 2019 issue. Not immediately seeing any direct influences in his work (sometimes I can, sometimes I can't), I asked Victor if he'd name his early influences, and he replied: "Frank Frazetta, Geof Darrow, and Al Jaffee." I had to look up Frazetta (often referred to as "the godfather of fantasy art") and Darrow (a renowned comic book artist) but did not have to look up Al Jaffee, a cornerstone MAD magazine artist, responsible for the famous MAD fold-in back page. It will never cease to amaze me how much MAD DNA there is among New Yorker artists, no matter the era—Victor is one of the newest New Yorker artists photographed for this book and still cites MAD as an inspiration. Speaking of the modern-day cartoonist, it's about time I noted that nearly all New Yorker cartoonists these days work in some capacity outside of cartooning. The older culture of a full-time working cartoonist has just about left the building.

BEING A STAND-UP COMEDIAN, AS VICTOR IS

(and as a number of his colleagues are), seems like the perfect complement to creating humor on paper. Cartooning is a silent enterprise; stand-up comedy is anything but.

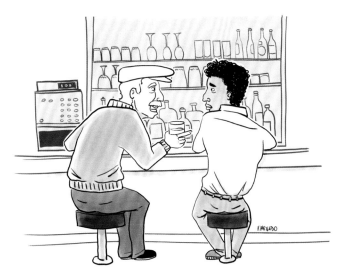

"I hope you're ready for some unsolicited and shortsighted advice."

"Actually, we're just getting started."

P.C. VEY

Peter Vey's cartoon world is unlike any other cartoon world in the *New Yorker* galaxy. Vey people, either male or female, are *his* people, and no one else's. The faces seem flounderish. His people are Manet-like flat figures floating over a backdrop. His washes are as flawless as his captions. He uses language as a banana peel.

The first time I met Peter Vey, he had not yet begun his run at *The New Yorker*. We shook hands in a small coffee shop on the ground floor of the magazine offices at 25 West Forty-Third Street. At the time Peter resembled a version of a young Roy Orbison—dressed all in black, with jet-black hair. He brought an edge to the tweedy crowd that gathered upstairs on the twentieth floor in the magazine's art department.

Before his long slog to getting his world onto the pages of *The New Yorker*, he, like many of his generation, provided ideas to Charles Addams (others who did so include Jack Ziegler, Peter Steiner, myself, Leo Cullum, and Mick Stevens). A few years ago, I asked Peter a few questions about his work. Instead of me telling you what he said, I think it's better to hear it from him.

I asked him about his connection to Charles Addams. Vey described his Addams ideas: "One had the title *Hot Tub Sabbath*, with three witches in the cauldron having a time of it. The only other one I remember was a businessman with a briefcase standing in front of an opening elevator opening onto another elevator opening onto another elevator, et cetera."

MM: Some cartoonists' work changes over time, but your drawings, as long as I've seen your work, it's always looked as it does now—I can't remember an early Vey period. What did your drawings look like when you were, say, fifteen?

PV: When I was a teenager my drawings were much more complicated, even ornate. I filled up as much space as possible with as many lines as I had the energy and stamina to draw. Which was quite a bit. An infatuation with the black-and-white work of

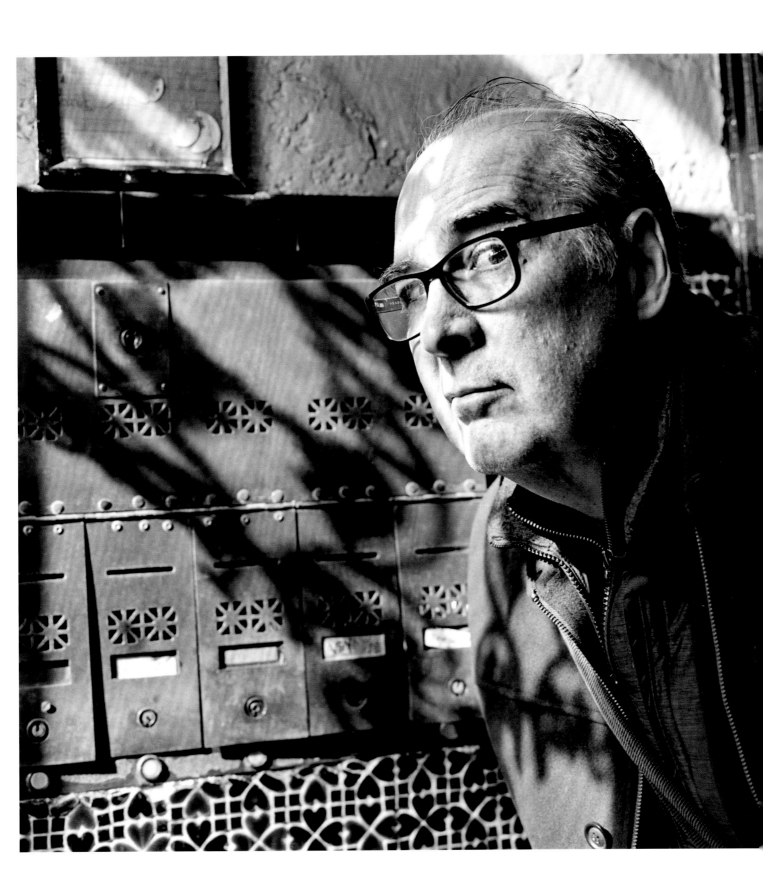

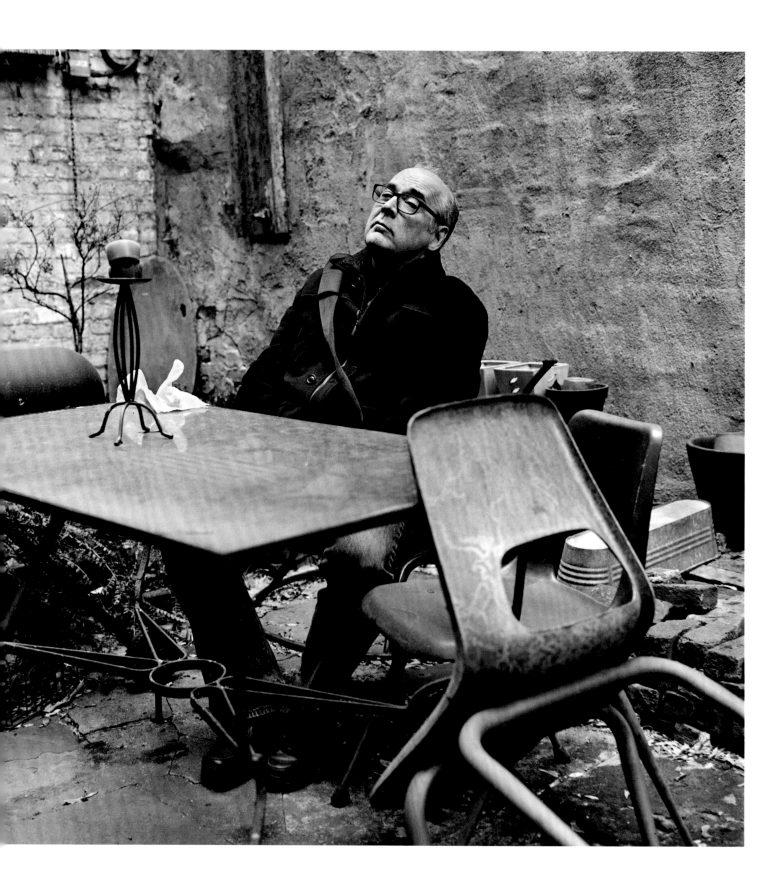

Virgil Finlay, Aubrey Beardsley, and Peter Max had a lot to do with it.

MM: Not long ago, you told me that the cartoon collection *The World of George Price* was meaningful to you. I can see some of Price's geometry in your style, but not in an obvious way. Meaning that your lines aren't Sempe-like but more straight edged. Am I totally off on this?

PV: No, you're not off. I use the lines to divide the space. I enjoy a pleasing arrangement of space, a balance. NOT PARTICULARLY WELL BALANCED BUT BALANCE THAT'S INTERESTING; THE LINE JUST HAPPENS, depending on the age and/or deterioration of the pen nib.

MM: I wonder: do you imagine you'd be the same cartoonist if you lived in, oh, I don't know . . . Indiana?

PV: Most of the cartoons I do aren't necessarily about New York but they do take place in New York. If I draw a living room, the building outside the window could be the building outside the window of my living room. But then the building across the street was torn down a few years ago and the building that replaced it looks nothing like a building I'd like to draw, so I don't.

"No wonder we could get tickets."

"Shouldn't you be reading that to me out loud or something?"

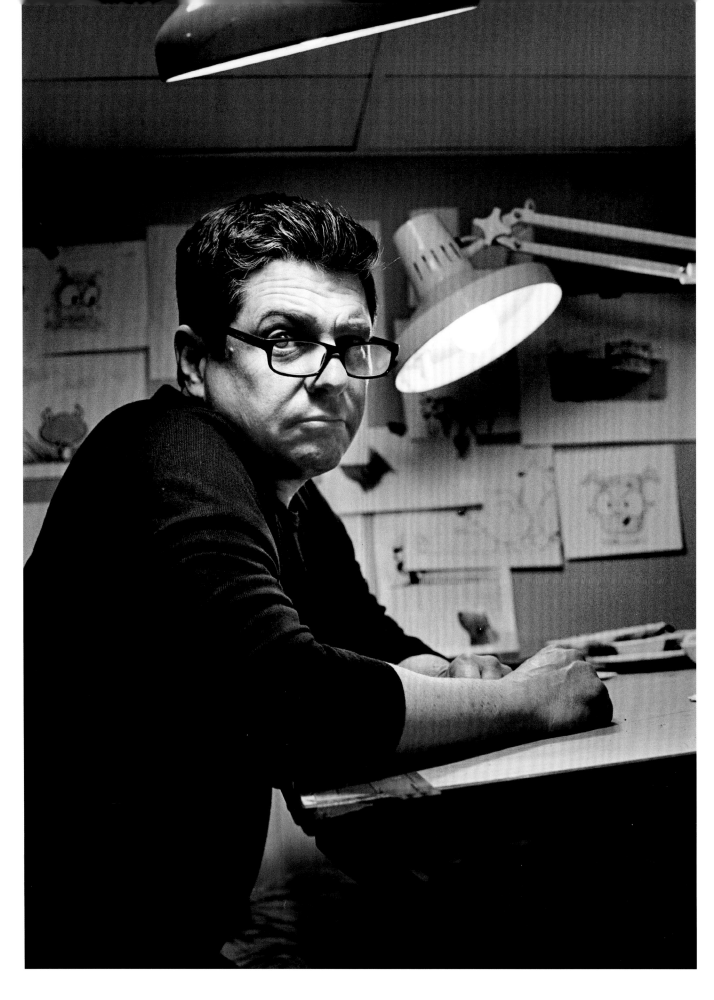

CHRISTOPHER WEYANT

CHRISTOPHER WEYANT

While looking through and enjoying hundreds of Christopher Weyant's *New Yorker* drawings, I posed the question to myself: What makes for a successful cartoon? And you know what the answer is? Surprise, surprise—there is no one answer. Each cartoonist, through their body of work, and, of course, the drawings themselves, defines their own measure of success. The late great *New Yorker* cartoonist Henry Martin used to say that certain cartoonists "draw funny." (One of Henry's examples of cartoonists who drew funny was George Booth.) The implication was that certain cartoonists already have the reader on their side simply by laying down their lines. A good caption, of course, seals the deal. Other cartoonists rely on the caption to carry the work. A number of cartoonists depend on their "cartoonist world" to make their drawings work. Others rely on a solid idea.

To me, Chris's work ranges over all schools. He has a friendly style that is his alone, with ideas supported by meaty captions. There's a strong undercurrent throughout his work of timely cartoons, in the grand *New Yorker* tradition of delivering a subtly camouflaged message. In this way, his work reminds me of James Stevenson, one of the magazine's middle-period masters of cartoons ripped from the headlines.

Chris once told an interviewer from *Cracking the Cover*:

"I read four to five newspapers each day and let the world sift down into my brain. Add a little coffee and staring off into

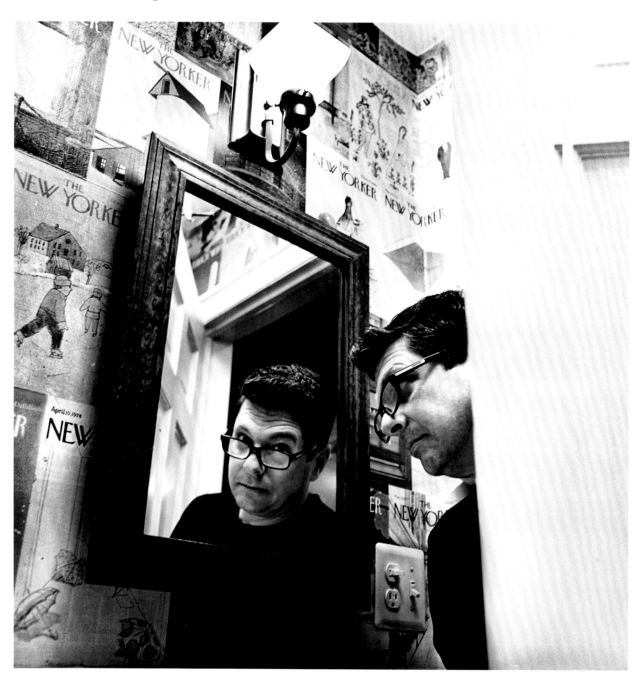

space with a pencil in my hand, and then funny ideas begin to percolate (on good days, that is)."

Letting "the world sift down into [his] brain" is not reserved for his *New Yorker* work alone. Chris

has a parallel career as a political cartoonist, with his work regularly published by the *Boston Globe*.

IT'S TEMPTING TO THINK OF CHRIS'S WORK, THEN, AS MOSTLY POLITICAL, BUT THERE IS ALSO HIS WORK THAT ONLY (ONLY!) ASKS YOU TO LAUGH. A good example is his December 7, 2015 *New Yorker* drawing of a fellow with a tiny rake raking leaves from around the base of a tiny tree trunk. Small bags of leaves are set to the side. This is funny drawing.

I've talked cartoons—specifically *New Yorker* cartoons—with more cartoonists than I can remember. Some won't go very far into "the art of cartoons," while others dive in with what comes close to glee mashed up with a great passion for the art form. Chris is solidly in the passionate camp.

"I never thought I'd have to move back in with my parents."

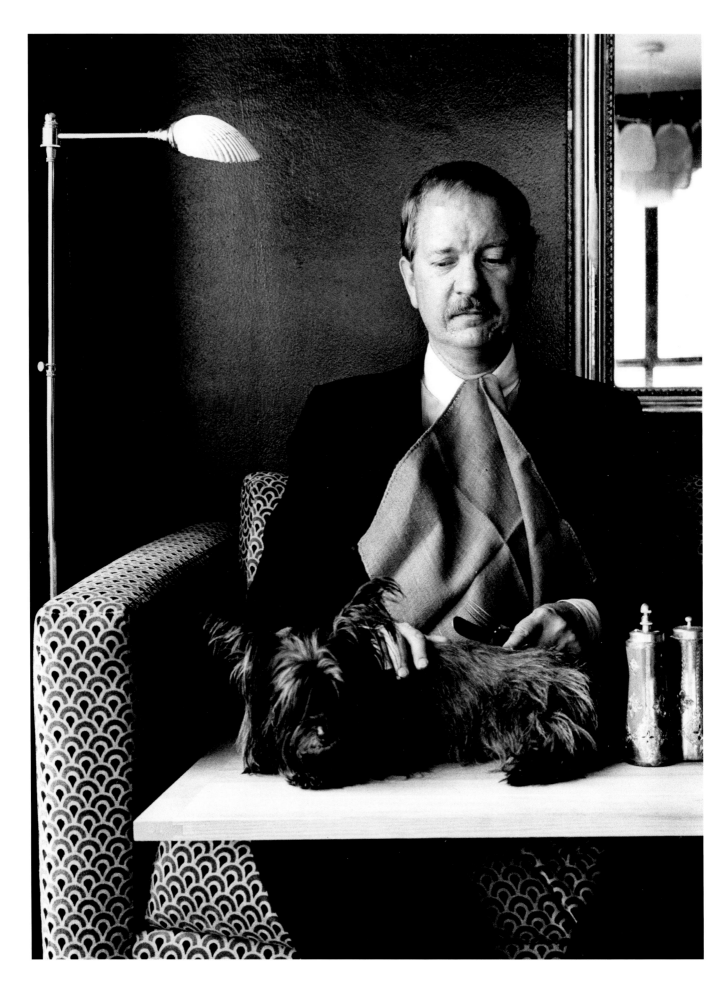

GAHAN WILSON
1930-2019

One of the few times I ever sat in *The New Yorker*'s cartoon lounge, an area designated for the magazine's cartoonists to sit in before they trudge in to see the cartoon editor, I sat right next to Gahan Wilson. It was our first meeting, although by then, he and I had been contributing to *The New Yorker* for about twenty years. He began in 1976, and I began in 1977. I was just passing the time in the lounge that day, taking advantage of the complimentary cartoonist coffee—not going in to see the cartoon editor. Gahan was looking down at his batch, sifting through cartoons he was about to show to the editor. He was wearing what I always thought of as the unofficial uniform of cartoonists: a khaki safari-like coat, with epaulets, and a belt. He looked like a cartoonist, which in itself suggests a persona unusual.

We shook hands and then sat in silence. What to say to one of the masters of the macabre? I decided it was better to say nothing. Silence, or near-silence, is sometimes an acceptable form of respect.

At that time, Gahan was doing something almost none of us could

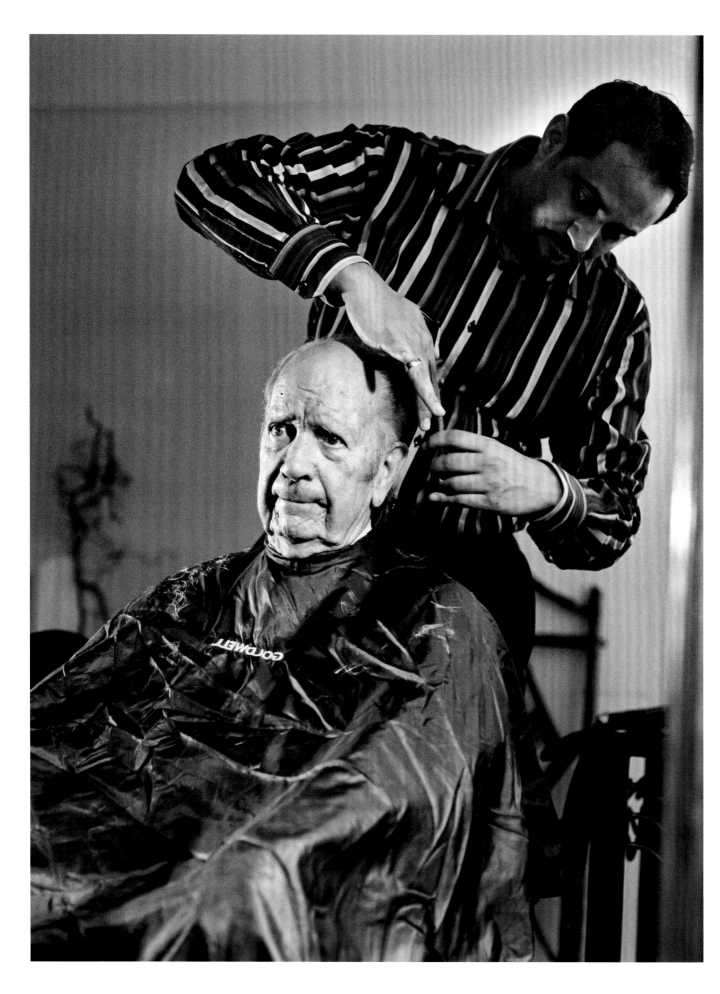

manage, professionally. He was a star in three places at the same time: *The New Yorker, Playboy,* and *National Lampoon,* delivering covers and series and single-panel work to those majestic peaks of the cartoon publishing landscape.

The title of a documentary about him, *Gahan Wilson: Born Dead, Still Weird,* tells us a lot about the man and his work. *Weird* is dead-on, so to speak. He's in the Charles Addams branch of cartoonery, but he's not a Charles Addams clone. ALTHOUGH HE HABITUALLY DELVES INTO THAT DARK, FUNNY CORNER WE ASSOCIATE WITH ADDAMS, GAHAN GIVES US MORE MONSTERS AND GHOULS PER POUND THAN ADDAMS EVER DID, ghouls more ghastly and ghostly, too. His subject matter is all over the place. It's ordinary folks encountering terror or experiencing the unthinkable in mundane places. It's a man at a pizza counter hovering over a whole pizza—the man's mouth the same oval shape, the same size, as the whole pie. It's fishermen on a calm lake, with one about to be murdered by an oarsman we see removing a human mask to reveal his true monster self. Gahan's work is both the heart-thumping you feel when you dare look under the bed as well as the relieved inner laugh after he's scared the pants off you.

Originally appeared, in slightly different form, on newyorker.com as "The Beautifully Macabre Cartoons of Gahan Wilson," November 22, 2019.

"How many times do I have to tell you to stay inside the bowl?"

"I sometimes wonder if I should have invested so much in the one cow."

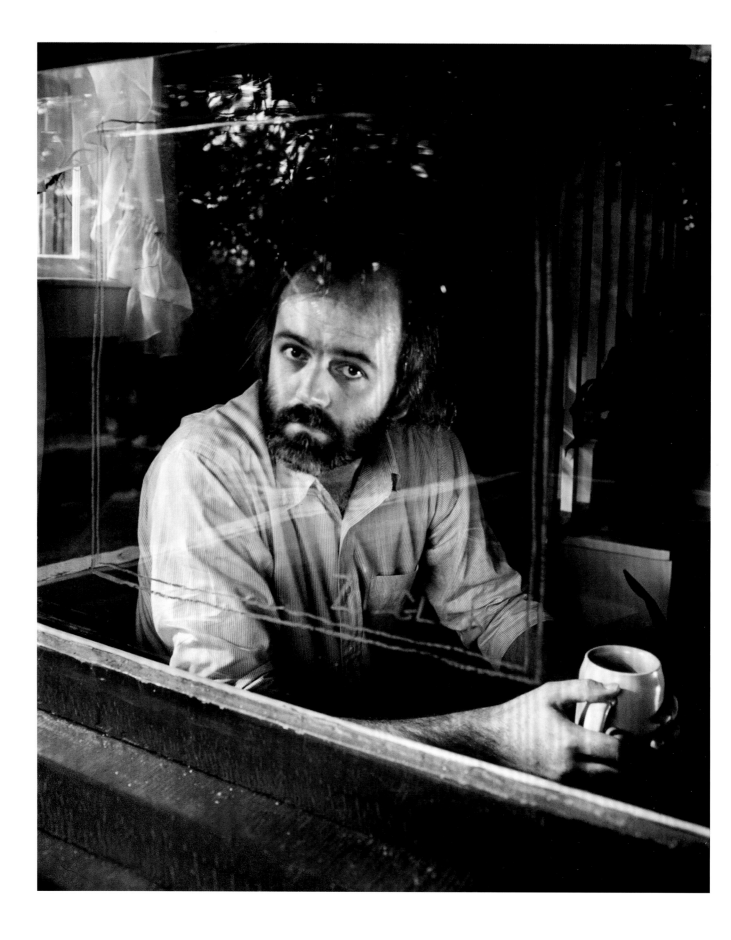

Jack Ziegler's ever-so-slightly-bumpy arrival at *The New Yorker* in 1974 was a turning point for the magazine's art. "Bumpy" because his work, though bought, remained unpublished for a while; the magazine's longtime layout man Carmine Peppe found Jack's cartoons unsuitable for *The New Yorker*. Following a directive from the editor, Mr. Peppe caved, and *New Yorker* readers were introduced to a cartoon world never experienced before in the pages of the magazine: flying people, a poetic coffee machine, giant hamburgers, Louis XIV in the subway, superheroes with human issues . . . and so much more.

Jack injected an underground comix sensibility into the magazine's DNA, as well as lessons learned from reading *MAD* magazine and comic books. In other words: cartoons steeped in contemporary popular culture. His influence at the magazine caused this writer to call him "the godfather of contemporary *New Yorker* cartoonists"—a handle picked up and spread out across the land by the *Washington Post*.

In an interview with him less than a year before he died, I asked Jack to expand on something he'd said a number of times, "I just want to do funny drawings":

JZ: A lot of my drawings are funny to me but definitely not funny to anyone else. But I always hope that if it's gonna appeal to me it could possibly appeal to others as well.

MM: What you're saying is fundamentally the way I operate. I'm trying to please my own sense of humor. Several people over the years have said to me, "I wonder what Lee Lorenz finds funny," or "I wonder what Bob [Mankoff] finds funny," or "What does [David] Remnick find funny," and I always say to them, "Don't think like that."

JACK ZIEGLER
1942-2017

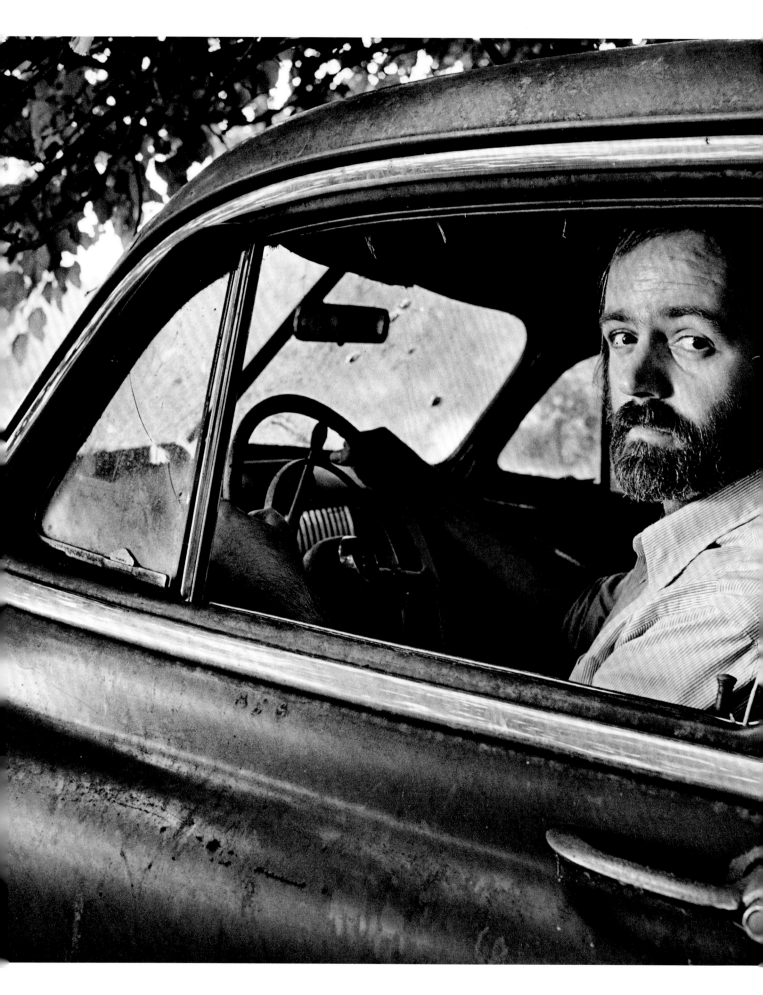

JZ: You can't—you have to just really think about yourself. Whenever I do drawings, I never think about *The New Yorker*— I'm just trying to come up with drawings that I like.

The drawings that he liked—

FORTY-THREE YEARS' WORTH OF UNSTOPPABLE GIDDY MAYHEM—

were published nearly fifteen hundred times by the magazine he loved. It's more than fair to suggest that a Mount Rushmore of *New Yorker* cartoonists (perhaps carved along the Palisades?) would have to include Jack Ziegler.

ABOUT THE AUTHORS

Alen MacWeeney, born in Dublin in 1939, is a well-known photographer based in New York. He won awards for his early work and landed a press photographer job at sixteen. An assistant to Richard Avedon in New York and Paris, MacWeeney then transitioned from fashion to street photography, developing his signature gritty style. Throughout his career, he captured portraits and everyday moments of Irish Travellers, the conflict in Northern Ireland, New York subways and the Bloomsbury group in London. His work was the subject of an extensive exhibition and limited-edition publication of *New York Subways 1977* at the New York Public Library. He is the author of numerous books: *Irish Travellers, Tinkers No More; Irish Walls; Bloomsbury Reflections;* and a limited-edition publication of Ireland and W. B. Yeats. Active today, his works are archived at University College Cork and exhibited in major museums such as MoMA, the Metropolitan Museum of Art, Museum of Fine Arts Houston, Art Institute of Chicago, and more.

Michael Maslin has been contributing to *The New Yorker* since 1977. His cartoons have appeared in four of his own collections as well as in a number of collections co-authored with his wife and fellow *New Yorker* cartoonist and historian, Liza Donnelly. In 2007 he began *Ink Spill,* a website devoted to *New Yorker* cartoonists and their history. His biography of *The New Yorker*'s legendary artist Peter Arno was published in 2016.

ACKNOWLEDGMENTS

It began in 1979, when Bob Ciano, then art director of *Esquire* magazine, gave me an assignment to photograph portraits of five *New Yorker* cartoonists to bring to light the invisible faces behind the artists of the cartoons in the magazine. And who doesn't look at the cartoons before anything else?

On a wave more like an impulse I continued photographing the cartoonists for another forty-three years.

Finally, it is a book, with forever thanks to my old friend and acclaimed designer Bob Ciano, who pushed this wagon uphill for years, with me in it, whose design brings our heroes' faces and quirky spirits to life; and to Michael Maslin, whose text reveals a masterful knowledge by being both a historian of *The New Yorker* cartoonists and a memorable cartoonist himself.

My gratitude also to Dalma Heyn, for her brilliant presentation of our book to Inkwell Management; to our agents there, Alexis Hurley and Naomi Eisenbeiss, for their enthusiastic involvement; to Sahara Clement, our editor at Clarkson Potter; and to Beth Brann and Yao Zu Lu, without whose knowledge of design and production we would have been lost.

—Alen MacWeeney, 2024

My forever thanks to Alen MacWeeney and *At Wit's End* designer, Bob Ciano, for bringing me aboard. My thanks as well to each and every profiled cartoonist for their contributions, good humor, and high spirits. A special note of gratitude to my *New Yorker* colleague and friend Peter Steiner for taking on the writing of my essay. Lastly, many thanks to my wife and fellow *New Yorker* cartoonist, Liza Donnelly, for continuing to lend an ear.

—Michael Maslin, 2024

CARTOON CREDITS

All cartoons are copyright the artist, with courtesy from CartoonStock and/or Condé Nast *The New Yorker* Cartoon Bank. With gratitude to Bob Mankoff and Trevor Hoey at Cartoon Collections/CartoonStock and Angelina Garavente at Condé Nast *The New Yorker* Collection Cartoon Bank.

CartoonStock
cartoonstock.com
Ellie Black, page 15
George Booth, pages *i*, 27
Roz Chast, page 39
Michael Crawford,
 © CartoonStock.com, page 43
Joe Dator, page 47
Drew Dernavich, page 51
Liana Finck, page 59
Emily Flake, page 67
Seth David Fleishman, pages *iv*, 71
Dana Fradon, page 75
William Haefeli, page 83 (B)
Charlie Hankin, page 87
Amy Hwang, page 91
Zach Kanin, page 95 (B)
Bruce Eric Kaplan, page 99
Jason Adam Katzenstein, page 107 (L)
Lars Kenseth, page 111 (B)
Edward Koren,
 © CartoonStock.com, page 115
Peter Kuper, page 119
Amy Kurzweil, page 123
Robert Leighton, page 131
Bob Mankoff, page 135
Jeremy Nguyen, page 143
Paul Noth, page 147
John O'Brien, page 151
George Price,
 © CartoonStock.com, page 155
Ellis Rosen, page 163 (T)
Benjamin Schwartz, page 167
David Sipress, page 175
Barbara Smaller, page 179 (R)
Edward Steed, page 187
Peter Steiner, page 191
Mick Stevens, page 195 (T)
P.C. Vey, page 207
Gahan Wilson,
 © CartoonStock.com, page 215
Jack Ziegler,
 © CartoonStock.com, page 219

Condé Nast
***The New Yorker* Collection/**
The Cartoon Bank
cartoonbank.com
Harry Bliss page 19
Barry Blitt, page 23
Ed Fisher, © *The New Yorker*
 Collection/The Cartoon Bank,
 page 63
William Haefeli, page 83 (T)
Zach Kanin, page 95 (T)
Farley Katz, page 103
Jason Adam Katzenstein, page 107 (R)
Lars Kenseth, page 111 (T)
Barbara Smaller, page 179 (L)

Directly from the Artist:
Harry Bliss, page 19
David Borchart, page 31
Hilary Fitzgerald Campbell, page 35
Roz Chast, page 39
Joe Dator, page 47
Liza Donnelly and
 The New Yorker, page 55
Mort Gerberg, page 79
Maggie Larson, page 127
Michael Maslin, and
 The New Yorker, page 139
Akeem S. Roberts, page 159
Ellis Rosen, page 163 (B)
Justin Sheen, page 171
Edward Sorel, page 183
Mick Stevens, page 195 (B)
Tom Toro, page 199
Victor Varnado,
 © Supreme Robot, LLC, page 203
Christopher Weyant, page 211